Watercolor Bold & Free

Watercolor Bold & Free

BY LAWRENCE C. GOLDSMITH

WATSON-GUPTILL PUBLICATIONS/ NEW YORK

To Robert Griffith, for his dedication to the watercolor brush; and to my loyal wife, Lynda.

Lawrence C. Goldsmith is a landscape painter in oil and watercolor. He lives and works in Fairfax, Vermont, and spends his summers on the island of Monhegan, Maine. Goldsmith received his B.A. from Yale University and studied at the Yale School of Fine Arts. He also studied at the Brooklyn Museum Art School with Reuben Tam, at the Art Students League with Mario Cooper, and with Eliot O'Hara.

Goldsmith has taught watercolor at Queens College and the University of Vermont, and was a guest teacher at the Art Students League. He has conducted workshops across the United States and in Canada, and his work is represented in many public and private collections, including the Lamont Collection of Phillips Exeter Academy and the Alfred Van Loen Collection. His paintings have also been featured in several one-man and group shows in the U.S. and abroad.

Front cover: *Return to Life* (detail), by Maxine Masterfield, 40 x 46" (102 x 117 cm).
Back cover: *Head-on Prospect,* by Lawrence C. Goldsmith, 18 x 24" (46 x 61 cm).

First published in 1980 in the United States and Canada by
Watson-Guptill Publications, a division of BPI Communications, Inc.
770 Broadway, New York, NY 10003

The Library of Congress has catalogued the hardcover edition of this
book as follows:

Goldsmith, Lawrence C 1916-
 Watercolor bold and free.
 Includes index.
 1. Water-color painting—Technique. I. Title.
ND2420.G64 751.4'22 79-26059
ISBN 0-8230-5654-6

ISBN 0-8230-5663-5 (Pbk.)

Manufactured in Malaysia

First paperback printing, 2000

2 3 4 5 6 7 8 9 / 09 08 07 06 05 04 03 02 01

Edited by Connie Buckley, Lydia Chen
Designed by Jay Anning
Set in 11 point Palatino

Acknowledgments

My gratitude, first, goes to the artists whose work illustrates this book. All of them generously contributed time and effort to select appropriate examples of their achievements, adding insights to the reader in extensive, thoughtful descriptions of their motivations and working processes. While these have been invaluable, I assume the responsibility myself for the final interpretations of the paintings given in the text. I especially appreciate the knowledgeable advice of two of the artists, Edward Betts and Edward Reep, on problems involved in presenting material most helpfully.

The photographs of my own work were taken expertly and efficiently by Kurt Stier of Burlington, Vermont.

Doris Birmingham, art historian at New England College, gave me astute appraisals of paintings that were most helpful to me in making my selections.

Donald Holden, with his rare editorial instinct, suggested the basic structure used in organizing both text and illustrations. I am also appreciative of the patience of my editors, Marsha Melnick, Michael McTwigan, Lydia Chen, and Connie Buckley, in whose experienced hands the book gradually took shape.

I owe an unpayable debt to Robert Griffith of Waldoboro, Maine, both for his constant encouragement to turn the ideas we share into a publishable book, and for the many letters in which he elaborated on those ideas so eloquently. I confess to many instances of transplanting his thoughts with his assent. Finally, I am thankful for and to my wife, Lynda, upon whose support I can always count.

L.C.G.
Fairfax, Vermont
September 1979

Finding New Directions

I'm writing these paragraphs while sitting on a veranda enclosed on three sides by panels of windowpanes. There are 180 panes, each with its own vista. I can see banks of clouds through them, mottled gray with spurs of bright white light softening their upper edges, with an occasional frayed patch of cerulean blue sky showing through. In the far distance lies a strip of slate blue land and close by, three small, rocky islands jut out of the pewter gray of the Atlantic Ocean along the coast of Maine. A fir-studded hillside with plumes of grass bent by the winds is at the perimeter of my view. What impresses me most in this scene is that each of the 180 windowpanes frames a promising composition. Here could be the starting point for 180 complete and distinctly different watercolor paintings, without even considering the variations that could follow from each.

Although this scene is unique it represents a truth common to everyone's surroundings. Ready themes are to be found through every windowpane. Every fragment of your vista is fuel for your artistic imagination—material for innovation, boldness, and freedom.

But where to start in a *personal* direction?

"To paint is not to copy the object slavishly," said Paul Cézanne, "it is to grasp a harmony among many relationships."

But how do you go about seeing those relationships in everyday things and using them in your own way? This book was conceived to suggest some answers. It is written for the artist who wants to sharpen his perception and to put his experience to use in directions that offer new challenges and a wider scope.

Ways to advance are highly personal. For this reason, this book offers a range of ideas that cover a wide spectrum of approaches in watercolor. No two artists will profit from them in identical ways. Each direction is described in such a way that you should be able to tell quickly if it offers you an avenue you want to follow. Enough practical information is given so that you will be able to translate the theory into terms that apply to your own work. But this information is not given in an *a*, *b*, *c* form, and you will not be told, "Now do this and don't do that." Ideas are presented as points of departure for your own imagination.

These ideas touch on most areas of watercolor painting. They suggest new approaches to color excitement, new uses of shape and design, and ways of perceiving and executing both common and uncommon motifs. You will soon realize, however, that one area has largely been left unexplored—and for good reason. This area is traditional, representational painting, which has been thoroughly explored elsewhere. The assumption of this book is that you know this field and that you are looking for ideas that you can use to expand the knowledge you already possess. It is also as-

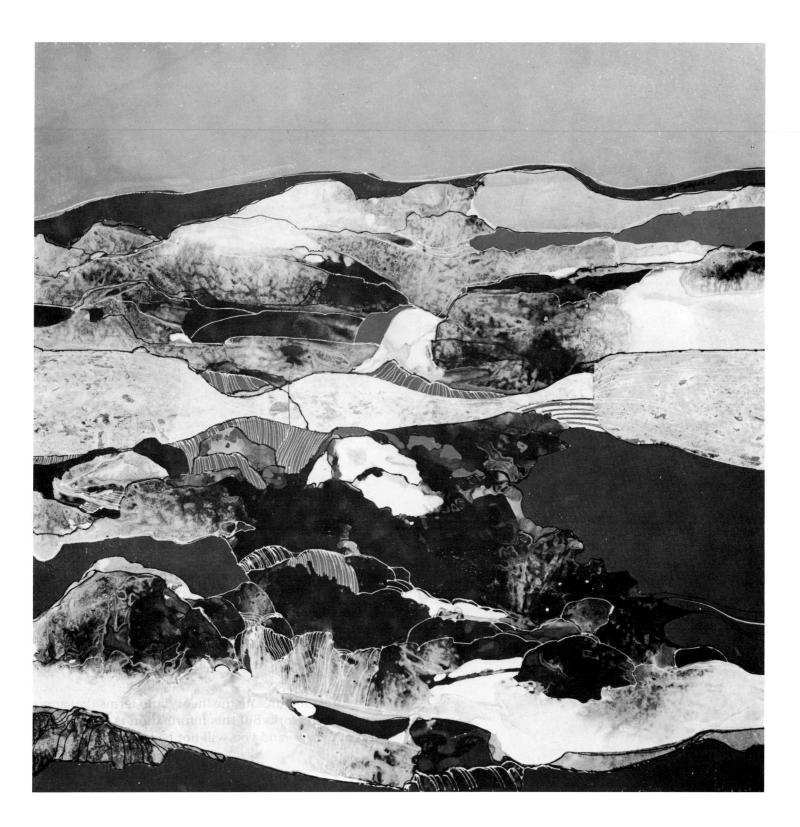

Earth's Formations, *by Maxine Masterfield, 38 × 40 in. (97 × 102 cm).* Out of ordinary subject matter, this artist has found a unique style. Her personal qualities are the assembling of irregular fragments, the juxtapositioning of flat and textured areas, and especially her introduction of lacy lines in Chinese white, or color.

sumed that you hope to become acquainted with entirely new directions and that this book will give you a start in one or more of those directions. Therefore, you will be confronted with a versatile array of new possibilities.

All avenues under consideration have this in common: they seek to capitalize on the unique ways of watercolor. Our medium can do things no other medium can. The watercolorist has at his command a freshness and exuberance in the medium that it would be folly for him to overlook. Wherever possible, I suggest letting these properties show through. They should be presented proudly (I even put in a good word for accidents), and the "watercolorness" of a work should always be stressed. The emphasis is on describing these characteristics literally so that you will be prepared to use them fully in the new work you undertake.

Besides explaining a range of new directions and showing how the uniqueness of watercolor can be used to explore them, this book has a third emphasis. As the title indicates, the primary focus is on achieving boldness and freedom. Each of you reading this will interpret this in your own light as you search for individual expression unfettered by convention. In short, I urge you to strike out on your own.

There may seem to be a paradox here. How can you be given instruction by someone else on how to become your own master? I have tried to solve this dilemma by providing just enough concrete material to get you started. From there on, you are encouraged to pioneer. You should follow the specific instructions given with this in mind. The aim is to learn how to use material so as to be successfully bold and free. Tools *are* needed. They are only productive, however, when you are receptive to innovation and exploration. "Painting is founded on the heart controlled by the head," John Marin wrote. The hope here is that you will find cause in your heart to free your potentials as an artist.

HOW TO USE THIS BOOK

The material in this book has been organized to help you act on your intentions. To widen your horizons, it does occasionally discuss what may be unfamiliar philosophies of art, but it primarily seeks to give you advice on solving your own problems and reaching your own targets.

A good plan would be to read through the book quickly the first time to see what it offers you. Some of the material may already be well known to you, while other sections will provide reminders, or possibly alternatives, to the ways in which you are now working. The sections of most value to you will be those covering new ground. Check these to come back to for deeper study. They will be the ones you will want to apply to your work.

Follow the ideas exactly at first. Then deviate from them. The aim is to get you moving in a given experimental direction. Repeat with variation what you learn.

There's also much to be learned from the illustrations in this book. The work has been chosen from characteristic examples of the output of established watercolorists (and a few selected unknowns). As you will see, each one differs in both spirit and technique. As wide a variety as possible was sought—although the level of skill is always high—to remind you of the endless scope of our medium. Study these watercolors to find ideas to adapt. Most have been done in transparent watercolor, since this is the primary focus of the book. A few—not many—show work done with acrylic, dyes, inks, or casein on paper, since inks, dyes, or acrylic used transparently will often accomplish nearly the same results as watercolor. In the case of one or two of the experiments, acrylic might even be superior in its controllability. If you use acrylic, you should be able to apply that medium to almost every project in the book. Don't overlook that possibility even when only transparent watercolor is mentioned.

WHAT THIS BOOK CONTAINS

The next section discusses the unique properties of watercolor. You will be reminded of ways in which watercolor pigment behaves that are out of reach for those working in oil, acrylic (except when used transparently), casein, gouache, enamels, or pastel. You will be able to single out qualities of watercolor that are especially significant in boldness of concept and fluidity of paint application.

Achievement of these goals requires a certain flexibility as you handle your brush. You need to loosen up. A section is devoted to why this is necessary and how to go about it. A number of ways are suggested that will actually limber up your painting arm, get you in the habit of designing and applying paint boldly, and encourage you to think on a grander scale about your work in general.

After giving advice on loosening up, the book discusses the fundamentals that must go into the planning of every work of art. These are the prerequisites of deciding on your theme, apportioning your space, picking a color scheme, choosing a range of values, and all the other familiar essentials. Reminders are needed because free painting demands *more* intensive planning, not less. You will be able to ask yourself a series of questions about any proposed painting and evaluate those answers before you actually start work. Finally, there is a brief discussion of the perplexing question of

how to know when a painting is finished.

Then you get to the heart of the book—sixty-four experiments selected from the countless possibilities available. Each examines an idea and gives practical directions for its achievement. The experiments cover a wide range and are grouped into three categories: composition, concept, and technique. Some embody new ways of thinking about art. Others are aimed at converting painting habits so that you can shake loose from your accustomed methods. A few suggest introducing new techniques and combining watercolor with other media (with watercolor always predominant). But you are encouraged to pick and choose according to your own needs.

Richard Diebenkorn, the landscape and figure abstractionist whose one-artist show recently toured major museums in all parts of the United States, once said "I can never accomplish what I want, only what I would have wanted had I thought of it beforehand." All of us share in that quandary. We can never predict precisely what will happen in a painting; we can only plan as carefully as possible and then let our unconscious impulses take over. These experiments, and this book in general, hope to reduce the chasm between starting idea and finished results to manageable proportions.

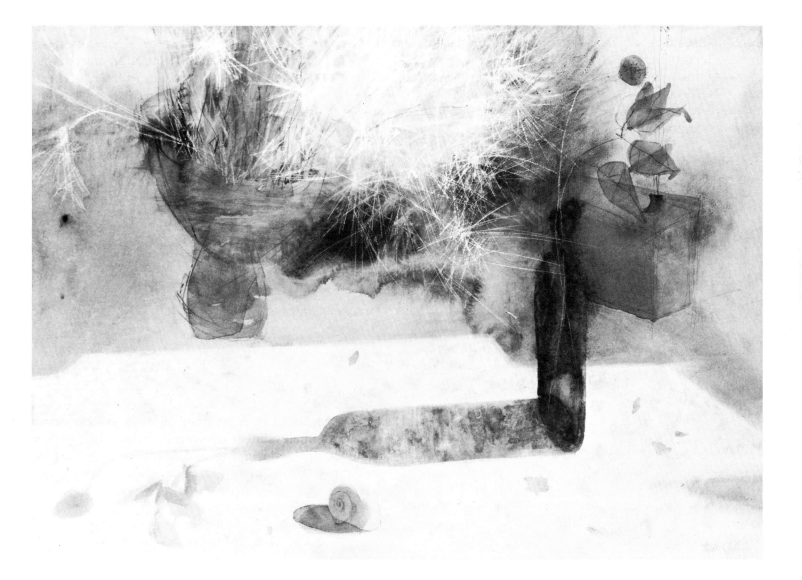

Sun and Shadows, *by Ruth Cobb, 21 × 29 in. (53 × 74 cm).* Out of common still-life material, the artist has performed an act of consecration. Bursts of light exploding against lurking shadows transform the material into agents of melodic expression.

Knowing Your Craft

In Singapore, in the National Museum Art Gallery, I came upon a delicate landscape by Leng Joon Wong, with this inscription describing its power: "Directness, spontaneity, and fluidity—qualities of a fine watercolor work." With remarkable brevity, those words sum up what the medium affords the artist.

THE UNIQUE WAYS OF WATERCOLOR

What watercolor offers—as does no other medium—is the unique interplay of the quick dissolution of pigment in water spreading over sparkling white watercolor paper. This interplay creates wonders. Not only does it behave differently with different artists, with no artist painting like anyone else, but it differs with each brushstroke. Each time the artist dips his brush into pigment he is making a highly personal statement that is never duplicated.

The true watercolorist appreciates this opportunity and cherishes the challenge. For him the unique qualities of watercolor are his basic instruments of self-expression. The more he understands and uses these qualities, the richer his work becomes, since there is no limit to his explorations. Following are some of the more outstanding characteristics of watercolor painting with which every artist should be familiar.

White Paper

Most important is the paper itself. Its white clarity and its frequent beauty of texture are always present to combine with the artist's own contributions, his application of color and everything else he does on the paper's surface. The paper's natural qualities are there to be considered, used, and never neglected. Its whiteness increases the brilliance and sparkle of pigment and can dominate a design by its glow. It can also be used by itself to offer a white element as part of the color put down by the artist.

Paint Transparency

An astonishing range of tonal values, both subtle and intense, comes alive in the clear transparency that watercolor on white paper creates. The tones appear as through stained glass, creating depths that are luminous and never opaque.

Fluidity

The free-flowing movement of watercolor pigment is without doubt the most distinctive quality of the medium. Paint runs or spreads swiftly, sometimes unpredictably, which is largely responsible for those ethereal and mystical qualities, those outbursts of lyrical feeling and poetic effects. This fluidity aids the artist in creating illusions of endless space, which adds to the feeling

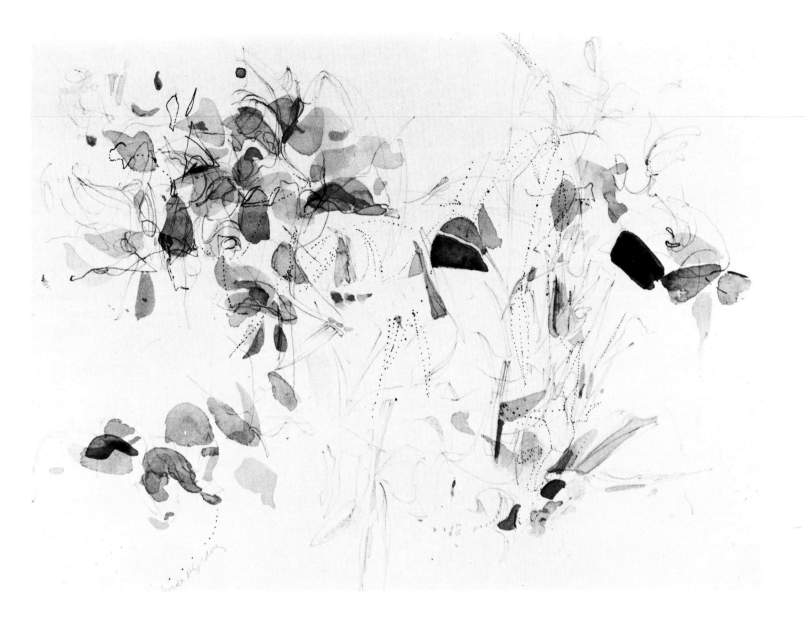

of freedom, and can be either a trusted or treacherous servant. Its mastery marks the competence that the watercolorist has attained.

Gradation

Watercolor allows for a smooth, sensitive progression of color tones and values, blending and slowly changing as they build toward the high points of a painting. These gradations accelerate movement and store up force. They relate one shape to another and give character to the shapes themselves. They form thrusts of fluidity that emphasize the push–pull action of the various picture planes.

 Gradation also makes possible subtle diminution or strengthening of a passage in a single color or a facile blending of two or more colors, which is another unique aspect of watercolor. Gradation enlarges and enlivens the capabilities of color far beyond what it can do without gradation. Watercolorists exploit it intuitively, and some are perhaps unaware that their use of

Mid Leaves and Flowers, *by Frieda Golding, 11½ × 14½ in. (29 × 37 cm).* The radiance of white paper as a ground gives the watercolorist a head start. Here the artist makes maximum use of it, letting the white illuminate her dabs of pigment and provide contrast to her solid and dotted lines. The paper is never isolated from the design; it becomes an organic part of it.

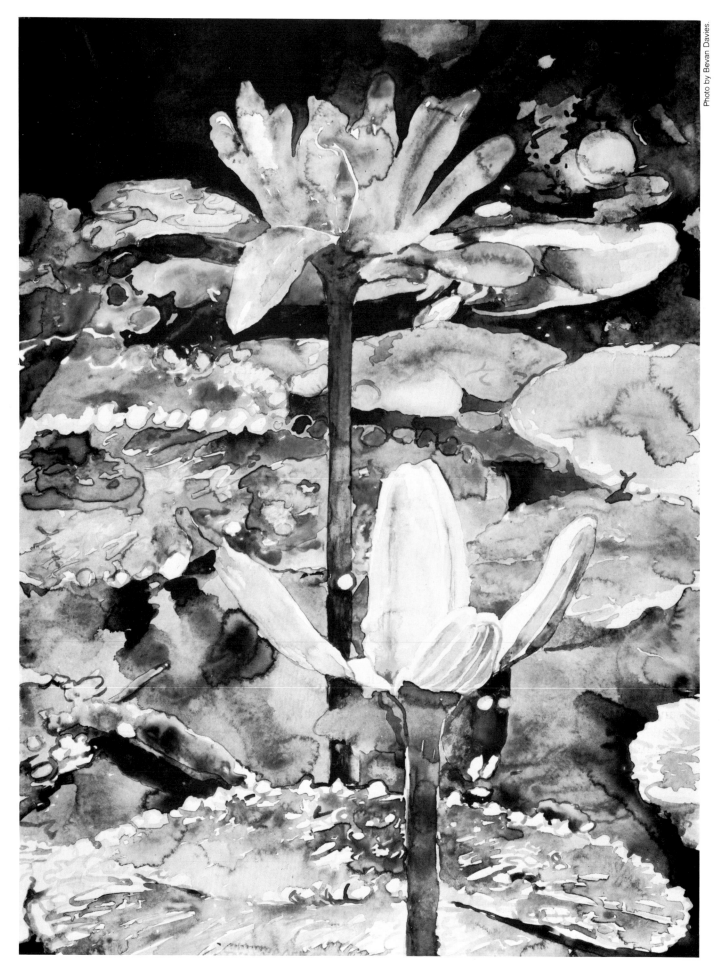

gradation is what gives them the most pleasure from color and makes color so captivating.

"Colour has taken possession of me," Paul Klee wrote in his journal after visiting North Africa where he worked on a series of watercolors. "I don't have to strain after it any more. Colour has conquered me for always. I know that. That is the meaning of this fortunate hour: I and colour are one. I am the painter."

Staining

The effects of color can be heightened by partial lifting of color, with the use of tissue, sponge, or damp brush. This leaves a haze of color that pervades rather than insists. Other colors can be laid over or adjacent to the stain, and they too can be lifted.

Drying Speed

In no other medium is the *process* of painting so evident. The speed in which pigment dries on various parts of the paper leaves its traces. This phenomenon sometimes reveals the artist's inner feelings in ways he can't foresee or control, but they are always there to add expressiveness to his work.

Accidents

Beautiful things happen inexplicably when colored water collects. Inexplicably, these arrested watercourses build hard edges, diminish soft edges, burrow into existing color, and form strange independent images. The artist may see these as problems, accidents he will try to obliterate. Or he may see them as strengthening his theme in unexpected ways. Finally, they may suggest a change of theme that he will seize upon happily. Good or bad, accidents are inevitable in watercolor. The artist accepts this and finds ways to convert his accidents into assets.

Linear Activity

The liquid nature of painting in watercolor lends itself to working freely in line. The options are many. The artist can control his linear statements or give them minimum control, venturing into bold, intuitive strata to find the fullest emotional expression. The fluidity of the paint allows also for utmost color variety and gradation within the lines themselves.

Texture

Numerous textural effects are also possible. A single technique is immediately changed when it is combined with a second technique, or a third one. Drybrush work, spatter, the scattering of coarse-grained salt, airbrush spray, lifting, absorption of paint with strips of facial tissue, application of paint through lace or other open fabric, stampings, and tilting of the painting surface—these are some of the devices that can be used to vary the texture of a watercolor. The artist can call upon a number of such techniques that have been well tried, and he can also invent his own.

Use of Other Media

Original effects can be obtained by combining another medium with watercolor, since it adapts well without sacrificing its luminosity and fluidity. Some of the media that can offer additional excitement to a watercolor are pen and ink, crayon, Cray-pas, pastels, collage, and markers.

All these characteristics of watercolor aid the artist in whatever direction he is working. They are especially significant for the artist who aspires to become freer and bolder. Whereas the artist who works tightly keeps in check much of the energy possible in the medium, the bolder artist gives the unique behavior of watercolor freer rein. Consequently, his knowledge of it is more vital and his use more imaginative.

Later sections will give you specific ideas on how to work with your knowledge of watercolor's properties. Making the best use of these qualities, however, requires that you be flexible enough to let things happen. You must be enough of a visionary so that you don't sink into triviality. In short, you must be loose.

How do you become loose? Just telling yourself to be loose usually doesn't work. Like learning to ride a bicycle without holding on to the handlebars, as you may have done in childhood, it takes a lot of practice before you become really loose. The next section will give you some hints.

Red Lily, *by Joseph Raffael, 29 × 21¼ in. (74 × 54 cm).* Courtesy of Nancy Hoffman Gallery, New York. This painting exhibits an especially wide range of variations in the use of paint transparency, one of the most wondrous ways of watercolor. Within his forms, and surrounding them, the artist moves from the very lightest tints to deepest darks—keeping all of them transparent. Each part of his work therefore can be enjoyed for its luminosity.

Environs of Pamajera, *by Alex McKibbon, 22 × 30 in. (56 × 76 cm).* Linear activity offers much of the flavor of this work. Washes are thinly and lightly applied, leaving the linework to make its statement almost independently. Lines are abundant throughout. Light and dark, swirling and straight, thick and thin, they produce a movable feast.

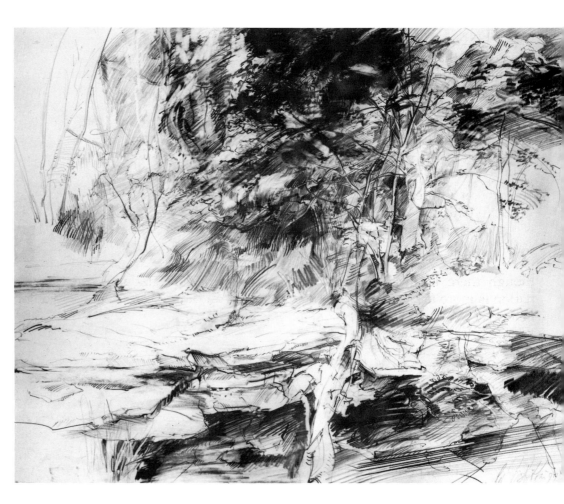

Northern Spruce #579, *by William Thon, 20½ × 27 in. (52 × 69 cm).* Courtesy of Midtown Galleries, New York. By an artist noted for pushing back the frontiers of texture, this watercolor is an example of his inventions. Graininess is everywhere, but never is a grainy passage exactly duplicated. Textural qualities are enlivened by sharp lines loosely painted. This combination—basically a simple one—evokes the endless mysteries of the artist's woodlands motif.

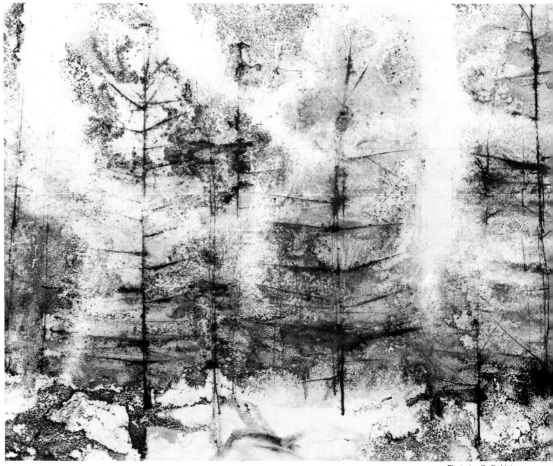

Photo by O. E. Nelson.

LOOSENING UP

One reason that painting in watercolor is so full of tension and excitement is that success comes only when certain conditions are in fragile balance. The artist must feel sure of his technical facility. His imagination must be sparking. And his emotional state of mind must be receptive to developing ideas. All three are essential, and they must happen simultaneously. When one is missing, the work is a flop. To test this notion, try working on a watercolor when you are expecting a crucial telephone call. You will soon realize that your state of mind just isn't in tune with creativity.

Technical facility is the most reliable of the three factors. When you acquire it, it sticks with you—although there is always room for expansion. Imagination is more fickle. Still, it can be prodded. You can look over your old work, or someone else's work, or pick up ideas such as those offered later in this book. You can find a concept with which you feel sympathetic. But a receptive state of mind is delicate and intangible. And sometimes it seems that the harder we try to put ourselves in a particular frame of mind, the more difficult it is. However, it does just happen—most of the time—but only after it becomes a habit. Since it's largely self-assurance, it comes only with time. You then know by experience that you have the ability to cope with a bold new idea.

Fortunately, there are ways of speeding the process. You can deliberately induce an emotional state of relaxation, receptivity, and the freedom to accept and cooperate with opportunities as they arise. You can invite your soul to loosen up. After a while, this loosening up becomes a habit, a conditioned reflex. I'll start with procedures that obviously make loosening up easier.

Use Larger Paper
Simple as it may seem, the jump from a cramped bit of space to a larger field has brought out hidden potentials in many a painter. Beginners often make the mistake of starting small. Just as being in a large room often means you must speak a bit louder to be heard, a large sheet demands greater boldness.

Keep Your Paper at Arm's Length
Eliot O'Hara used to urge his pupils to place their paper on or near the ground (or floor) and seat themselves so that they could paint comfortably only by stretching their painting arm at full length. This is a sound idea. It requires that you move the brush with your arm, not exclusively with your fingers. More body motion goes into the strokes, and it is virtually impossible to make tiny spots or lines. Your total effect is likely to be stronger. (You can move in closer for the finish.)

Work Wetter
Try using more water at the start and keeping your paper wet longer than you have previously done. Wetness is almost synonymous with looseness. You will get floods of color that are full of promise, almost demanding that you use them inspiredly. They may suggest forms and images to develop that you had not considered at the start, or you may discover that they are sufficient for a successful painting this time, and leave them alone. Or you could go on and tighten up passages that you feel are too loose.

A pupil once remarked, "Oh, I see. You paint from Z to A!" She had caught the gist of it. A painting starts with large, loose, free areas and progresses, through gradual tightening, to a finished image. You enter the danger zone as you approach "A." Take it easy there.

Use Larger Brushes
Especially if you have become addicted to small brushes, experiment with large ones. Try a flat, single-stroke brush that's at least one inch wide—better still, one and one-half or even two inches. Keep going with these as long as you can. Then switch to medium-sized brushes, perhaps a flat one-half inch brush or a round one of equally generous size. Try finishing your painting without using anything smaller. Large brushes will dictate a stronger and more daring mood.

Work for a Shorter Time
This one is hard to make specific. Obviously there's no optimum span of time that will govern the quality of your work. And no two people are likely to run at the same pace. Yet often the person who works laboriously will profit by limiting his painting time. His quick sketch may be freer than anything he has been doing previously.

See what you can accomplish in two hours if you are accustomed to working three. School yourself to make quicker decisions. Pay less attention to detail. Take a firm stand when you think your painting might be done. Don't waver by adding "finishing touches."

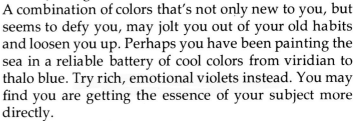

Pick a Jarring Color Scheme
A combination of colors that's not only new to you, but seems to defy you, may jolt you out of your old habits and loosen you up. Perhaps you have been painting the sea in a reliable battery of cool colors from viridian to thalo blue. Try rich, emotional violets instead. You may find you are getting the essence of your subject more directly.

Strangely, if you get the essence, you are apt to see the same colors in nature later on. An artist friend of mine was working with deep violets in one of his seascapes. Then he discarded them, saying they were not

true to nature. Some days later the sea blew up in a storm. He and others did see those very deep violets.

Limit Your Drawing

Overcautious painters who want to form habits of greater looseness should try starting a work with less drawing. Too detailed a drawing often serves as a crutch. The artist falls back on it at times when he should be depending more on his brushwork. By its very nature, a fluid line of watercolor paint is looser than a line created by the pencil's lead. Also, because the paint is wet, it must be dealt with in a short period of time. Quicker decisions are imperative. Hence a painting with minimal drawing should show more spontaneity than one that relies on the pencil and more nearly resembles a colored drawing.

Don't Try for a Finished Painting

One sure way of loosening up is to try new ways without expecting to get a successful painting out of the experience. Think of the experiment, not the product, and you won't be hampered by setting a goal you think you must reach.

All too often we try to strike out along a new path, only to get more and more involved in that particular painting. In order to save *that* painting, we retreat to our old ways. We promise ourselves that we will experiment tomorrow. Do it today. The exercise that you are attempting should be of far greater value to you than a repetition of ancient habits.

My favorite bit of advice (and one I never expect anyone to follow) is to punch a hole in the center of your paper before you start to paint. You have now destroyed that lovely paper. You can't make a painting from it. All you can do is to use that paper to try new shapes, new colors, new brush techniques. You are free to experiment, and you will be loosening up.

Put Those Rules Aside

Too many rules and regulations tend to subjugate self-expression. Too much regimentation produces pictures that are testimonials to contrived stiffness, that are unemotional and lacking in personal feeling and mood. All that can be said for them is that the painter who did them knew his rules. Too well.

Rules are meant to be absorbed so that you can apply them when your intuition tells you they are needed, not because someone said they must be obeyed. When you put rules in the forefront of your mind, you become a slave to them. Freedom flies out the window. Put rules in the back of your mind, where they belong. Let them become second nature. Concentrate, instead, on the immediate sensations about you—the ideas and impulses that excite your imagination. Let them take over.

You Can Correct Mistakes

You will feel a good deal less tight when you remind yourself of how much you can do to change things you don't like in a painting. You can control *almost* everything. It's easier to be bolder when you know you can retreat, if necessary.

The emphasis is usually given the other way around. People talk about how difficult watercolor is because they think you can't correct mistakes. They tell you it's so hazardous! Being human, we like to agree with this notion. Since watercolor is so difficult and we're doing well with it, we must be superior beings. Actually a high degree of control is possible. Changes can be made. Mistakes can be erased. Thinking in these positive terms is more realistic than being floored by the occasional ineradicable accident.

The greatest control is possible when you are working wet-in-wet. The slower drying period gives you more time to step back and think and change the overall picture. You can save whites, regroup middle tones, and pull up pigment where you don't want it, using a damp brush or dry tissue. And you are free to add pigment where you do want it. But control does not end with the first drying period. Your ability to re-wet allows you to do many things later on. You can lift out paint to achieve better values. You can add soft-edged effects by scrubbing hard edges with a bristle brush or by applying them freshly in lightly painted areas. You can deepen tones that dried out too light in value. You can use calligraphy to rescue a painting by unifying it.

More dramatically, you can remove some accidents that intrude upon your original intentions and make other accidents conform to them. You can also capitalize on accidents that open your eyes to changing your original concept. This will be discussed in detail later.

Correction is possible throughout the painting process. Remind yourself of this and you will put yourself in a looser frame of mind.

Think Bolder

Some artists have found that they can deliberately school themselves into painting with bold assurance. They see the need and force themselves into accepting it. By telling yourself that you *can* be bold, even if that is not your habit, you can then take appropriate measures to obtain it. Paint with swifter strokes. Use stronger color. Design larger images. Go at all the work in a more carefree attitude. You may surprise yourself with what you can accomplish. Tightness begins to disappear. Boldness itself creates new opportunities. Gradually you find that you don't need your old habits and that they only stand in your way.

When boldness becomes your *new* habit, you can apply it to your knowledge of how a good painting can

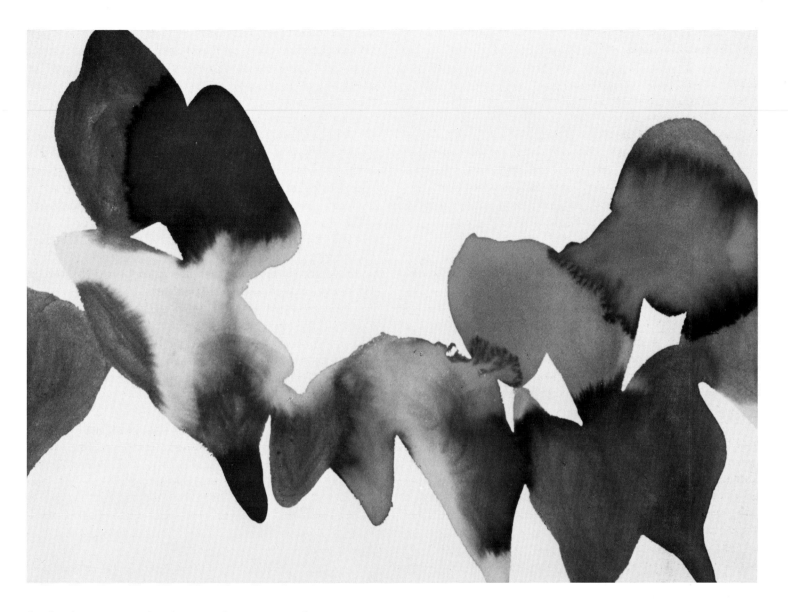

be built. Certain fundamentals go into planning any painting. In the next section, you will be able to refresh your memory of essentials that must be considered before you actually pick up your brush. In your more receptive state of mind, you will be able to incorporate them more inventively in any new direction you choose.

The Floating Tree of the Jaguar, *by Alice Baber, 30 × 41 in. (76 × 104 cm).* Boldness of conception led to boldness in design and execution. Nothing was allowed to impair this purity of purpose.

BEFORE STARTING TO PAINT

Before starting work on any painting you should ask yourself a series of questions. These questions have two main objectives: (1) deciding what you hope to achieve in the painting and (2) determining what you are going to do to achieve it.

Before going into these objectives in more detail, I will anticipate a question that may be uppermost in the minds of some readers. Attracted by the main purpose of this book—which is to explore ways to paint more boldly and freely—you may ask: "If I am going to paint boldly and freely, must I have some preconceived idea

think bolder
Design larger images
Paint w/ swifter strokes

(deciding achieve in painting
determining how to do this.

19

of the painting I am about to undertake? Isn't the whole idea to leave myself open to whatever impulses brew in my mind or develop on the paper itself? Won't I be hindered by thinking things out in advance?"

The answer may come as a surprise. You need to sort things out ahead of time more clearly than ever! Only when you have clearly stated your objectives will you be able to exploit the developments that will take place. You will need to appraise impromptu conditions in the light of those objectives. You must see what contributes to them, what deviates from them, and what may possibly lead you to turn those objectives into unforeseen directions.

The artist who leans heavily on subject matter will always have the reality in front of him to guide him. He will be able to relate that material to his objectives at every point. But the artist seeking greater boldness does not have this help. He will only be *using* subject matter—if he relies on it at all—as a means of reaching his objectives. He will be motivated much more by his inner, personal intentions. He will need to know exactly what they are and how they can be expressed in tangible form on his paper.

Assume you're inspired by something as simple as a clump of birch trees. You want to express how you feel about it. The emotions that the trees arouse in you will be your motif. You're not interested in rendering your subject. You may not even be looking at it. Perhaps only a memory of birch trees will be your starting point. You want to resurrect that memory and do it in personal terms. What does the tree say to *you*?

"There's no question of my drawing a tree that I can see," said Henri Matisse in a revealing conversation with Louis Aragon. "I shan't get free of my emotion by copying the tree faithfully, or by drawing its leaves one by one *in the common language*, but only after identifying myself with it. I have to create an object which resembles the tree. The sign for a tree, and not the sign that other artists may have found for the tree." And Matisse summed up, "The residuum of another's expression can never be related to one's own feeling."

Your *own* feeling, then, must be understood, scrutinized, and evaluated as the wellspring of a work of art before you can hope to present it convincingly on your painting ground. And you must present it in your own terms.

This process of thinking through your purposes starts taking place the moment you contemplate making a painting. It should be continued until all the problems you are likely to confront are resolved. Obviously other problems will arise—especially with watercolor, when fluidity often seems to have a mind of its own. But the more you are able to anticipate problems, the better equipped you will be to fulfill your original objectives.

Going back to the two basic objectives stated earlier—what you are going to achieve and how you are going to achieve it—you must ask yourself a series of questions; the answers will help you realize your objectives. The questions here may seem obvious, many of which you have been over many times in your study of art. But you need to face them each time you begin a painting.

What Is Your Theme?
Is it to be an emotional experience? Is it to be your personal statement of a reaction to something in nature, as Matisse described so fluently? Is it to be an involvement with aspects of the behavior of paint itself, with spatial relationships, and with the enticements of fluidity? Is it to be a special exploration of color?

With any of these possibilities, you will want to decide what material will help you establish your theme. For example, what will you use if you want to express the prevailing mood of your city as you sense it at the moment, or how will you best present the delicate patterns made on a wet beach by the feet of sandpipers?

The less tangible themes require the most forethought. Your theme may be an aspect of horror, violence, or struggle. Or it may be the stillness of dawn, delight in childish laughter, or the overtones in the history of a weathered board. Other intangibles might be your emotional response to ominous clouds, frost tracery, a stained wall, a lonely road, thorns, energy-charged traffic, a forgotten woman, a never-to-be-forgotten woman. Whatever your theme, the mood and the emotion you want to translate into paint should concern you more than the material. That will be your *unique* contribution. Your subject, after all, could be handled by others in their own ways. The *feeling* that you apply to it is entirely your own. This preoccupation with your own sensations is the essence of being both bold and free.

Not that subject matter need be disdained. It does have importance and can hardly be dismissed. But the key difference between the pedantic artist and the creative artist lies in what is done with material. The creative artist *uses* it. He doesn't copy it. Neither does he exploit it or simply adapt it. He digests it. He uses what he wants and needs and discards the rest.

It is really a matter of rethinking the purpose of subject matter. Perhaps a way of capsulizing the concept is to substitute the term "motif matter" for "subject matter." Your material must serve your motif or it will not survive in your work.

A more philosophical way of putting it is that as a creator, you are seeking independence from the eye. What takes its place? The mind. Or the soul, if you like. "Art seems to me to be a state of soul more than any-

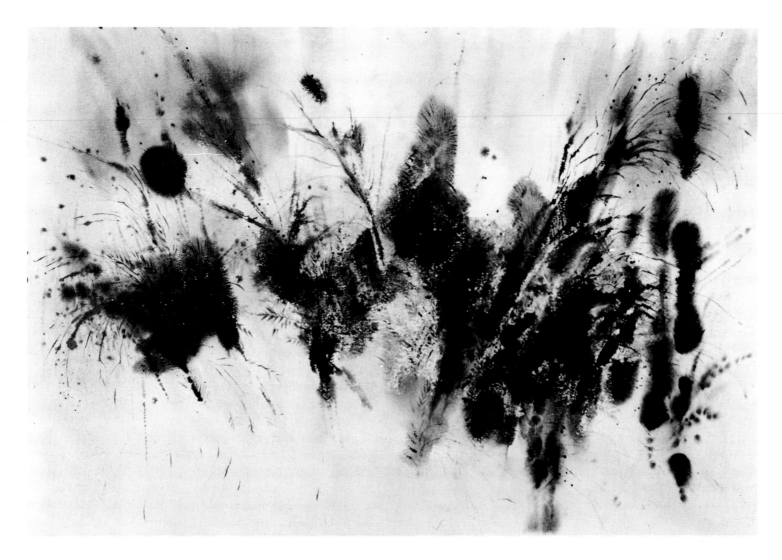

thing else," said Marc Chagall. "The soul of all is sacred."

A word of caution. Viewers of your work may not immediately understand the essential difference between what a subjective painting is all about, as distinct from a painting of a subject. You may be in for a hard time with your closest admirers when you start becoming freer. Most people feel comfortable only when they can identify with subject matter.

Let's say you have developed in your mind's eye the theme of the power of the ocean. Not having done this literally, with pedantic attention to every wave and rock, your work may be mystifying and strange to many people. Be prepared for that. Your satisfaction should come from your own originality. If your work "doesn't look like Lobster Point," so much the better.

One day one of the nonseeing, but not silent, viewers of modern art went indignantly to the reception desk of the Museum of Modern Art in New York City after passing through a major Picasso exhibit. "Good Gawd," he demanded, "What does that fellow do for a living?"

What really matters is your own satisfaction at having successfully carried out your theme. If you have

Winter Bouquet, *by Vincent A. Hartgen, 24 × 36 in. (61 × 91 cm).* The artist's early decision concerning his combination of values is evident. He chose deep values primarily, injecting only a few light washes to correlate his deep tones with the whiteness of his paper. Having imposed a limitation of value, he then felt free to develop an array of lines and shapes that were all kept dark.

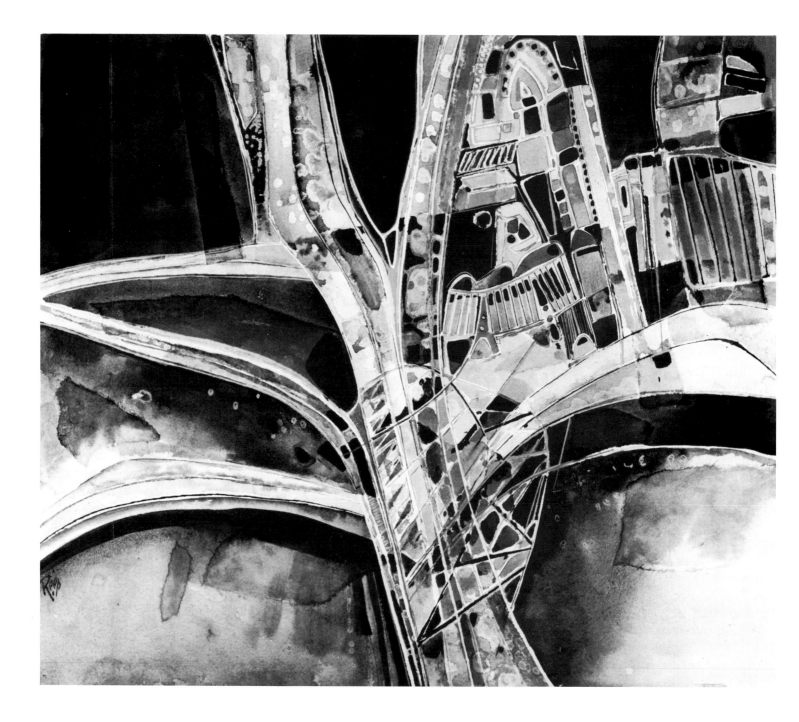

Three Rivers—Pittsburgh, *by Edward Reep, 21½ × 25 in. (55 × 64 cm).* Strong shapes rule this cityscape watercolor. In spirit, the artist's girders, trusses, and arches seem to roll out of the city's steel mills. Small shapes are riveted to larger ones. Yet with all his emphasis on shapes, the artist never descends into pictorial images. His shapes are boldly inventive.

succeeded, other people will grasp it in time—not everyone, but eventually the people you want to reach. They will see in your work a certain style developing, possibly even before you are aware of it. For style is simply the graphic expression of the artist's personality. When the artist consults himself for both a theme and the "motif matter" that will help him articulate it, he is putting trust in his own personality. This reliance will become more and more evident in his work. The resulting individuality that marks his work is as close as we can come to defining style.

Having decided upon your theme and evaluated what is most essential in it to you, you are ready for practical considerations.

How Will You Apportion Your Paper?

This is an obvious but still vital consideration. What large spaces are you planning and where will they be placed on your paper? What lesser spaces do you have in mind? How will they relate to the larger spaces and where do you plan to put them? What small spaces will you use? Again, where do you want them? Will you use them to supplement other spaces or as a means to enliven your composition with eye-pulling accents? Your choices will depend on the objectives that underlie your work. You may want to project a feeling of vastness or a feeling of intimacy, or some intermediate impression.

Interest is usually enhanced by variety in the sizes of the areas in which you divide your paper. Some themes, however, are best fulfilled by repetition of identical or similarly sized shapes. Consult your primary intention in making your decisions. See if you can forecast how the division of your paper will help evoke the mood you intend to convey.

What Value Combination Do You Want?

Do you want this combination to add up to an impression of mostly dark, mostly light, or mostly middle values? A painting that is *evenly* balanced between, say, lights and darks will seem indecisive. A more eloquent painting will result from a preponderance of one range of values over another.

You might want to consider a single value (in several colors), as discussed in one of the later "Experiments in Concept." That would be a bold adventure. Your safest scheme would be to concentrate on one value range, adding bits of contrasting values for emphasis.

All other things being equal, a light painting speaks of gaiety and a dark one of solemnity or gloom. One with middle values would strike a comfortable balance. Although this rule of thumb is sound, it is affected by other factors. Your choice of color, for example, might easily alter or elevate the mood created by your values.

Choose a combination of values that will make this particular painting successful. At some later time, you can see if you can work out your chosen theme in some other value range. But this time establish one set of values and be prepared to stick by it.

What Shapes Do You Want?

Shape and color (color will be covered later) are perhaps the two most essential elements in modern art. Shapes can be exciting or dull, original or trite. Don't take them for granted. Give thought to the personal qualities you can express through them. If you are abstracting from nature, see what appeals to you in the shapes before you and concentrate on them. Or create shapes in your own mind when you don't want to rely on visible material. In either case, sharpen and exaggerate a shape for maximum effectiveness, dwelling on its essence. Avoid incidentals.

You will also want to repeat a shape in a painting, perhaps exactly but more likely in an interesting variation. Sometimes you might even echo the shape a number of times in an overall pattern.

Two different *major* shapes—with variations—are probably all you can handle comfortably in one painting. Maybe you can add a third, although it may undercut the total impact of the dominant shapes. Subordinate aspects of the painting may contain other shapes if they do not drain the major shapes of their importance.

What Movement Do You Want?

Movement in works of art means how the viewer's eye travels into, through, and around a painting. There are no road maps. Strangely, though, you will find a good deal of coincidence in the way people's eyes examine a particular painting. They will see *this* first, then their eye moves up to *that*, and then it may return down to *there*, and so on. Part of the artist's skill lies in knowing how to plot this aesthetic journey the way *he* wishes it.

Everything in the artist's vocabulary contributes to movement—washes, accents, darts, blobs, gradations. Linework is only one of these many devices. First consider *how much* movement you want. Then consider its direction. You may want the drama of fast movement or swirling fluidity that seldom gives the viewer a restful moment. Or a slower pace may be more in keeping with your theme, where you want to hold the eye to each part of your painting in turn, moving only gradually. Within those two extremes any more moderate sense of movement could be established. It would be difficult, however, to imagine any painting, especially a watercolor, with no movement whatsoever.

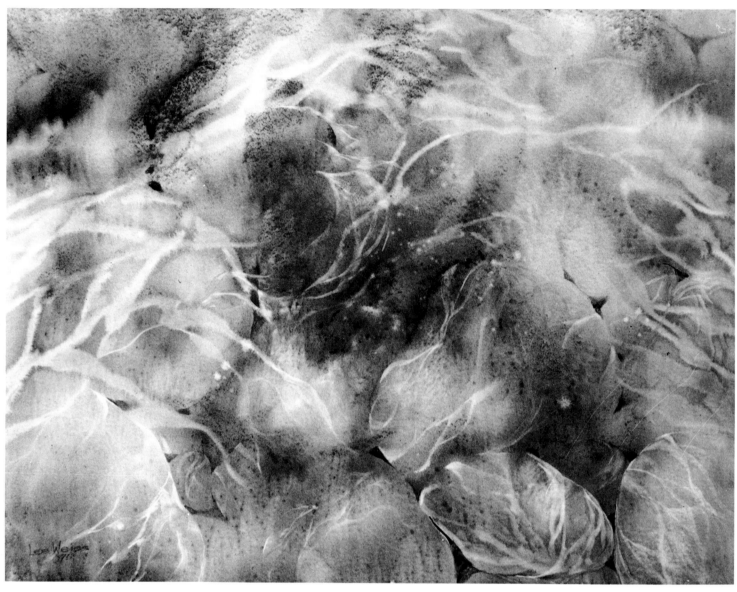

Surface and Refracted Light, *by Lee Weiss, 30 × 40 in. (76 × 102 cm).* A sense of movement is foremost in the purposes of this artist. To convey this sense, she relies on curvaceous lines that flow gently around and about her shapes. Many of her lines are wet, with soft edges, although she varies this technique by also introducing more tightly painted lines. Having chosen curvaceous lines, she holds true to them and does not allow other types of lines to intrude.

Having thought about how much movement you want, consider how you will get it. Are you going to create movement chiefly through verticals, horizontals, diagonals, or curves?

Simply stated, each of the four major directions in movement behaves differently. Horizontals, almost by definition, can be considered earthbound, solid, comforting, and stable. They move only right and left. Conversely, verticals, moving up and down, induce a feeling of growing, striving, even exaltation. Diagonals have a cutting, slashing, impetuous quality. They give more urgent movement than do the other directions and often have the power to take over a painting. Their oblique thrusts compel attention, seldom filling a supporting role. Watch and use diagonals with special care. Swirling, curvaceous movement has repetitive grace that is generally pleasing to the senses. Used profusely, it can personify restlessness.

Which of the four directions in movement answers your purposes best? Are you going to resort to one direction entirely, or more than one? Generally you gain by relying mainly on one direction—horizontal, vertical, diagonal, or curvaceous—and using anything else for purely subordinate purposes.

This is also the time to think about the kind of brushwork you will use to carry out the movement you have planned. Do you want strong, structural strokes? More reticent and romantic sweeps? Erratic, nervous, tense darts? Naturally, you will not be able to plan all your brushwork in advance, nor would you want to. You will want to leave most of your decisions for when you are actually painting and being guided by impulses on the spot. I certainly do not want to underestimate improvisation, but a measure of forethought will enable you to organize those impulses better when they do occur later on.

How Much Depth Do You Want?

Pure abstract painting seeks to eliminate depth and distance as much as possible. Abstract painters want the picture plane—the surface of the painting itself—to be all-important. What happens to *paint on paper* is their total preoccupation. Other contemporary artists working in other ways see this as essential, too. They are not particularly concerned with distance except as *implied* distance.

Actually, elimination of distance is more readily accomplished in oil or acrylic (when it is applied opaquely) than it is in watercolor. In watercolor, and acrylic used as watercolor, transparency is inevitable, and with transparency comes the suggestion of depth. As a matter of fact, a beautiful sense of distance is one of watercolor's prime capabilities. It is the rare artist who would want to dismiss it entirely.

You therefore have objectives at opposite extremes from which to choose. Assuming you prefer neither extreme, but will seek *some* depth, you will need to plan various planes in working with your motif that will give you what you want. Study how you want the eye to perceive distance and where you want this to happen. Think about the color, value, and shape that will create an illusion of depth or lack of it. And if you want to emphasize depth, give this top priority. Consider this and all other questions you are asking yourself about your painting plans in the light of what will carry the eye into the beyond.

What Will Be Your Basic Color Scheme?

Although I have left the question of color until now, it is by no means the question of least importance. Color is your most glorious tool. It is also the most elusive, beguiling, contradictory, and unfathomable element in watercolor. Paul Klee's outburst, quoted earlier, would not have been made if he were being enthusiastic over some other element. Color for him was king. He had finally come to terms with it. Not only was he at home in using color, he had mastered it.

Because of its preeminence, questions about color deserve your closest attention and involve your biggest decisions. Poor color, or badly conflicting color passages, can ruin your watercolor. Few painters would be so bold as to claim which colors are poor (although every artist dislikes some). And of course no one can tell you which colors are good. That is an opinion based on your own aesthetic sense.

In reality, there probably is no poor color or good color. There are just poor combinations and good combinations of colors, poor juxtapositions and good ones, and good mixtures and unsuccessful ones. Part of your being an artist is your ability to sort out these things. It is a lifetime pursuit.

Some artists have created masterpieces from color combinations most other artists wouldn't consider. You can therefore pick a shocker—and you may succeed with it. In general, though, you'll be on firmer ground if you choose a pleasing combination of warm and cool colors, with one set predominating. This is your first decision—the temperature of your palette. Select your basic balance in advance. You can vary it as you go along, adding more warmth or more coolness, but usually you cannot make a complete reversal.

This predetermined balance ought not be an *exact* balance. That is, there should not be an even division between warm and cool. Let one or the other dominate. As always, there is more interest in a painting when the emphasis on any of its components is made clear.

Now, pick actual colors you *expect* to use to carry out your motif. They may be all you do use, but be

prepared to make changes as you go along. Your initial colors may not work out as happily as you hoped. Be flexible. Your present choices are simply the best candidates you can think of in advance to do the job.

Pick only a few colors. Too few is far better than too many. A multitude of colors will clash and compete. At the very least, they will nullify one another, like tasting every kind of chocolate in the candy box at once. It takes an extraordinary artist to master a wide range of colors in one painting, and even he is probably more often successful when he narrows his palette.

Choose two or three colors as your major preferences. If you see others that you would also like to use, restrain the temptation. The others might be used another time to work on the same theme in another way. Of course, there's hardly any limit to the colors you could use profitably for minor touches.

While you're thinking about your scheme of colors, you should also be making decisions about their intensity. Will you be working with all your paints at their most brilliant? Or just some of them? How will you deal specifically with each one? Also, where will subdued or grayed hues fit into your scheme?

Think about these questions of color, and rethink them, if necessary, until you have a clear idea of how your painting will look ideally. You can always adapt yourself to new circumstances. You will do this best only if you have a planned color scheme definitely in mind.

What Personal Qualities Will You Introduce?
One final question to ask yourself before you start any painting: what will identify it as clearly and uniquely your own? Naturally you are indisputably the artist, and some may see things in the painting that they associate with you and no one else. You may not even be aware of this identification. But here we are interested in things you can do *deliberately* to reinforce your intentions. What personal inventions will communicate the emotions with which you originally regarded your theme? This is a highly individual matter in which your only real help will be your own experience. No one can tell you, in effect, how to be yourself. But think about how your knowledge of watercolor can help you identify a particular painting as yours alone. Have you come across some technique that you feel is especially appropriate—one that you handle in an individual way? This could be as expressive of personality as of expertise.

The main body of this book, which follows in a few pages, offers ideas of a wide scope. They have in common a promise of helping you to personalize your productivity. The freer you are, the more personal your efforts become. A popular way of putting it is that you have your own style.

As you advance, your identification with your work becomes more pronounced, but even at an early stage there is much you can do to make clearly visible your feelings as you create. Along with your decisions on theme, space, values, shapes, movement, depth, and color, a few ideas on personal qualities you could introduce will give you a definite image of the work that lies ahead. Discover what you can introduce into your painting that will become your emotional signature.

With these questions thoroughly considered in advance, you will be much freer to plunge ahead. You will know where you are going, and that, of course, is the first step in getting there.

WHEN IS A PAINTING FINISHED?

Having decided what you intend to accomplish in a projected painting, you ultimately will come to the critical period of deciding whether you have accomplished it or not—in short, whether your painting is finished. This is a tense moment, particularly in watercolor. The properties of the medium come so quickly to a climax that effects can easily be destroyed. As you well know, you can often overstep the mark. You must also anticipate not one peak but several. Work in watercolor often reaches a plateau that can be satisfying. Should you accept that plateau or go on to another that might be still more satisfying? A third plateau also might be possible. You must be prepared to decide which finishing point you most want—and to recognize it when you reach it.

To quote again from Paul Klee, who understood so much about our medium: "To achieve vital harmony in a picture it must be constructed out of parts in themselves incomplete, brought into harmony only at the last stroke." That last stroke is the most decisive one. But how to tell which *should* be the last one?

The decision will come more easily when you have thought about the steps leading up to it in a way that marks the true artist. The beginning painter concentrates on the scene he wants to put on paper. He wants to "get it" in terms of how the material appears to him. The growing or mature artist thinks about his project in

a dramatically different way. He is concerned with what his painting *needs*. He studies what develops on the paper itself. What does it need to project the *essence* of his material? What can he do to relate his colors, his shapes, his plan of values? What will pull the painting together into a cohesive whole? He dwells almost entirely on these needs. He puts aside all other considerations, including the intrinsic nature of the material he has used as a springboard. The painting itself is his sole concern.

This emphatically different approach separates the dabbler from the serious artist. It is *the* great leap forward that must be taken before anyone produces a genuine work of art. While it is not difficult to accept the concept superficially, it takes long commitment to painting before you can instinctively incorporate it into your thoughts about every artistic problem.

Remind yourself constantly that the needs of your particular painting surface should take precedence over anything else. Build your painting with those needs in mind. Every application of paint and every brushstroke should serve those purposes. You will then get a clearer idea of how close you are to completing your painting process. You will know when you are nearing fulfillment. You will be better prepared to make the final, critical decision. Is this the last stroke that brings everything into harmony?

The last stroke could be your *best* stroke. Many a watercolor has been brought to a happy conclusion by one last stroke. A brilliant piece of color placed in exactly the right spot can pull everything together. It makes the whole painting sing. Your components finally all work in unison without any distracting element, without anything that doesn't carry its share of the burden. Your painting will be incomplete without this final bit of inspiration. It is clearly needed, and anything else you do to your work will be redundant, excessive, and will spoil the harmony.

At that moment your painting is finished.

How can you recognize that moment? One simple but effective rule is to keep asking yourself what you will do next. Pause to reflect on your answer. When you tell yourself that you don't know or aren't sure what you should do next, the chances are very good that you have really reached your conclusion. You sense intuitively that you have done all you should do. Anything else would be dross. Stop *now*.

Another good rule is to stop there and reserve your final decision for a while. Come back later in the day, or next week, or next month, to take a fresh look at your

work. You will come upon it in a new light. You may see things in it you didn't see before, things that require additional work. You can then add or make changes. Or you might see that, yes, you did quit at the moment when everything truly fell into place.

One way of resolving your doubts is to place torn bits of colored paper, leaves, twigs, grass, or pieces of cloth over places on your paper where you think additions might be needed. See if they suggest that the additions are really necessary.

One other reliable device for seeing a painting in a fresh way is simply to look at it in a mirror. With everything reversed, it will look like a different painting. You may then notice factors, especially in structure, that weren't apparent to you previously. You had been so close to it that you overlooked them. Now they protrude.

Also, a common practice is to lay a mat around the painting. The wide white border will enclose the work so that you can see it in much the same way your viewers will see it. Tensions in the painting will be kept within it, and you can see how they work. You will also see how the painting looks when isolated from its surroundings. Because the nature of the watercolor medium is essentially fragile, your work needs this kind of isolation in order to be fully felt. The mat will give you a truer feeling of whether the work is finished or not.

What if you have gone beyond the finishing point? This happens to the best of us. In the section on loosening up, and later in some of the experiments, I stress procedures that you can try that will correct mistakes and even overcome excessive painting. All hope may not be lost. You may be able to get back to where your work was at its best. Try some of these measures before you give up.

If you find that you can't restore things to an earlier stage—more than likely you can, but you may lose freshness in doing so—you can always consign your painting to experimentation. Start another one along the same lines, and this time be careful not to go too far.

Disappointments are inevitable. No watercolorist is ever entirely pleased with everything he starts. Even the most experienced painter doesn't always know when to stop. But your percentage of successes will go up when you develop your paintings in response to their own needs. And as you learn to appreciate the importance of that final stroke, you will learn to approach it cautiously and then apply it boldly.

Discovering Your Own Way

Once you have read this book, you will be aware of the rich store of possibilities offered by watercolor. You will have discarded the comforting but untrustworthy notion that there is any one, right way of doing anything. The range of choices will be bewildering. All paths will open. Which path is truest to your own nature?

Fortunately, we are working in a time when the gates to pioneering are wide open. Painting in watercolor is in a state of provocative revolution. Conceptual freedom and the freedom to explore new techniques are both prevalent, as they are in every other field of art. In watercolor, especially, they overlap. Innovative techniques often give rise to new concepts.

The artist's concepts are born out of his own insights, not imposed from the outside. He is free to express his own feelings—and is applauded if the results are sound. He is also free to work with the pictorial aspects of objects in nature, as much or as little as he likes, and again the results will be appreciated when his statements are valid. There is no need to conform such as there once was.

Happily, this century has seen watercolor break out of its stuffy prison (and there always were some rare artists who rebelled earlier). As much innovation and daring are now shown in watercolor as in any other branch of art. Furthermore, there is no longer any arbitrary distinction between one type of painting and another. Extraordinary advances in technology have been prime movers in this evolution. The watercolorist now has at his command materials that give new dimensions to water-based paint, just as the oil painter has new materials that increase his powers of fluidity (and others that invade the domain of sculpture, for that matter). It has become perilously difficult to decide what exactly *is* a contemporary watercolor.

Is it a work on paper? Then what about water-based paint on fiber glass, or Masonite®, aluminum foil, or a plastic base? Must the pigment be transparent watercolor, and not acrylic, casein, ink, or a mix of media? What about layers of one material superimposed by others, with show-through, tearing, and scratching producing assorted textural effects? Should these still be termed works in watercolor? These are problems that beset art historians and juries of shows more than they do the artist, but the perplexity of trying to arrive at any true definition of a watercolor reveals how influential the technical explosion has been.

This revolution in technology is touched upon in this book. Our main concern is transparent watercolor, however, and how *its* capabilities can be expanded. Other techniques lie largely beyond our scope. Yet the artist working in transparent pigment stands to widen

his own prospects by becoming better acquainted with what they have to offer.

Viewing other artists' work—in these new materials as well as in transparent watercolor paint—is always of value. Study works on canvas, too. Since, as I have said, borderlines have largely disappeared, the watercolorist gains from absorbing what the oil or acrylic painter has learned.

There are a number of good books which can extend your knowledge of the aspects of watercolor painting particularly stressed here. Some are out of print, but most can be found in any good-sized library. These are the ones I would recommend that you read. Edward Betts's *Creative Landscape Painting* (Watson-Guptill Publications, New York, 1978) will give you a compendium of different contemporary approaches to painting landscape, although not focused particularly on watercolor, with each approach intelligently described and illustrated. Also by Edward Betts, *Master Class in Watercolor* (Watson-Guptill Publications, New York, 1975) offers you an array of concepts and techniques that goes far beyond the fundamentals to suggest greater individuality on the part of the artist—reader. Abstraction in many forms is included in this comprehensive work.

The Many Ways of Water and Color by Leonard Brooks (North Light Publishers, Westport, Conn., 1977) demonstrates and illustrates a wide range of other aqua media as well as transparent watercolor. *Wash and Gouache—A Study of the Development of Materials of Watercolor* (Fogg Art Museum, Cambridge, Mass., 1977) provides useful technical information on paper, pigment, and the preservation of paintings, together with an illuminating study of the history of schools of work on paper. More than most manuals, *The Joys of Watercolor* (Van Nostrand Reinhold, New York, 1973) by Hilton Leech will help you rise above literal treatment of subject matter. And if you want your eyes opened to the most commonplace but usually neglected material, study the text and photographs in George Nelson's *How to See—Visual Adventures in a World God Never Made* (Little, Brown and Company, Boston, 1977).

Edward Reep's *The Content of Watercolor* (Van Nostrand Reinhold, New York, 1969) presents a history of the development of watercolor painting that leads into present-day experiments in concepts, materials, and unconventional shapes of paintings. *The Painter and His Techniques—William Thon* by Alan D. Gruskin (Viking Press, New York, 1964) is particularly useful for the information it offers on a gamut of inventive textural effects and how to obtain them. Nathan Cabot Hale, in *Abstraction in Art and Nature* (Watson-Guptill Publications, New York, 1972), takes a hard look at natural phenomena that disclose nature to be the source of almost every conceivable abstract motif. The photographs are useful to the artist as a starting point for the production of his own ideas.

Studying work in galleries, museums, books, and private collections is an important help in finding your own way. At the same time, you want to be studying your own work, past and present. What in it do you see as consistent? What is most characteristic of you as an individual artist?

Experimentation is priceless, as this book tries to make plain. But eventually—gradually perhaps—you will want to narrow down your aspirations to a chosen few. These will be those that incite your emotional responses most fully. They will probably also be those that you deal with best. Your feelings *and* abilities will ultimately coincide. You will then be working in what will be, for want of a more tangible term, your personal style. Once you have identified it, keep at it. Vary and expand it, of course, but let it become the center of all your use of energy.

Another suggestion. This one is so obvious it sounds foolish in print, but it is too often neglected. Paint. Paint often. Successful artists speak far more often of *work* than of *talent*. Almost never will you see a profound work of art coming from the brush of a person who paints only occasionally.

That doesn't rule out the amateur! "There is no such thing as an amateur artist as different from a professional artist," Cézanne said. "There is only good art and bad art." But it follows that only the amateur who works persistently—as is true of the professional—attains a level of quality.

Discouragement must always be expected—and faced. It is as familiar to the watercolorist as are his accidents. One consolation comes from realizing that discouragement is the crucible out of which progress comes. Another is that you are not alone.

Claude Monet was nearing the height of the reputation he was to win during his lifetime, producing those water lily masterpieces, when he wrote this letter (in 1912) to his dealer and benefactor, Paul Durand-Ruel: "More than ever today, I realize how artificial is the undeserved fame I have won. I keep hoping to do better. . ." His latest exhibition was about to open in Paris. "I know beforehand that you'll say my pictures are perfect. I know that when they are shown they will be much admired, but I don't care because I know they are bad. I'm certain of it. Thank you for your comforting words, your friendship and all the trouble you have taken." And he added, "I hope to see you next Sunday for lunch as usual."

After lunch, we expect, Monet was out there in his gardens painting again with his customary spirit.

Using These Experiments

There are as many ways to learn to be bold and free as there are artists. No one can tell you which way will be more rewarding for you. But, to help you in your search, the remainder of this book examines sixty-four ways that have been found to be of great help. These are experiments in the sense that you will discover your own ways of taking advantage of the ideas that others have pioneered. You start with your own experience and your own aspirations. From there, you will experiment with an idea and discover what in it will help you achieve your aspirations.

WHY THESE EXPERIMENTS?

Why sixty-four? There is no magic number. There could be a thousand. Here I have simply distilled the experience of many successful watercolorists into practical exercises that others should find helpful. Often artists' achievements are intuitive. I have tried to isolate and define the elements of those achievements so that you will have a guide to follow in your own work.

Just as in walking in the woods there is no one tree you must look at first, these experiments are not placed in any hard-and-fast order. Painting does not lend itself to regimentation. Should you learn to use yellow before learning to use red? Nonsense. Naturally, though, some sequence is necessary. The experiments are arranged for convenience only. Don't attach any other meaning to the order in which you find them.

The experiments *are* organized into three groups. The experiments starting on page 32 are concerned mainly with composition. Experiments from page 49 through page 124, by far the largest group, offer suggestions for new concepts. Finally, experiments on pages 125 through 159 have to do with technique. These describe unconventional brushwork and the use of auxiliary devices that give unusual textural effects. These are

arbitrary divisions and some overlap is inevitable. There is truly no way of quarantining one element from the others; all three—composition, concept, and technique—obviously must be considered in any painting and, therefore, in any painting exercise. The groupings have been made only to show where the emphasis lies.

WHAT TO DO AND WHAT NOT TO DO

First flip through all the experiments. Note which ones cover familiar territory. These may contain hints on matters you have not thought about. After appraising those hints, you may want to skip those experiments, since you don't want to be retreading known ground.

Then look for experiments in all three groups that promise to come close to your own needs. These should help you reach your potentials. They will give you practice in working along paths you know you want to explore, and often in ways that may be new to you.

Finally, sort out those experiments that move in entirely new directions. These may raise your sights to possibilities in your work that have not previously occurred to you. They may revolutionize your thinking. These are the ones to concentrate on most thoroughly. When you have found them, try them in whatever order seems most logical to you. You may find more challenge in a new technique than in a new concept, or vice versa. One compositional idea may lead you to experiment with an opposing compositional idea. Jump around.

There is purposely no attempt to arrange the ideas from the easiest to the hardest, or by any other rigid system. You have obviously gotten past a stage in which you needed training that starts with a simple step and goes on to more complicated ones (although I don't believe that is a good way to teach anybody art). These experiments are based on the assumption that you have mastered the fundamentals of design and workmanship and are ready to push on to new frontiers. For that reason, the emphasis is on ideas, not specifics. In some cases I give specific suggestions I feel are necessary, such as advice on the kind of paper, brushes, or colors to use, or what plan of values is best. Generally, though, I take it for granted that you are familiar with these matters and can use your present knowledge and methods in working out the new idea. Remember, however, that although a particular idea is the focal point for an experiment, the idea must be supported by step-by-step craftsmanship at every stage. This does not have to be stated each time. Rather than being lessons, the ideas are planned to free the spirit—a far more challenging, if sometimes veiled, objective.

Although they are not formal lessons, they *are* exercises. You might think of them as starting points, as aids to innovation in your own work. You may produce a highly satisfying finished painting as you work on an exercise, but that should not be your immediate goal. Instead, allow yourself to explore the ideas thoroughly and unhesitatingly even at the expense of the sheet of paper on your board. Finished paintings will come later, after you have become comfortable in handling the experimental process.

Once may be enough of a trial in some instances. The idea may not be for you after all. On the other hand, you should find some ideas—let's hope a good many of them—that lead you in the right directions. Don't stop there with a single trial. Go back again and again. Each time you work out the idea you will do it differently, with greater depth, greater fulfillment. Any conception of art that has value bears repetition. You don't need to look far to find the artist who has discovered his own special bent and mines it for an entire lifetime. Even that never seems long enough. One of these experiments may lead you to your own bonanza.

Experiment 1

Compose from the Top

Instead of positioning the center of interest in a painting at or slightly above the center of your paper, as is most often done, try placing it near the top. You will accomplish three things.

First, when you place major interest toward the top, whether you do it with deep values, intense color, or arresting detail, you will rivet the eye on that focus of interest. The eye will travel farther to reach that point than it would in reaching a point in the middle of a composition. You will have more space for motion.

Second, by giving yourself this extra space, you will have greater room for design devices. The strong barrier near the top will control the design so that it doesn't sprawl out of your picture, thus allowing you to design more actively. The design will be held down, literally, although not suppressed. Also, restful areas won't be in danger of dissolving into atmospheric portions of the painting because the only possibility for including *any* atmospheric portion will be in that narrow band at the top of your paper.

Third, traditional ways of seeing a scene will have to be revised when your planes become foreshortened. The usual approach is to put more detail in your foreground, less detail in your middle ground, and then let your distant plane fade away with even less detail, using lighter and grayer pigment. That distant plane would usually be near the top of your composition. But with this kind of composition, the top will be *more* emphatic, not less. The impact given it will move the top section forward. The other planes—the near and middle ground—will appear compacted and therefore foreshortened. Cézanne pioneered this approach. His endeavor was to make color rather than perspective imply distance. By hanging your painting from the top, you will be pursuing the path he opened, which many consider the start of modern painting.

These three theoretical concerns will become more easily understood as you develop this experiment and see how they affect the painting process. You will probably need to reverse some of your usual practices. Concentration on the upper part of your space requires a new look at your theme, even if it is a familiar one such as a landscape or seascape.

When you study a landscape, for example, select features that will create a bold, insistent wide panel at the top. Then place features that will create less impact below it. Paint that band strongly. Go back again and again if necessary to intensify the effects inherent in that panel. Use rich color. Don't be afraid of glowing darks that you would ordinarily hesitate to use in that part of the composition. To relate this panel or band to lower parts, let some of your washes flow downward. Wet-in-wet serves well here for a start. Then come back when the paper dries a bit for reemphasis.

The lower parts will give you opportunities for lighter design techniques. You can suggest by line or color a series of lower hills, perhaps, or a mass of trees or foliage. Work even more lightly as you approach the bottom of your space. You could even fade into tinted passages, and then possibly leave areas of your paper unpainted. Look back repeatedly to your upper panel. Make sure it is still predominant. Should you find lower portions competing with the upper panel, give the upper renewed emphasis. Sharp color accents in the panel may be your answer if it threatens to recede.

A seascape will require even more ingenuity than a landscape because you will be limited to horizontals in the water. Water at a distance always looks comparatively level. Naturally this restriction doesn't pertain if you have used sky above the water. You can use all your painterly devices there, not just horizontals.

What will you discover by composing your painting from the top? A new way of handling an old theme, at least. And you will convey in the painting the challenge you experience in trying a familiar theme in a new way. A stronger, more vibrant image of the material should be apparent, not merely because the approach may appear novel, but because centering interest close to the top lends greater immediacy to the scene and demands involvement. Far-off, atmospheric qualities of a subject in nature tend to disappear and are replaced by a bolder impact.

Let the Base Dominate

Now try basing your composition low on your paper. Give extra strength there. This way of organizing space is often used and is not a radical step. But by placing your focal point far down on your paper instead of near the center, you will force yourself to confront opportunities that are unusual.

These opportunities also bring problems that need solving. How are you going to compose all that space from, say, a few inches from the bottom to the very top of your sheet without losing control of it? How are you going to relate that large, open space to the powerful footing you have already decided upon? Finally, how are you going to attain a feeling of freedom both there and throughout your painting?

Your opportunity here is to devote the lion's share of your space to atmospheric illusion—sky, air, and openness between the objects you depict—the creation of a delicious airiness in your work. You could also enjoy the fragile, elusive light on things poised in space, what Kandinsky called "unmoored space."

Watercolor exceeds all other media in its marvelous ability to capture the essence of atmospheric space. What can be achieved only by laborious effort, if at all, in oil or acrylic, comes easily in watercolor. In fact, it is almost impossible in watercolor not to get some feeling for atmosphere in at least part of every painting.

Airiness usually implies outdoor air—the sky—but airiness surrounds every *thing* we can comprehend. A collection of still-life objects will have one quality if the objects are rendered as a mass and another if they are posed widely separated. You might, therefore, choose still-life material for this experiment. A landscape would be a more obvious choice. For example, take the same bold barrier of hills that I talked about and that you may have used in the previous experiment and place it very low on your paper. Then develop the space *above* it in ways that aren't the same as those you developed *below* it in the last project. In a moment I will discuss some of those ways more fully.

A cityscape also makes a challenging motif here. More often than not we think of the city from the viewpoint of the person in the street. That vast conglomerate of sky-bound buildings reaches ever upward, almost lost to sight as they soar so high. Suppose you turn this scene around. From the sky the city appears totally different. Now it's a carpet of stone cubes and other blocks. The sky now is dominant.

Using the buildings and streets for your compositional base, you need not worry about lack of interest in the sky. One of the very few benefits urban pollution offers is the variety of gray and murky tones in the atmosphere. Some artists have found this more intriguing than clean, pure, undifferentiated air. Even in Whistler's time, London smog contributed to many of his rich grays.

Grays make a natural palette for a sky. So do blues. People think conventionally of the sky as blue. Learned arguments can be heard or read in which observers of phenomena battle over whether the blue is cerulean, Prussian, or perhaps cobalt. The artist who wants greater originality will not be bound by the question of which blue is correct, or even care if *any* blue is expected. He will invent his own colors. Try any color on your palette for sky except blue. Add that color to some grays, perhaps. Use one color in one part of your sky and other colors in other parts.

Airiness can be achieved with *any* pigment. It's only essential that the white of the paper show through. Keep your paper wet. Then use plenty of water on your brush as you add color. Wetness and light color should give a sense of the atmosphere.

You will want to relate this vast upper space to the strong base below it. One device is to use similar shapes. The same shape that is strongly defined in the base can be repeated in the air with less definition and painted more softly. Another device is to repeat colors. Spots of color low on your paper that are echoed higher help to relate the two areas compositionally. They also relate the areas *visually*; that is, the repetition of color gives unity to the entire watercolor, even though top and bottom contrast dramatically in other ways. Massiveness still contrasts with airiness, but color bridges the two.

These principles hold true no matter what the subject matter. Parts of every painting must be related to one another. We are all seeking ways to do this effectively and imaginatively. By letting the base of your composition dominate the whole, you won't run the risk of getting a rootless painting that just floats. You will have solid footing. But ask yourself whether or not you used the space above the footing creatively. Is your "unmoored space" linked to your footing? Does it hold its own interest? Have you achieved airiness?

Compose from the Top

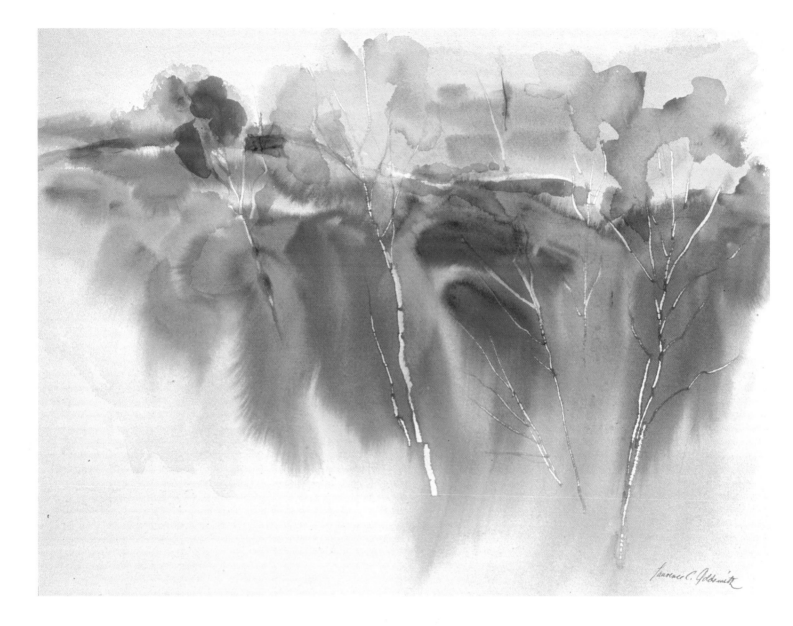

DISTANT MUSIC, *by Lawrence C. Goldsmith, 18 × 24 in. (46 × 61 cm). Alfred Van Loen collection.*

The structure of this watercolor was decided in advance—to compose the painting with a line of hilltops rather near the top of the paper, with washes floating from it almost as if it were a clothesline. Other decisions were made later, in the process of developing the washes. By placing a firm structure high on the paper, more space was made available for washes to expand and spread. Another advantage in fixing a little solidity there was to give the washes an anchorage. They could not then become entirely diffused. For much the same reason, strong lines representing tree trunks were etched into the larger washes while they were still wet. The painting thus exploited the beauty of transparent washes but tightened and controlled them by more concise elements. The painting was inspired by the gentle Vermont landscape, but there was little attempt to record any of its specific features. The subject matter of this watercolor could be described accurately as the mobility of the paint itself.

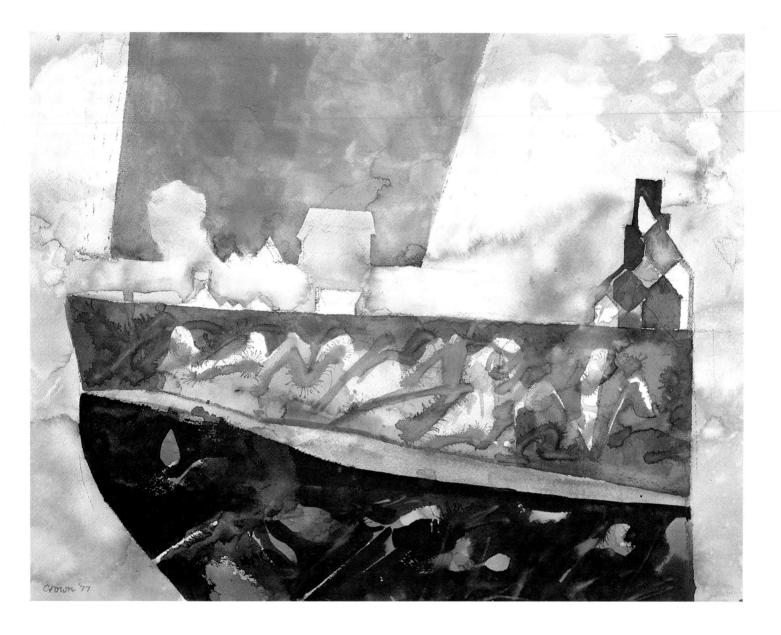

FARM AND GRAIN ELEVATOR, ILLINOIS, *by Keith Crown, 22 × 30 in. (56 × 76 cm).*

By letting the base of this evocative rural scene dominate, Crown not only introduced a fresh approach to a subject that would ordinarily be a cliché, but he also created a scene that exudes the solidity of the "unusually flat and endless" midwestern land as he saw it. Plowing wet color, often with an air brush, into the dark lower panels, he then balanced the farm architecture on the horizon so that it was "afloat in the gray afternoon." Fields, wild plants, and buildings were thus used to meet his demands. "My problem," he says, "is to bring together in a painting two seemingly conflicting, impossibly unmixable ideas. One is that the finished work shall evoke a sense of recognition; of the mysteriously familiar; of something that seems real. The other idea is that in order to do the first I must deeply know my subject, and instead of mindlessly or faithfully rendering it, to react selectively, contrarily, arbitrarily, perversely, and always with intensity directly from the subject." Crown is Professor of Drawing and Painting at the University of Southern California.

Experiment 3

Compose from One Side

A composition is commonly anchored at the bottom of the sheet even if nowhere else. Less commonly it is fastened only at the top, and often it is tied to both sides as well as to the top or bottom, or both. The proposal here is an arbitrary one. It is simply to fasten a composition to one side of the paper instead of to the bottom or top. No magic immediately comes of this. A mechanical step such as this one is something apart from aesthetic inspiration. But it does make possible new aesthetic experiences. It throws the artist off-balance, and artistic exploits may come out of *that*.

Obviously, the weight of the painting will be concentrated on one side. Probably most of the development of color and texture will be placed there too. An evenly balanced painting, right and left, will be out of the question. You must evolve an asymmetrical balance rather than rely on a symmetrical one. The former is far more likely to produce excitement, so the painting starts off with a better chance of succeeding. Success won't come easily. Skillful placement of elements to balance that heavy, one-sided mass is all-important. In your pencil sketches, try various solutions.

What you're after is a *visual* weighing of material, right and left. Size is only one of the factors. There are others. A small child seated at the very end of a seesaw will balance a heavy adult seated opposite him but closer to the balancing point, the fulcrum. Just so, a spot carefully positioned on the opposite side of the paper from the mass could attract equal attention, even if the spot is only one-hundredth the size of the mass. Bright color or a sharp, erratic shape could be the decisive quality. Or a much deeper value than that of the mass.

Less dramatic than the use of distant spots, but also effective, would be soft washes of much warmer color than that of the mass. A patch of intricate linework is another alternative. Possibly the washes and lines could be used in combination.

Don't overlook the power of *no* paint at all. That is, try letting the brilliance of your paper, untouched, balance the painted mass on the other side. This is effective only when the clean paper appears to be part of your composition. Ponder this question: do you see a white portion of your design, or are you looking at unpainted paper? Strange as it sounds, you usually can answer that question definitely. There's seldom any middle ground. Clearly, if what you see is the paper, then that part of your composition will look empty and it will not serve to balance the other side. But if it is a white portion of the design, it will look needed, and it will not only balance the mass but contribute spectacular contrasts to it.

One way of testing this contribution is to simulate cropping of the painting to eliminate that white section. If the imaginary cropping would only make the mass look heavy and lopsided, then you really need that open space. It works. (For more on leaving paper white, see the later experiment, "Reveal White Paper.")

An irregular feat of balance is the core of this experiment. Otherwise, the painting can be developed in usual ways. Be sure, though, that once you find your ideal set of balancing elements you don't upset them with hastily considered innovations. A very little more weight on one end of that seesaw will ground it.

With ingenuity you will be finding a whole bag of balancing tricks. They are a joy to use. In each painting, the combination will be slightly (or vastly) different. The artist who enjoys watercolor used loosely could not duplicate one of his own paintings even if he tried. Even the simple device of switching sides should produce surprising results. Hang the next painting on the left side if you hang this one on the right.

Since this is an exercise in balancing a composition, success can be measured simply. Would an eye sighting straight down the barrel to the center of the painting see a visual fulcrum, whatever the mix of sizes, shapes, and colors on either side? Have you achieved pleasing asymmetry?

Emphasize Diagonals

A diagonal is as versatile as the sweep of a razor blade, and can be just as cutting. It is usually the key to movement in a work of art, pulling attention uphill or downhill, or often in zigzags, as a composition requires. Of course not all of these thrusts are equally compelling. Diversity of thrust makes for diversity in interest. Skill lies in creating a strong but subtle combination of thrusts that is unique—a power structure for each separate painting.

Nevertheless, *any* diagonal has extraordinary power. It does not lie supine like the horizontal. Nor does it soar independently like the vertical. It shoots across a composition, cutting into some areas, skipping others, uniting still others. Seldom is it inconspicuous. Drama is inherent in its use.

You are probably familiar with a common occurrence in the process of painting a watercolor. You suddenly realize that your latest stroke has managed to take over the painting. Now it has become something quite different from your original concept. Stepping back to see what has happened, you are likely to find that this take-over has been accomplished by a diagonal. You have let loose its power, and now, whether you are pleased with it or not, new energy has been added.

Skillful control of this power is one of the artist's most useful tools. Of course this one experiment is not going to give you this skill immediately, but you have used diagonals as long as you have been painting and so acquired some skill already. This experiment and others like it will polish that skill.

Choose a theme where diagonals would naturally dominate. It's hard to think of *any* theme where they are unimportant or could not be made important. You could work with the popular subject of a sailboat, or the abstract shapes of pure triangles, or anything between the extremes of representation and abstraction. An acquaintance of mine who has been looking at sailing vessels all his life paints one composition after another of pure triangles. His watercolors give the illusion of either sailing or of geometric abstraction, depending entirely upon how the viewer sees it.

As you plot your diagonals, notice how each one alters the flow of movement. It is up to you to choose whether that movement will magnify some previous thrust or turn the eye into another direction. You may want to direct the eye toward the center of your composition, lead it toward an edge, or possibly move it around in a wide circle.

Step aside often to get a sense of the patterns of motion you have created. Also, look away for a few minutes or do something else that will keep you from gazing at your paper. When you return, you will get a fresh view. You may see a stream of movement you didn't notice before.

Does everyone see motion in the same way? Probably not. Unless paint is handled in a blatant way—and few would want to do that—movement can appear different to different eyes. But most of the difference is what we perceive consciously. Unconsciously most people are probably affected by the movement in a painting in much the same way. They may not be aware of what causes their eye to run and skip, or even know that it does. But by training your eye you become more alert and can spot turning points, highways, and detours. And the more proficient you become at *seeing* lines of movement, the better you will become at *creating* movement consciously. You will be able to plot a course that affects your viewer's eye, even though that viewer may be oblivious to your tactics. Laboratory studies of eye movement bear this out.

As you proceed with this painting project, make sure the viewer's eye goes where you want it. You should be leading it in a planned series of directions that your diagonals will govern. Make sure the eye stays on the paper and doesn't wander off. Also, vary the speed of motion. Give the eye restful passages to slow it down, intense passages to speed it along.

As a rule your dominant diagonals will lead the eye to either the top or bottom of your composition. You will also need less powerful diagonals to bring the eye back to its original position. That is, if you are building a series of zigzags to the top, provide others to offer an easy descent.

Make a note, mental or written, of how you see the movement in your painting. Then come back to your watercolor a few hours after you have finished to look again. Does the movement still follow the same course? If it does, you can be confident that others will be affected in the way you intended. If you see a marked change of direction, do another painting. The first one may be a winner on its own terms, but you want the satisfaction of controlling things the way you planned them.

Compose from One Side

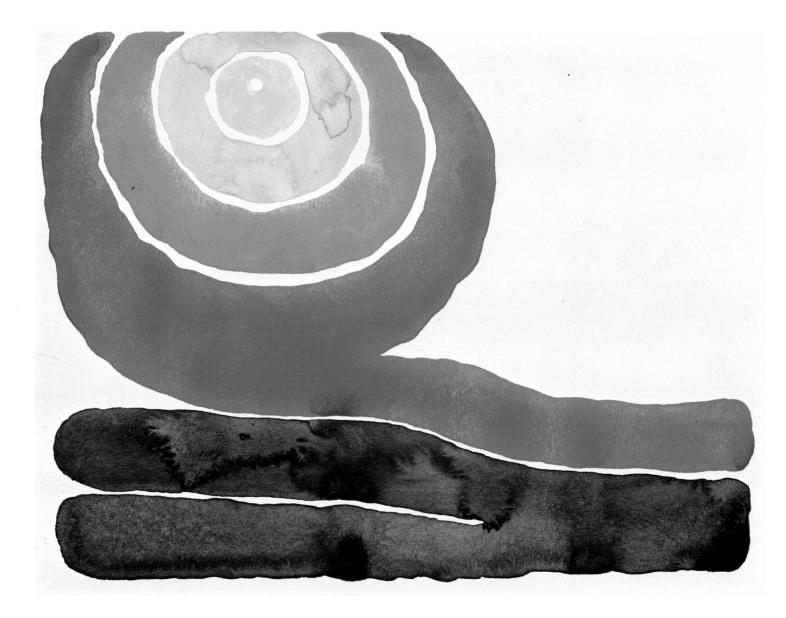

EVENING STAR, III, *1917, by Georgia O'Keeffe, 9 × 11⁷/₈ in. (23 × 30 cm). Collection of The Museum of Modern Art, New York; Mr. and Mrs. Donald B. Straus Fund.*

Georgia O'Keeffe's watercolor is one of ten she derived from the same theme. In this one she has left a large eloquent space free in the upper right, anchoring her ribbons to the edge of the paper. The massive forms are hung on the left half of her sheet, thus giving maximum clarity to her theme. She painted this watercolor while she was teaching in Canyon, Texas, living with her sister Claudia, who shared her walks into the countryside. "We often walked away from the town in the late afternoon sunset," she recalled. "There were no paved roads and no fences—no trees—it was like the ocean but it was wide, wide land. The evening star would be high in the sunset sky when it was still broad daylight. That evening star fascinated me. . . . My sister had a gun, and as we walked she would throw bottles into the air and shoot as many as she could before they hit the ground. I had nothing but to walk into nowhere and the wide sunset space with the star." (From *Georgia O'Keeffe,* Viking Press, 1976.) Some of the explosiveness of her sister's rifle shots seems to be echoed in the swift, imperative flow of color in O'Keeffe's masterly statement.

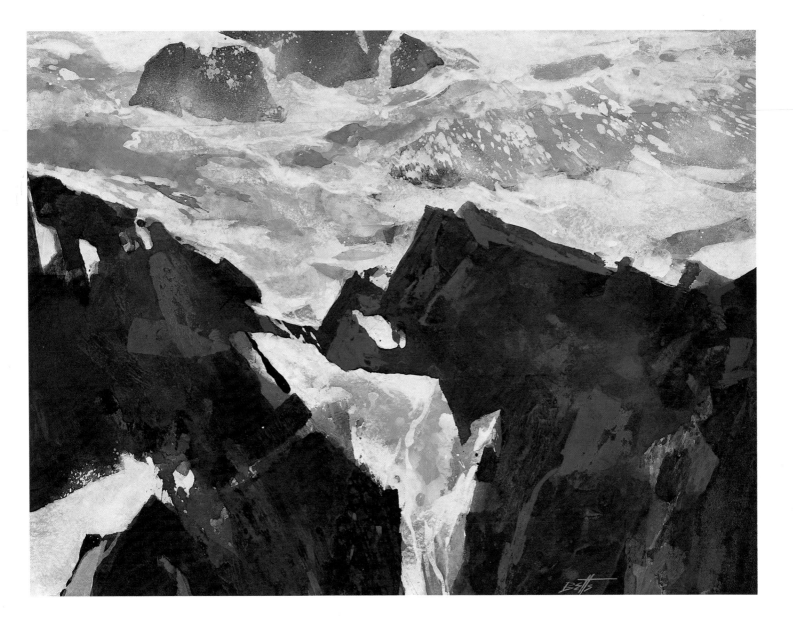

SURFSPILL, *by Edward Betts, 21¼ × 29 in. (54 × 74 cm). Casein on fiber glass paper, Courtesy of Midtown Galleries, New York.*

Diagonals used with great boldness give this painting a sense of dramatic action. One diagonal flows into another to speed the movement. Jagged edges increase the tension. The soaring effect thus obtained is held in check at the top of the work where smaller, lighter wedges are grouped together. They slow the flow of movement and keep attention on the picture plane. Betts has spaced incisions of bright red and green to relieve the massiveness of his major wedges of rock formations. The medium is casein used similarly to watercolor or fluid acrylic. The artist prepared his fiberglass paper with three thin coats of acrylic gesso before applying the casein. Betts is author of *Creative Landscape Painting*, Watson-Guptill Publications, and teaches advanced painting and watercolor at the Urbana-Champaign campus of the University of Illinois.

Experiment 5

Emphasize Horizontals

Horizontals breathe tranquility. Perhaps hoping to generate more energy than their paintings would release otherwise, artists have been known to hang their work turned halfway around so that the strong horizontals appear to be strong verticals. Often a landscape hung in that fashion will seem like a vibrant abstraction, since verticals, as a rule, offer more lift, more vitality than horizontals. This experiment is aimed at seeing what can be accomplished by sticking to horizontals, emphasizing them, and yet achieving a measure of excitement—quiet excitement, perhaps, but excitement nonetheless. As with many other experiments in this book, this one will force you to concentrate on a single element. Thus, without other elements to lean on—at least not heavily—your ingenuity is called into play to exploit that element to the fullest.

Certain material lends itself best to horizontals. Water generally lies flat, even in rough seas. Land is bound to the curve of the earth, even with soft curves of hills or jagged peaks to break the monotony. A desert scene would be an obvious horizontal painting. A reclining figure would express restfulness more than a striding, erect figure. Still lifes could be arranged horizontally too.

Use a fairly wide sheet of paper. This will naturally give you a head start in plotting your horizontals. If you want to offer yourself an even greater challenge, choose a vertical sheet. You will be working against odds, and, if you succeed, yours will be a special triumph.

As you plot your composition, be careful with any shapes that tend to become diagonals or verticals. They will be more conspicuous than usual because they will run counter to your basic motif. Yet you may want to use a few of them to give a counterpoint to your dominant shapes. Your horizontals will also be conspicuous because there will be so many of them, so plan for systematic variety. Consider their height, width, intensity, and interplay of values. They should not all be alike, but don't employ every variation in your repertory. You'll be aiming for a planned, not a helter-skelter, effect. For example, using nothing but half-inch bars could easily become monotonous. But you could try narrower as well as wider ones along with those half-inch ones.

One device to give a sense of movement in a composition of horizontals is to position patches of bright color so that they jump the eye from one place to another, giving upward movement even though they are part of shapes that move only right and left. Properly placed, these patches will form a secondary design moving the eye onto different levels.

In an imaginative seascape, for example, you could include arresting bits of warm color among your range of blues and greens. Scarlet, red, even burnt sienna in well-placed accents will not only cause the cooler colors to vibrate but will create a system of movement in that sea. Are those colors there in reality? Perhaps not, although the sea on a brightly lit day does have warm colors in it. Whether or not you can justify them on the basis of reality, they will make your sea colors more convincing, and you will get a more provocative watercolor out of their use. Anyway, you will be seeking a *sense of the sea* rather than the picture postcard quality of a conventional rendering.

Interest can be enhanced in another way by a system of value changes rather than color changes. What was suggested about spots of color could also be done with spots of intense darks or lights. Place them in the same way—in positions where they will move the eye about the paper. The eye will rove from spot to spot, enjoying the contrast between the dark or light accent and its surroundings, and then be carried off to another arresting accent elsewhere in the composition.

Such accents will keep the eye *on* the paper. One of the challenges of a horizontal structure is to find ways to prevent movement from running off your picture plane, off the sheet to the right and left. Horizontals naturally have this effect. They tend to spread out over that curve of the earth. You will want some of this feeling, but not so much that you dissolve your watercolor's unity. Spots of color—or spots of dark or light accents—will stop the viewing eye from going off the paper and losing the thrust of the painting. Choose places where you need these "stop" signs.

When you have completed this experiment, try turning your sheet halfway around. Does your composition hold together better? It should not do so, ideally. If you have worked your earthbound passages successfully, you will find that they hold interest on their own. They will give the feeling that they *belong* the way you saw them.

Emphasize Verticals

In the previous project, horizontals were stressed to the exclusion of almost everything else. Here try the opposite—use only verticals. You may find it somewhat of a jolt to avoid your usual horizontals and diagonals, but, as you must realize, one effective way of becoming bolder in your work is to experience the shock of discarding your ordinary procedures in favor of a new one. This time, despite your inclinations, think vertical.

You will feel the power of the soaring shape or line. Your brush will deposit paint that goes up, up, up. Nothing restful here. Any sleepy quality you may have in mind for your other painting will be unattainable in this one.

But if you are not ready for—or even interested in—purely abstract shapes, search about in nature for likely subjects that lend themselves to perpendicular design. There are many of them. Trunks of trees come quickly to mind, especially spindly firs, cedars, and poplars. Flowers like hollyhocks, larkspur, lupine. A sea of television antennae, smokestacks, Greek columns, or telephone poles—vertical shapes abound wherever human beings build. One artist developed a lively series of watercolors from a clutch of music stands.

When you have decided upon your motif, think next of blocking in your major shapes to fill your entire space (or to give the illusion of filling it). Remember to respect the spirit of independence that vertical shapes have. They are upstanding, stalwart, forceful—qualities that will be reflected in your resulting painting. Any excessive softness—too diffuse washes, for example—will dilute this effect.

That doesn't mean that you can't work to produce a bit of mystery. Panels of high-key color can be interposed between darker panels. You may be seeking, perhaps, the mystery of a dense wood. This shifting of key will create the feeling, "I'm not sure exactly where I am," that makes wooded areas so inviting.

The starkness of your verticals can also be offset by delicate horizontals to give you an effect totally different from that of brooding mystery. A web of fine lines will weave a surface mesh, which will stop the eye and diminish depth. Gently, though; that web must not compete with the strong verticals.

Don't let that net *sit* on the surface. Tie it to your verticals or to other passages. You can do this by softening with a damp brush some of the ends of your brushstrokes. That's a good rule in making *any* watercolor. Some softening is almost always needed. Besides having a pleasing quality of its own, this softening helps unite a brushstroke to its companions. This will fuse parts of your watercolor, leaving no one part high and dry, as if it were pasted upon your paper.

A particularly startling contrast between fine lines and the broad verticals they connect can be achieved by choosing two very different brushes. Pick a wide, flat brush—a one-inch or even a one and one-half inch single-stroke brush if you own one. Use this for your verticals. Then make the fine lines with your smallest brush. A choice one is what is sometimes called a rigger or script liner; it has a small clump of long, fine sable hairs that come to a point. The length of the hairs gives unusual flexibility to the brush. The slightest pressure of the artist's fingers becomes telegraphed to the tips of the hairs, giving a varied, delicate, personal line.

Work more slowly than usual as you finish this experiment. Being vertical, your shapes will be especially prominent. Everything you do with them will be visible. All the more reason for proceeding boldly—but with forethought.

By singling out those perpendicular strokes you will have the opportunity to study their effect on one another. You will see that they could become mechanical. You might find this result to your liking. Or you might want a less mechanical feeling, and this can also be accomplished. Slight subtleties in color, outline, and change of value will curtail that mechanical aspect of the verticals and even eliminate it entirely.

Emphasize Horizontals

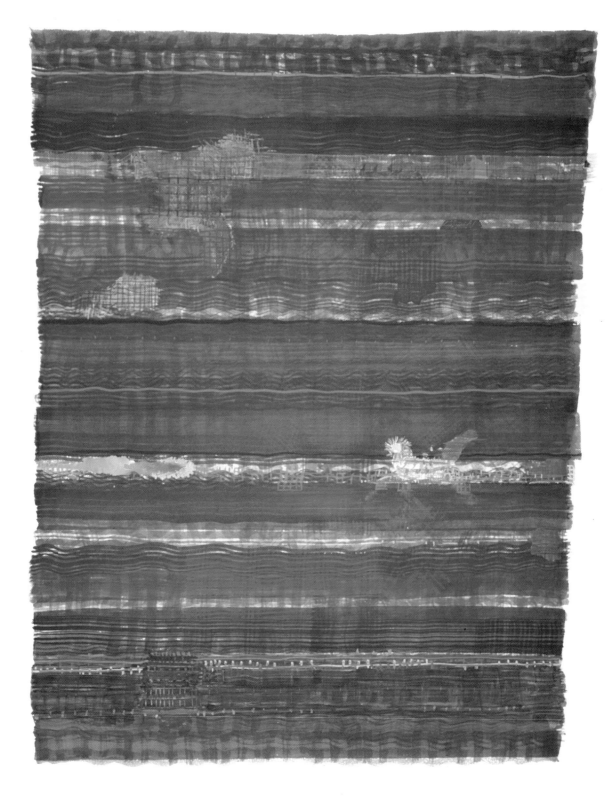

MIRAGE, *by Tom S. Fricano, 30 × 22 in. (76 × 56 cm). Watercolor with chemical dyes and opaque white.*

The structure of this tapestrylike painting clearly emphasizes horizontals. While the artist has used these horizontals as the armature of his composition, he has softened what could have been rigidity by introducing segments of subtle color in many of his bars. Some of these segments are expanded into flares that cause the eye to jump from bar to bar, offering supplementary movement to offset any left-to-right uniformity. He has produced further interest by varying the size of the bars themselves. Heavy bars are contrasted to thin ones painted in luminous color. A rich, warm, earthbound pattern is the result of these deft variations. Fricano says that his "prime concern is the final visual statement" in his work. He enjoys using watercolor in "the purest traditional sense" in his transparencies, combining that technique with the use of other water media such as dyes and opaque pigment. Born in Chicago, he is at present Professor of Painting and Printmaking at California State University.

FOREST COVER, *by Lawrence C. Goldsmith, 18 × 24 in. (46 × 61 cm). Georgia Anacker Collection.*

Verticals are the overriding emphasis in this woodland study. Soft color, applied mostly while the paper was wet, descends from top to bottom. Some lines and definite passages are interspersed with the washes, but it is the washes that are instrumental in weaving a curtain that extends throughout the painting. The aim was to suggest the prolificacy of newly budding leaves on twigs and branches in early spring. The upshooting movement in nature was a conscious motif. As a counterpointing theme, the horizontals of the land, partly veiled by the trees, were used to express earthbound permanence. Horizontals in the hills, the banks of a river, and a nearby marsh were introduced to reinforce the prominence of the opposing verticals. Color variation within the larger areas was kept to a minimum, as were differences in value. The hope was to let the eye dwell on the rising tree shapes and the nuances of the washes without risking the distraction that sudden changes would have created.

Use Different Shaped Paper

CIRCLE AND YELLOW, *by Edward Reep, 17½ in. (44 cm) diameter circle. Watercolor and ink on rice paper, Collection of the University of North Carolina—Chapel Hill.*

Using his circle as an integral component in his design, Reep has composed sectors of grays and earth colors that slowly cause the eye to revolve while allowing for moments of pause. One "stop sign" is the ellipse of bright color standing alone at the very bottom of the perimeter. Reep often works with circular paper. "I dwell a great deal over work completed," he confides, "perhaps wondering if more could have been gained from the statement." He explains the origin of this particular work: "In poring over earlier sketch notes for paintings completed, I suddenly found myself pasting things down and into the rice paper surfaces. The intricate detail, totally irrelevant and often in disagreement with the image, nonetheless provided a strange impetus which I found delightful." Spurred on by these quick sensations, he developed this new painting. Reep, born in New York, spent much of his lifetime in southern California, moving to eastern North Carolina in 1970. He teaches at the East Carolina University School of Art.

DARK CONVERGENCE, *by Michael Loew, 22 × 30 in. (56 × 76 cm). Collection of Allen and Harriet Fristoe.*

Loew has focused on a central dark area in a most emphatic way. He has massed his brooding blacks, blues, and muted reds in the center, leaving a startling border of white or near-white on all sides and linking the two areas by a network of lines, mostly in the same colors. These lines, delicate as they are, have been directed so that they become extensions of the mass. He has also alleviated the density of the mass by leaving flecks of white throughout much of its surface. As a counterpoint to the mass, he has introduced a bar of bright red at its upper left edge. These embellishments become an integral part of his total scheme. Loew returns again and again to a given watercolor before he pronounces it finished. He scrubs out passages, rewets, imposes new layers of pigment, and adds accents as he feels they are needed. Reworking a painting is fraught with hazards, but by allowing himself time to consider changes, he avoids the muddiness that besets so many other artists. Clarity results from his reworking, as well as depth and conviction.

Paint on a Narrow Sheet

KEWEENAW SUITE, *by Glenn R. Bradshaw, 10½ × 4¾ in. (27 × 12 cm). Casein on rice paper, one of a suite of 44 paintings.*

Like Edward Betts, Bradshaw too works in an alternative water medium. This painting exploits the challenges of a narrow sheet, with graceful strands of color weaving across the middle area, thus relating the darks at the base of the panel to the middle values of the upper section. Bradshaw describes his work as "affectionate responses to the land—waterscape of northern Wisconsin and upper Michigan. They are developed directly on rice paper without prior sketches or studies. I use casein paint applied to both sides of the paper. The paint is usually liquid, is allowed to penetrate from one side of the paper to the other, is blotted, is overlapped, and may be wet-in-wet or wet-over-dry as seems appropriate. To begin a painting, I confront the bare paper without any idea in mind, make a number of bold, rapid gestural marks on it in liquid paint, and let it dry. Additional marks and areas are added over a period of weeks. Each new mark is based upon judgment of what has already been done in the painting but idea and execution are often nearly simultaneous. Key decisions must be made as to which side of the paper is to be developed into the painting, what subject matter is to be depicted (some forms in nature are similar to the gestural marks), and how much of the phenomenalistic painting should be maintained, and how much deliberate painting is needed to resolve the work." Bradshaw is Professor of Painting at University of Illinois, Urbana-Champaign.

50

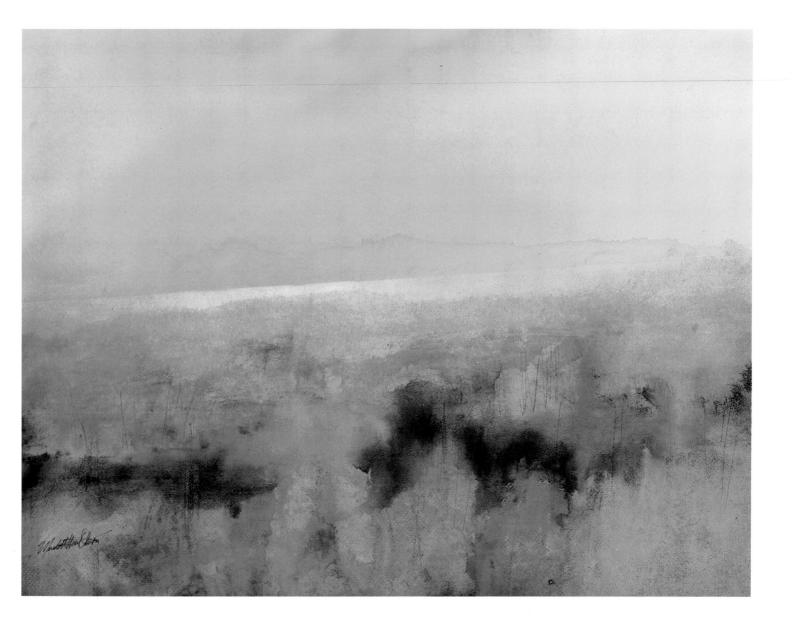

LANDSCAPE MIRAGE, *by Meredith Ann Olson, 19 × 27 in. (48 × 69 cm).*

Wet washes dominate this atmospheric painting of sky and land, blending and fusing, bathing the scene in warm effusions of light. The expanse of sky, covering half the paper, consists of a single sweeping wash illuminated by a subtle stream of pigment that creeps into its lower portions and suggests clouds or distant hills. The lower half of the watercolor contains smaller washes that play against one another in contrasting color and value. Olson's landscapes are painted from memory. "They are concerned with light, color, atmosphere and their effect upon the forms of nature," she says. "Although I fill sketchbooks with many on-location studies, I frequently indulge in returning to the memory of the landscape of my youth. My first memories are from Clinton Street Hill overlooking the haze-draped basin of the city of Los Angeles. I could stand in the front yard of the old family house and see the great vista of the city, the distant mountains, the ocean, the haze, the setting sun, and the glorious colors of the sunset. These early experiences of nature have been the single greatest influence on my landscape painting."

Experiment 11

Paint from a Painting

Redoing a familiar theme is, of course, an incessant, sometimes compulsive drive in artists. Monet's series of haystack renditions stretched from here to immortality, and so did his water lilies, to mention two masterly examples. Monet returned almost daily to his site, catching the light at the most favorable moment. But here I am suggesting that you get away from your original site.

You will be doing a painting based on a painting that was the product of your firsthand exposure to your motif. In this second, experimental version, you will be profiting from that first experience and adding new dimensions to it. You will be free from having to concentrate directly on that motif. You will be concentrating on the earlier painting itself. Once you have removed yourself at least one step from literal observation, you will be forced to think in aesthetic terms, taking the harder road of internal creativity.

Your problems now will be concerned with the picture plane. What opportunities does it open up that you didn't see the first time around? Where did that first painting fail to measure up to your ideals? The painting you will be working from may have been a good painting—perhaps even one of your best—but all works of art have their limitation. Tomorrow's efforts will always offer greater promise. For the purposes of this project, examine the painting particularly to see where it might have been bolder in concept and freer in execution.

Take up its artistic components one by one. Criticize your color scheme to see if it was more conventional than it could have been, or too diverse, or too precisely balanced between warm and cool colors. See if your scheme of values resulted in an overly conservative statement that could be heightened with greater contrast. Scrutinize your shapes, lines, textures, and composition to give them more intense meaning. Look to see how any aspect of the painting could have been simplified.

Mostly, make a conscious effort not to dwell on the original subject matter; instead, concentrate on what the painting itself requires to resound with a greater impact.

Your best choice for this project will be one of your watercolors that now seems to you to have bogged down in overly careful attention to subject matter. What the particular subject matter is makes little difference. You can add emotion to any motif. Choose a painting that, even before studying it, you sense could benefit from a fresh start. Then study it carefully to see what specific improvements you can make in the new one.

Have clearly in mind what you intend to do before you start the new painting. Place the older one nearby. This will enable you to refer back to it as you progress with your new plan. About halfway through your painting procedure—that's an intelligent guess, of course, because you won't know at this point how long you will be working—banish the earlier painting from easy view. Put it where you can refer to it if you must, but now turn your full attention to the new version. Seize upon any new directions you have opened up for yourself. Carry them through to their fullest realization.

Don't worry if you find yourself moving far away from the original concept. This is to be hoped for, and will be the measure of your ability to realize new possibilities. Your new discoveries may well set the tone for all your future work, or at least for a series of paintings on a new level until you are ready to move still further forward.

Create a Species

This experiment ventures into what may be unexplored territory to you—inventive, organic forms. Quite often, at least by the viewing public, watercolor painting is associated with landscape painting first of all, then perhaps still life, and, less frequently, cityscapes and portrait or figure painting. The artist striving for individuality will either find a new way of presenting this familiar material, or he will strike out in a bold new direction of his own. This experiment suggests another of these directions.

Arshile Gorky is remembered chiefly for the extraordinary inventiveness of his later years. Earlier, he studied, imitated, and even copied the work of other artists until he became one of the most knowledgeable men of his time, but hardly an innovator. In his last years, struck by debilitating illness, he would be helped into a chair on his lawn. There he became fascinated by the multitude of small creatures crawling, flying, burrowing around him. From these creatures he invented others. His work became alive with volatile organic forms, interrelated on his painting surface.

Gorky worked in a variety of media besides watercolor, but his concept is particularly appropriate to watercolor. Flowing watercolor itself makes innovative shapes. Sometimes it almost seems as if your paint has taken over as your draftsman.

Start this experiment by becoming better acquainted with a whole family of species. The color plates of encyclopedias and nature manuals are full of exotic examples. Then look at your outdoor surroundings. You will see fewer examples of species, naturally, but you will see them in their native habitat and can study their movement and habits.

Choose what is most prevalent in your area, if you like. Three promising subjects (there are many more that are equally absorbing) are shells, butterflies, and insects. All are plentiful at some season and in some places. All have almost infinite varieties. The number of *different* species of insects science estimates to exist is staggering—somewhere in the millions.

Also remember that you do not have to confine yourself to known species. Invent your own. Use existing species only to excite your imagination and to start you off in creating color, form, movement, line, and design. You will want to express the character of your species—the crawliness of insects, for example—but find ways of your own to illustrate this.

Painting techniques can be chosen to suit your own purposes. Thankfully, there are no "correct" ways to paint, let's say, a carpet of shells. For example, you might try strong curvilinear lines done wet-in-wet and tightened as the paper dries for the spherical shapes of shells. Or you could use a good deal of busy, nervous line work to establish the fast darts of waterborne insects. Flowing washes of richly varied color might suggest the radiance of butterfly wings. Experiment with whatever techniques seem to work best for you.

Experiment also with scale. Create larger-than-life species. That is, larger than they would be if they really existed in nature. A single insect eye, perhaps, with dozens of reflecting facets, could make a thrilling motif filling a full sheet of paper. Or go the the other way: invent swarms of tiny creatures spreading over the paper.

You will have such a wide choice that it might be wise to impose a few limitations. Perhaps it would be best to work with only one group of creatures—all spiders, possibly, or all grubs. Or go further and examine only wings or some other bodily feature typical of your species. Another sensible limitation would be to work close to your picture plane so that your viewer can concentrate on your creatures and not be drawn back into the distance. Within your selected limitations, you can improvise and exaggerate. You are the creator. In this experiment, the world *is* your oyster.

Invention breeds invention. In working with new material, you may take a fresh look at your painting habits and find opportunities for revision. Furthermore, the creatures you create will open up new realms to explore. Organic forms provide endless material for the artist whose eye is on nature. *Natura Artis Magistra*. "Nature is the teacher of art."

Paint from a Painting

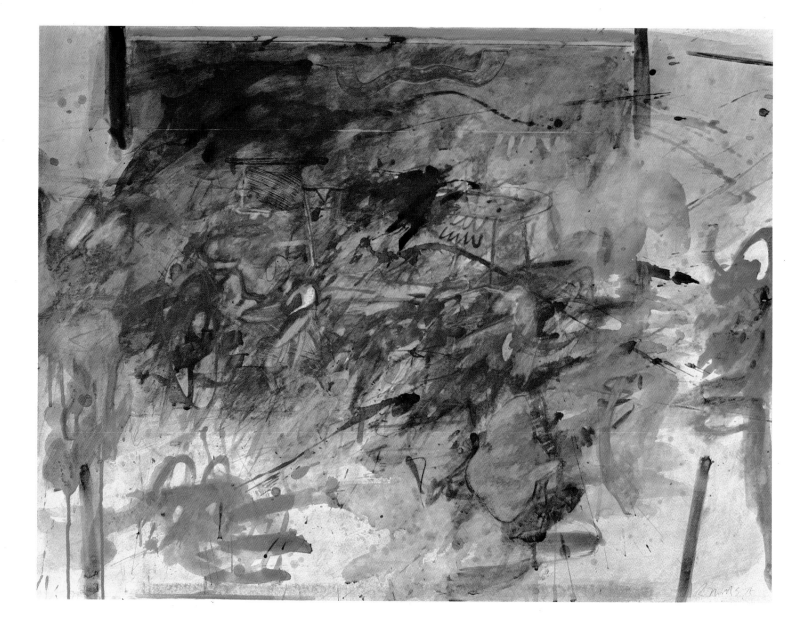

TOKEN LANDSCAPE SERIES 1, *by Richard Mills, 30 × 40 in. (76 × 102 cm).*

Mills develops his ideas from one painting to the next, seeking in each one to further refine and sharpen his original impressions. "I work in a series," he says, "because I am often influenced, at least subconsciously, by the paintings that precede the one in progress. Perhaps there are problems that need solutions, or perhaps I am too reluctant to let go of a good idea." The series of which this watercolor is a part was done in the studio, based on memories of landscapes, "the most enduring of which came from my homeland of East Tennessee." (He now lives in Alabama.) Mills feels himself especially gripped by "the chaotic aspect of areas of wilderness." This comes across in his vigorous brushwork. In contrast to his turbulent passages, other sections are more polished and clarified. He works with many layers of wet-on-dry transparencies, letting loosely knit geometric forms appear. As he puts it, an "intentional paradox" results between the natural and geometric forms.

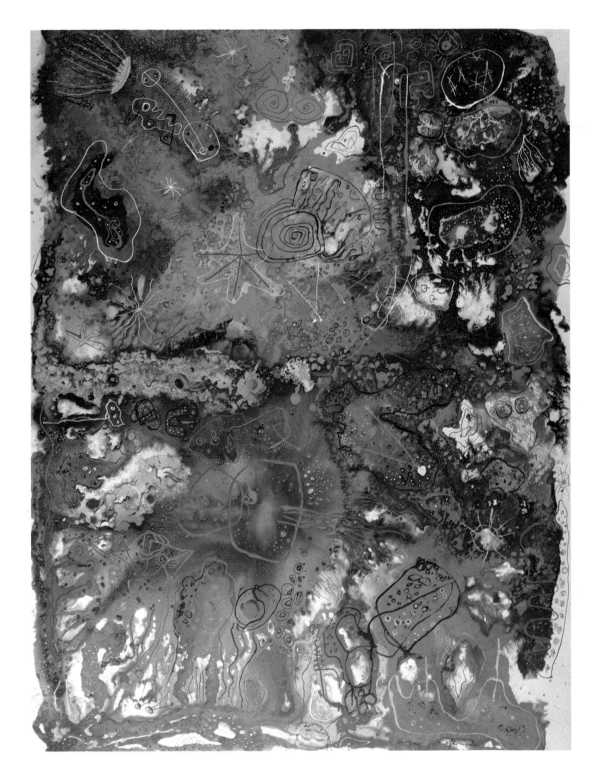

COMPLEX OF THE TIDE, *by Lawrence Kupferman, 27½ × 30¾ in. (70 × 78 cm).*

As a creator of species, Kupferman, in this watercolor, has given our planet a swarm of creatures born out of his imagination. Invented they are, but all possess some of the creeping, slithering, crawling, clutching faculties characteristic of inhabitants of a tidal pool. The artist sees this type of painting as a poetic absorption in marine specimens as if seen through a microscope. "I . . . try to suggest, at least, the wonderful dense complexity of matter, or indeed, of *being.* The miracle of being. I try to allude to the atomic structure, to the ceaseless spinning movements, the endless pulsations inherent in all beings." Sharply etched in some instances, partially hidden by mottled color in others, the artist's creatures pervade every inch of his paper. They have made it their domain. Kupferman lives in Massachusetts, where he has spent much time on Cape Cod. He has also painted extensively on the Pacific coast of Mexico.

Experiment 13

Reveal White Paper

Letting the sparkling white of your sheet of watercolor paper play a conspicuous role in your painting is the objective of this experiment. Curiously, where you *don't* paint will be as important in your creative process as where you *do*, and when adroitly designed into your painting project, this absence will not only speak for itself but will enhance the feeling of the painted passages.

A critic said of Chagall, "His white space illuminates, aerates, highlights the secure yet delicate line, the stippling, dotting, skipping, scratching, undulating traceries of his thought, left behind like the glittering web of a spider in the sun."

Success depends on your ability to relate painted passages to unpainted ones. Areas that are unpainted and look empty, serving no purpose, will create jarring notes. Similarly, unpainted portions that appear isolated, without affinity to other parts of the painting, will give a fragmented appearance to your surface. What you are seeking is connective tissue binding painted and unpainted areas. This bond may be as bold as a buttress or as fine as a cobweb, but it will always be strong. Several painting techniques are especially useful in creating this illusion of strength.

Before applying these techniques, select a piece of quality paper. Ordinary paper will do in a pinch, but since you are going to let much of the surface stay exposed, paper that has superior qualities of brilliance and texture is preferred. Use handmade or moldmade rag paper if you can. I prefer rough paper to cold-pressed or hot-pressed because of its more articulate texture.

Subject matter can be whatever strikes your fancy. Avoid a snowscape, though, because it will not be demanding. Your skill in leaving paper white will be much more apparent if you deal with a subject that is not customarily white, as is snow.

Design your composition with as close attention to the parts you aren't planning to touch with your brush as to the rest of the space. Try to forecast mentally how the white will fuse with the pigmented passages. Anchor at least one portion of the painted area to an edge of your paper. This will keep the painted area from being surrounded by a sea of white and prevent it from looking like a vignette. The secret of avoiding the cramped, rather prim feeling of a vignette is in this extension to one or more of your edges. If you find you are still creating a vignette, strengthen those extensions.

Certain devices in technique will be helpful in bridging the white areas to the painted ones. Transition between painted and unpainted areas should be almost invisible. You can create this effect by keeping your darks well away from the edge of a wash. Then melt the edges of all, or almost all, of your washes and other painted passages into the white by keeping both the passage and the adjoining area wet, showing very little paint on the painted side. You could alternatively make a transition from a wash to the white by painting on *dry* paper with only a speck of pigment on a very wet brush. Where there is still a suggestion of an abrupt, unwanted transition, soften the edge by lightly going over it with the damp tips of a bristle brush. Use only water, not pigment. Scrape until the color softens and spreads to either side.

Another effective device is to leave some rather small white areas within your larger painted areas. These will then relate to your larger unpainted sections, giving visual connection. Neither will then look isolated. A third device is to incorporate sharp accents. Naturally these will be placed in painted areas. Make the accents vivid in color or value change so that they contrast with their surroundings. A double impact will result from vividness in both color and value change. Aside from their usual value, these accents will engage the eye of the viewer so that he doesn't question the melting away of color into white paper. The accents will make the illusion you are creating more tenable and more enjoyable.

What you will explore in this experiment is how to make the white of your paper work for you in a new way. Naturally you always depend on the whiteness of the paper to give transparency to the watercolor—that is what makes it a *transparent* watercolor, and is one of the wonders of the medium. But here you will investigate what *pure* whiteness will do.

Let a Motif Stand Alone

The objective of this experiment is to confine yourself, so far as it can be done, to one item or motif, eliminating everything else, and still producing a full painting. Your first thought may be that you will have to rule out all sorts of subjects to make this concentration possible. And yet you may find, as you go further into the problem, that many motifs don't really need all that they're usually surrounded by. Could you paint a live fish without the water in which it is swimming, or a dead fish without a platter to hold it? After some hesitation, you might discover that, yes, you *could* make a convincing fish. Georgia O'Keeffe's series of paintings showing nothing but strings of clouds is a good example of eliminating extraneous matter.

Cast about for other motifs that might be refreshingly seen standing by themselves without their usual supports—a rock by itself; a single flower enlarged to fill most of your space; a mountain peak alone, with no sky shown; a single ear of corn or a human ear. There's a rich assortment of other possibilities in man-made objects—a pair of eyeglasses, for example; an engine; one glistening bottle; a work glove, well-worn, with the almost living presence of the calloused hand that shaped its every crease.

This experiment leans far more on originality of concept than on any particular method of painting. About all that need be said is that your single motif should either monopolize your entire space or dominate it in some other way. Should it get lost in your space, you will have defeated your purpose of giving it prominence. The most convincing factor in giving prominence is size. Let your subject loom so large that it gives the feeling your paper can hardly contain it.

Once you have designed your sheet to do justice to your motif, your personal battery of skills is all you need for executing the plan. You will want to lean heavily on bold washes and wide strokes with your brush. Aside from these, no unusual methods or special techniques will be needed.

You will want to keep reminding yourself not to let any secondary motif intrude upon the scene. See if you can devote yourself to that primary motif exclusively.

In a sense, you will be accomplishing a tour de force. Why should you delineate a cloud without showing the sky around it? Would it be a technical achievement only, rather than an aesthetic production? Possibly. Yet, as with many of these experiments, the feeling you put into it will enable you to expand your sensory horizons.

By concentrating on a single motif, you will have done to an extreme degree what should be done in every painting to a lesser degree. Does that cloud interest you more than the sky around it? If so, then even in an ordinary watercolor, you should give most of your attention to the cloud. Save the sky for another painting when the sky rather than the cloud absorbs you.

This experiment should convince you that unless you concentrate your attention, you dissipate it. The untrained landscapist often pays equal attention to sky, land, and water in a single work. As a result, no one element makes a forceful statement. It is far better to dwell on *that* sky, or *that* land, or *that* water.

This generalization has validity for all kinds of material. A figure or group of figures as a motif would suffer if so much attention is paid to the background that it is no longer a painting about *them*. True, as with all generalizations, there can be brilliant exceptions. Pierre Bonnard, for one, combined his figures with their background in imaginative, textured tapestries— but for every Bonnard there are a hundred artists who achieve *their* best work by letting the figure dominate. Or the background. But not both in one painting.

Reveal White Paper

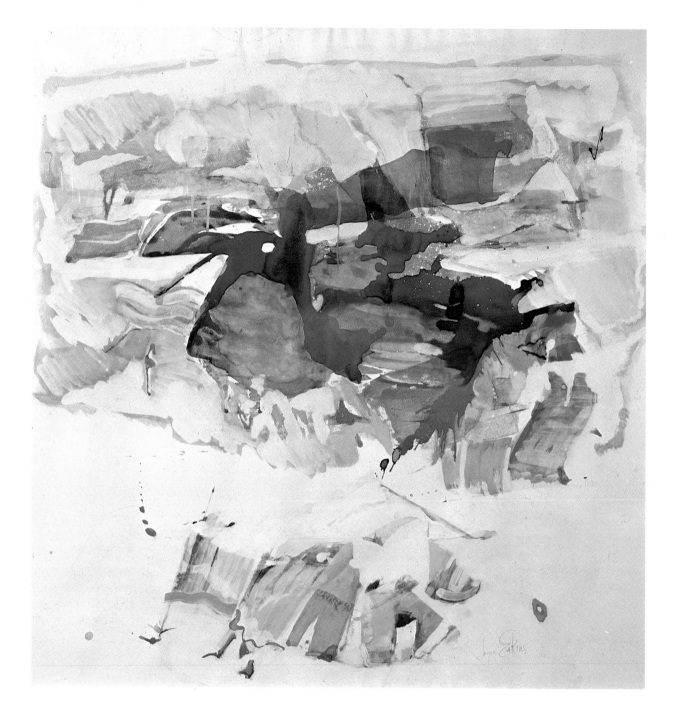

COLORADO SKY SERIES: BOULDER WIND, *by Joyce Eakins, 32 × 32 in. (81 × 81 cm). Collection of Mary Lou Parker.*

Here the whites speak out—clearly! Much of the paper is entirely bare, with lacy shapes in very light pigment improvised to tie the white of the paper to the darker shapes. The artist's working process is highly emotional. "I love spontaneity," she explains, "and I like to work quickly, although some paintings take weeks to finish. I begin in a spirit of play. Unfocused play often leads to new responses. Shapes grow and change, intense colors become subdued, smooth texture becomes rough, light becomes dark. Interest heightens. I react to my materials. They must be allowed to speak. I do not dominate them. My involvement becomes intense and what started in a spirit of play has begun to grow. A course of action has been determined—I have a direction. Play has turned into work. The action grows, guided by instinct, by spontaneity. Back and forth—working together, analyzing, investigating, feeling, doing, acting, reacting, thinking, not thinking. Self-awareness dissolves, a fusion occurs between myself and the painting. Vital sparks burst forth and the life of the painting begins. I take a chance, risk, destroy, rebuild, act upon. Time passes—the battle nears an end. The painting is in control. It becomes an entity. The work is finished." Eakins is Artist in Residence at Colorado Women's College.

PAPILLON, *by Bette G. Cooper, 22 × 27 in. (56 × 69 cm). Collection of Mr. and Mrs. Edward Hyans.*

The motif stands alone here in all its grandeur—the tinsel fragility of a butterfly. But instead of rendering the exact features of any particular species, she has let floods of paint convey the wonder of *all* butterflies. Her washes shift between blues and greens, reds and yellows, and she suffuses all of them with value changes that, although gradual, cover a span from very light to intense dark. In places her washes pale into thin air, gently losing all detail as they do so, the fluttering wings eluding identification. In contrast, remaining passages are strongly built into a cohesive, sharply defined shape that clearly signals her motif. It is a butterfly beyond doubt, but also a highly personal statement derived entirely from the artist's imagination. Its importance is magnified by her positioning of the image. It engulfs her space, even spilling out over the edges of the paper. She handles her paint mostly wet-in-wet, enjoying the fluidity of transparent watercolor. The result is a luminosity that she feels she could achieve in no other way. Cooper is a New Jersey artist and teacher.

Experiment 15

Express a Mood

This project—to express a mood—will let you wander as far away from dependence upon subject matter as you could wish. Mood has no easily identifiable symbols except those brash ones seen in a comic strip. You will need to invent your own symbols. Even when you deal with tangible objects, your imagination will have to endow them with emotional content.

How can you paint a mood and make it *yours*? A child can accomplish this more intuitively than an adult. Children are often encouraged by their art teachers to paint how they reacted to a situation at home. Since the very young are usually less constrained in expressing themselves, they put down some bold, quick splashes that adults envy. How spontaneous and uninhibited by adult training they are!

Yet training can so enrich the artist's vocabulary that in expressing maturely felt emotion he can add dimensions that are beyond a child's reach. Adult perception and insight are basic to the creation of art. Training, including self-training, affords tools to transfer one's feelings to a painting surface. The endeavor here is to experiment with some of these tools.

Take color. Hot color almost automatically conveys passion. Loving passion, angry passion, and all other kinds of *heated* involvement. Cool color, on the other hand, generates contemplation, quiet, detachment. A psychological study has shown that anxiety and conflict have an affinity with the violets. All colors and combinations of colors have their own psychological overtones. One artist claims that cerise and white is the most passionate combination of all. You will want to use the knowledge you have acquired of the emotional content of color.

Color is a first step only. The very way you apply your paint will also express feeling, whether this is done consciously or not. Here you will be trying to do it consciously. For example, jagged edges to your washes will suggest a more abrasive feeling than soft edges. Abrupt changes will cause a more definite effect than passages that flow smoothly into one another. When painting a dreamy mood, exploit this flowing quality. Use abruptness when you want a more staccato effect.

You will need to analyze your feelings before trying to transfer them to your paper. In doing so, it might be helpful to recall, or take a new look at, other artists' emotional works that stick in your memory. Determine what effect they achieved and then try to define what tools they used to reach this result.

The work of Emil Nolde is eminently worth looking at. So is that of Van Gogh, whose watercolors, as well as his oils, reveal clearly his wonderful command of emotion-evoking tools. His writhing, swirling brushstrokes give a turbulence to what, in other artists' hands, would be placid bucolic scenes. This turbulence was internal in his case, but it was also his artistic intention. He felt the heat waves of his locale. He lived in empathy with impoverished, agonized peasants. He responded passionately to both the countryside and its people.

Intellectually, he knew he must go beyond appearances to get across his feelings. He had to select and distort, as well as overturn the superficial. When someone criticized his tampering with the literal appearances of subject matter, he wrote in an impassioned letter to his brother Theo, ''My great desire is to learn how to achieve such inaccuracies, such deviations and conversions, such refashionings of reality, so that they may become—yes, lies if you will—but more true than literal truth.'' Emotional truth is what Van Gogh sought. This is the aspect of creativity that's more vital than anything else.

I haven't said anything about *choosing* a mood for this experiment. In a way, if the suggestion were to come from someone else, it would not likely be your mood. So pick a feeling that moves you deeply at the moment or that did in some experience yesterday. An encounter, a sudden flash of insight, a crisis, or a poetic impression remembered now in tranquility.

This is a complex, subtle area of creativity. Expression is elusive and also highly personal. Any two people are likely to react differently to an expression of emotion just as they would to the emotional experience itself. Put the reaction of others aside. What you are developing, mainly, are tools that convey how *you* feel. When a painting seems valid to *you*, other people will sense the validity of your expression.

Choose a Single Value

When rules are understood and then violated for a clear reason, the result can be startlingly innovative. Stuffiness goes and invention takes its place. This experiment is an effort to attain this state of freedom. The procedure is to conceive and execute a watercolor in a single value and see what happens in the process.

Which rule are you going to disobey? It's obviously the one that says that success depends on your use of three values—dark, middle, and light. If you bypass this rule, you can also violate another and get away with it—the one that says that too many colors cancel each other out and lose their individual effects. Here you can use as much color as you like because you won't be combining variety in color with variety in value. Your painting will be predominantly a painting of color.

Test the theory in this experiment. Decide first, of course, what strength of value you will use. Any degree should work as well as any other, although all have their individual impact. Once you have chosen the value, stand by it as closely as you can in the application of *any* color.

Selection of a motif is incidental. The handiest would be material that already has an assortment of hues, such as a bed of multicolored flowers or a room crammed with fabrics, wallpaper designs, and objets d'art. Those exotic Oriental corners piled with pillows that were a preferred Edwardian style of decor would be ideal.

You can pursue your motif with none of the customary restraint in maintaining a color scheme. Yellows, oranges, reds, greens, blues—the whole spectrum is available. As always, though, you wouldn't want to apportion your space in identical shares. You'll want a predominance of either cool or warm colors. There's no reason for not using all warm or all cool colors except that you'll probably want to take advantage of the opportunity to use the widest range of your favorites in every color temperature. But remember, don't deviate from that chosen value. Even your accents should conform. They can derive their sparkle from shape and size rather than from the more customary variation in value.

To obtain a valid test of this idea, avoid white spaces this time. They would defeat your purpose. Instead, you could use restful colors in spots where you would ordinarily leave the paper bare.

Having tried this experiment in, say, a middle value, plan another watercolor in a dark or quite light value. An interesting series could be worked out by executing an identical theme three times—once each in high, low, and middle value.

Any new departure you make from your habitual methods will widen your skills. This project helps to explore the possibilities of color, happily an endless pursuit. Ask yourself if, by working without differing values, you have found color juxtapositions that you will want to push further in other paintings. See also if you have achieved a luminosity that hitherto seemed beyond your reach. Finally, think about violating other standard rules so that you may progress to bolder, freer concepts in your painting. Watercolor is such an amorphous medium. Its very nature seems to scoff at rules. They have their importance, naturally. They need to be understood. But very often an artist's inner understanding will go beyond those rules and he will make a major breakthrough outside the realm of rules.

Express a Mood

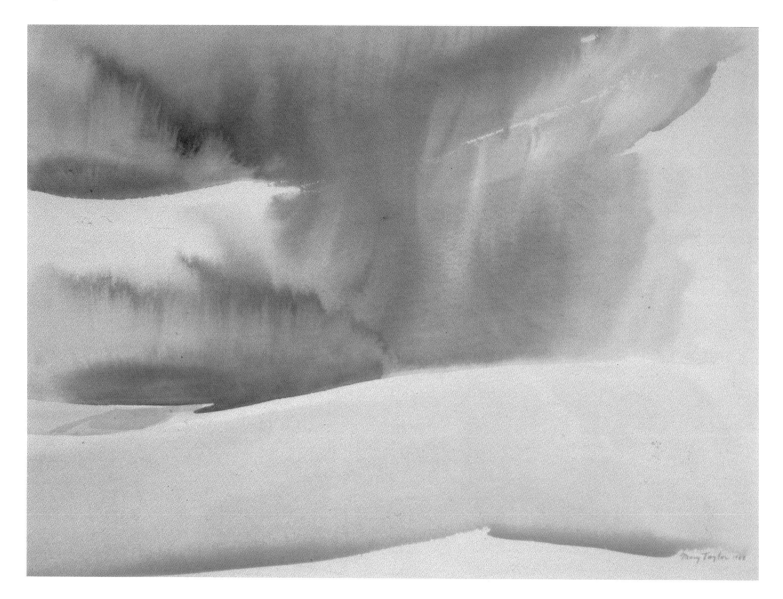

WHEATFIELD, *by Mary C. Taylor, 16½ × 23 in. (42 × 58 cm). Collection of Christopher Kressy.*

In painting a mood, the artist shows what can be accomplished by bold division of the paper, a direct confrontation of colors, and sweeping brushstrokes. The mood is one of exultation. Simplicity is the key here, produced by planning a graded wash of yellow for the field of grain and a modulated wash of grays for the contrasting sky. "Painting in watercolor is like walking a tight-rope; one must find a perfect balance between what the paint wants to do and what the artist wants to do, or all is lost," says the artist. She feels the influence of Chinese painting, "not directly as a style but in terms of the general approach to natural subjects. I feel some kinship with the clouds, mists, trees, and flowers of Sung painting (A.D. 960–1280) and with the old philosophy painters who subordinated self to nature." She soaks her paper, lets it dry on a wall until the water sheen is gone, and then stretches it on a board, taping it all around with heavy brown paper tape. She uses large brushes—number 12 or number 14, sometimes round, sometimes flat—to lay on early washes. Various other smaller sizes are used as the work develops. "I use both wet-on-wet and overlay washes but avoid the latter if possible so as not to lose freshness."

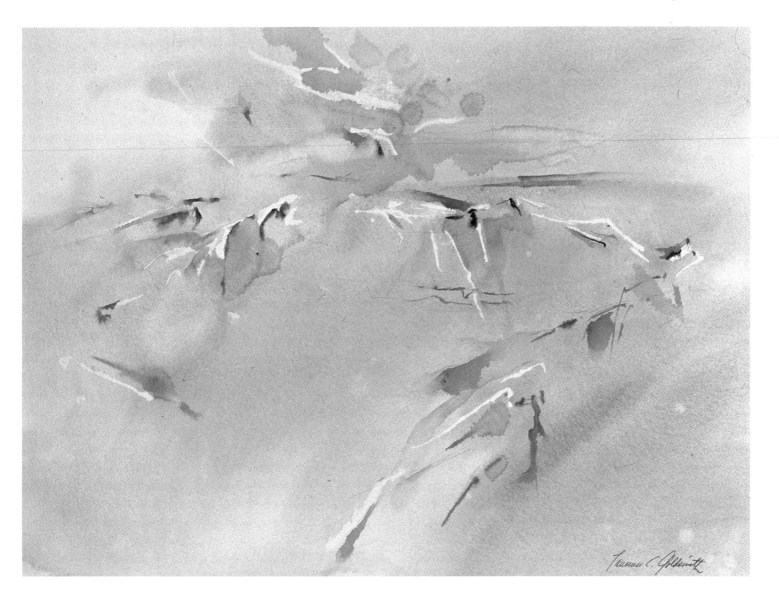

SEA SORCERY, *by Lawrence C. Goldsmith, 18 × 24 in. (46 × 61 cm).*

Use of a single value throughout this seascape coalesces the random shapes that are its chief interest. They roughly form a diamond in structure. Without the unifying value—created in an underlying wash—the shapes might scatter indiscriminately. The shapes have little in common—they move in at least four directions, they vary in color, and their formations range from blobs to streaks. The concept was to dwell on the gusty winds over the sea and the spurts of activity in the sea itself. Pictorial features were not considered. The atmosphere of the scene provided sufficient stimulation. Much was left understated, although here and there it was felt desirable to establish decisive accents, which hint at the nature of the scene and turn the eye at pivotal points to roam along the diamond shape without much interruption. Strokes were applied with forethought, but the more deliberate intention was not to build structure but to convey an impression of nature and weather.

Experiment 17

Use High Key Only

In the preceding experiment, I proposed concentrating on a single value. Had you used high key then, you would have explored some of the territory discussed here. But in this section, you will be exploring qualities that pertain specifically to high key and not—or at least not so much— to other narrow ranges of value. The recommendation here is simple: plan and execute a painting in light values throughout, resorting to only an occasional dark or middle value. Whenever you use those other values, confine them to a tiny fraction of your working space.

You will discover two benefits from this experience. The first is luminosity. That glorious white of good watercolor paper is more easily seen through a light passage of color than through anything darker. That whiteness shining through your work is a quality, as I have repeatedly said, that is unique to painting in watercolor. You can paint translucently with acrylics on paper (but not so readily as with watercolor) and you can let some of the color of a canvas show through thinly applied glazes of oils or acrylics. But only watercolor depends inherently on the combination of paint and surface for its effects of light. Anyone who tries to hide the paper by heavily coating it with pigment loses a valuable asset and would be best advised to turn to another medium. Luminosity should be synonymous with watercolor effect.

Gradation is the second benefit afforded by working in high key. Again, your use of gradation becomes more visible than it does in middle and low values, although its importance is always undeniable. Gradation makes possible the even (or uneven) diminution of color tones and values and the perfect blending of two or more colors. Look at the subtle way it was used by Cézanne and other masters. With gradation, "Movement across the shape is accelerated," as Rex Brandt explains it, and "creates a visual vibrato without violating the readability of the shape." This, too, is an opportunity that abounds in watercolor, more so than in any other medium.

Strive, then, for maximum luminosity and gradation in this work in high key. Both are essential, and both rewarding.

What colors are best for the purpose? The choice is open. Warm or cool colors, grays or earth colors—all will perform nicely. Any combination would also be effective. The only rule is to keep all of them light.

Subject matter is not a relevant factor. You can work in high key in a landscape, still life, or figure painting, and in using either an abstract or pictorial manner. Select what is sympathetic to your taste.

Use cold-pressed paper as an alternative if you are accustomed to rough paper. You will get greater fluidity than usual. Rough paper, however, will give more variety in your gradations. Your choice should depend on which aspect is of greater importance to you. But whatever your choice, use plenty of water. Start with your paper wet, and rewet sections when necessary. Wet-in-wet is an especially useful technique.

Be careful not to overwork. That's gratuitous advice, of course, like "don't panic" at a fire. It still serves as a handy reminder when you are undecided about whether or not to repaint a passage. Remember that each time you do repaint you are reducing luminosity.

Keep your gradations from moving into middle and deep values. There's plenty of range to play with and still keep the total effect light. One more drop of water on your brush, or one less, and your stroke will differ from your previous stroke. Color change can be equally subtle. Sneak a bit of neighboring color onto your brush as you apply a new stroke. That's always a good habit, and especially so when you are limiting yourself to a narrow value range.

The time to make exceptions to only high key will be when you introduce accents. See if you can make them high key, but, if not, switch to a lower value. These exceptions, as said earlier, should cover only a small proportion of your total space. Don't let them take over this painting.

This experiment should produce a light painting. Transparency and eloquence of gradation should be responsible for almost all the joy experienced by those who observe your results. Use this as the yardstick in measuring your accomplishment. See if your painting really glows. Question, also, if it does justice to the capabilities of watercolor and could not be reproduced in any other medium.

Understate Your Subject

We often hear that in art "less is more." But to achieve more by putting in less is a good deal more exacting than taking the easy way out and overburdening our paper. Understatement demands that we curb our lazy instincts. This experiment aims to illustrate in a single exercise three principles of free painting: (1) simplicity, (2) suggestion, and (3) brevity. Their joint product would be a work of understatement.

First, simplicity. Start off by deciding what factors most simply express the nature of your material. Rule out all others. (As an elementary example, if you want to show windiness, leave out everything that doesn't wave in the wind.) Make anything distinctly secondary that you put in to *support* your theme, and if it doesn't support it, don't use it at all. A bit of sky may sometimes be necessary to support the image of a horizon, but don't paint it if you don't need it.

Second, suggestion. Here's the moment for artistic courage. You are looking for a few bold passages that in themselves suggest what the rest of your design is about without your painting it all in. These few passages will identify your material and evoke your mood. Once established, these factors will pervade the whole conception. Easier said than done, of course. In a number of quick sketches practice painting some features of your material and leaving out others. Decide from those sketches which features are essential. Don't develop the others. The ones that are essential will suggest all the rest.

For a while, work done suggestively may look unfinished. Eventually, though, you will arrive at work that is actually more revealing because you have reached the freedom to dwell only on essentials.

Third, brevity. Brevity is vital in understatement. Work sparingly—not necessarily quickly—just as if you were waiting in a conversation to drop in that one telling word that clinches the argument. However, don't rule out the possibility that by working economically you may finish a watercolor quickly. Unlike oil or most other painting mediums, watercolor does not allow you to turn back. Once you have painted one stroke more than necessary, you are on the road to ruin. Stop when you are unsure.

Don't feel you are cheating when you finish in a short time. What counts is the constructive use of energy, not the time spent. A heartening story comes down to us of a visit Rembrandt paid to a friend and patron, Jan Six, in a village outside Amsterdam. The master had been invited to a midday dinner that had to be delayed because it was discovered that the kitchen shelves contained no mustard. The host sent a servant to a neighboring village to replenish the supply. While waiting, Rembrandt made a wager with his host that he could turn out an acceptable finished etching before the boy returned with the mustard. And of course he produced a gem—*Six's Bridge*, which can be seen in the British Museum today. You might very well create a successful example of understatement in only the time it takes, in effect, to wait for the mustard.

Make understatement the goal in this experiment. Any motif is suitable as a subject as long as you make it obey the three principles just discussed. Keep reminding yourself of them until they become second nature, as automatic as the reflexes employed in tying your shoelaces. What you will make conscious in this experiment is a philosophy of art, not any specific guidepost. Let this philosophy seep into your work in general. Think of it, perhaps, as a good habit. Judge all watercolor as you judge the one done in this exercise. Has it been kept simple? Does it suggest its theme? Does it make its statement economically?

Use High Key Only

ECOGLYPH X, *by Gene Matthews, 39 × 27 in. (99 × 69 cm).*

Watermedia, rather than watercolor, best describes the components of this painting in high key. Matthews used transparent acrylic paint and transparent tissue on foil adhered to thin cardboard. Layers were scraped down, leaving paint- and tissue-stained images. The images can be read, he explains, "as below, in, or above the layer provided by the foil paper," and "below, in, or above each of the layers of paint." Light is his subject. "When working with such an elusive image as luminosity, I find it crucial to fully exploit all the factors involved, including the materials used, and try to go beyond the usual boundaries imposed. With such purposeful experiments, there is more potential to present luminosity in its many roles." Matthews' methods here produce a screenlike formation of fragmented shapes, each holding a fixed position. The light transmitted by the fragments and by the field in which they are placed glows in various intensities within a limited range of value without any strident intrusions. High key is universal. Matthews is Professor of Fine Arts at the University of Colorado in Boulder.

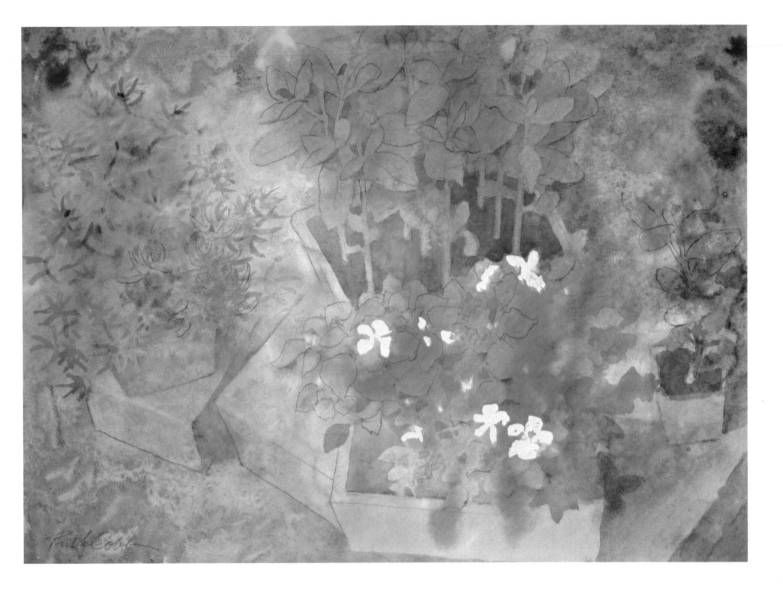

SEEDLINGS: IMPATIENS, PORTULACA, ZINNIAS, *by Ruth Cobb, 21 × 30 in. (53 × 76 cm).*

Understatement is Ruth Cobb's forte. There is nothing obtrusive in her work. She has bathed her trays of three varieties of seedlings in a mist of green, with barely perceptible differentiation between the warmer and cooler greens. Only in her flowers and stems has she allowed definition to intrude, and there it is done with subtlety. Her trays are seen clearly, but unobtrusively, as cubes. Yet the structure of her carefully planned work is unmistakable. What holds true of her colors and shapes is equally true of her value changes. They too are understated. With this attitude of reticence, she works and reworks areas until shapes indigenous to her material emerge. Flower and leaf forms begin to appear, gently identified. Recognition is always possible. Cobb's statement of the personality of her subject matter is obviously not an impromptu achievement but the result of a long process of refining images as they present themselves in the flowing of her paint. The wife of artist Lawrence Kupferman, she lives in Massachusetts.

Experiment 19

Invent a Color Scheme

Originality of palette is one of the characteristics of the artist who has found his own style. You can spot a Turner on a museum wall from a good distance. His use of color was distinctive, along with his masterly economy.

To pursue originality, study how much your habitual color schemes are like those of your contemporaries and earlier watercolorists. Then, for this experiment, break away from your accustomed choices where they seem to duplicate the choices of others. Choose new ones that may even be shocking or may superficially seem unworkable. Try them anyway. You may discover combinations very much worth incorporating in your future work.

Start by reconsidering today's motif. What colors would you ordinarily use? Put dabs of each of them on a piece of scrap paper. Rule these colors out for today! Then select an unlikely combination of other colors that you would not have thought of using for the purpose until now. Later on I will suggest how you could exaggerate this experience by deliberately making them inappropriate to your motif, but just now think about making the color scheme itself unusual.

Use pigment straight from your tubes if you like, or mix colors to give yourself a more personal combination. Just be sure to avoid the commonplace and to stick to your decisions as you proceed.

Without doubt, no combination exists that someone hasn't tried. The important thing is that it hasn't been tried by *you*. Better still, it will be one that you don't recall seeing elsewhere. For instance, if you have never used cerulean blue along with warm sepia and a bit of new gamboge, give that trio a trial. Perhaps there's novelty for you in a silvery gray made from a number of colors, contrasted with cobalt green. Use Indian yellow—or something similar—instead of your usual yellow, maybe with brown alizarin. Take something with an acid vitality, such as manganese blue, and use it with an assortment of grayed mixtures. You will know better than anyone else which combinations you find unfamiliar and daring. Look for them.

I said earlier you could heighten this experience by picking colors *inappropriate* to your motif. This will bring about two results: you will see what new effects color itself can give you, and you will enlarge your op-

portunities for originality. The material will be transformed. Here are a few random ideas.

You may have painted an arrangement of roses a hundred times, using hues as literal as possible. You would have turned to your old friends alizarin crimson, cadmium red, possibly scarlet, and rose madder. Modified greens would serve for foliage and stems. Instead of this assortment, rethink the arrangement in *blues*. Use warmer and cooler blues instead of the more obvious balance of reds. Touches of burnt sienna could provide unconventional accents. For a figure study, reliance on greens and blue-violets would give you unorthodox results. A snow scene in yellows? A sunset in grays? Give these brave concepts a try.

In any color scheme, even a novel one, you will want to be conscious of warm and cool color. Differences in color temperature will not be your usual ones when you use new color. No orange is going to look as cool as any blue, for example. But some orange tones are cooler than others. Some range, even though narrowed, exists in every portion of the spectrum.

Since you will be seeking novelty, look for places to use vibrating color juxtapositions, especially with your accents. A green sun in a rosy sky certainly would not be conventional. Yet this bold duet will give a touch of excitement that you never gave to a sky when you clung to a more traditional palette. You will find that novelty doesn't appear to be superficial when you are being true to the essence of your material.

Don't stop with the invention of one new color scheme. Keep going until you have depleted all the possible combinations that occur to you that could be used for watercolors on a single theme. Build a whole series around those color innovations. When you have tried them all, return to the scheme you considered tried-and-true before you began experimenting. It may not satisfy you now. Having enlarged your repertory of color, you may no longer be content with ordinary solutions.

The invention of color schemes is, after all, one of the great joys of painting. No other medium offers more opportunities than watercolor. All artists enjoy pushing back their own barriers in color. Without this adventuresome spirit, work becomes static. With it, something new is always possible.

Paint with Pure Color

Watercolor offers such infinite scope in the mixing of pigments—one of its chief delights—that it may come as a surprise that I recommend turning out one painting with unmixed color straight from your tubes. That's the interpretation of "pure color" to be understood in this experiment. Naturally, for most works you would mix almost all of your color scheme, exploring and improvising as you go along. Here you will be confining yourself to the contents of your set of tubes (or cakes).

Why? You will be avoiding dull, grayed, and muddy mixtures. Even when you use the grays and black in your battery of colors, they will have their full intensity. The same will be true of your earth colors. There will be no danger of diluting their purity by introducing a color that would have a restraining influence on the original color.

By eliminating mixtures that at other times might be highly desirable, you will will force yourself to make clear decisions. Does that tree trunk, for example, appear to you as umber with an overtone of violet? For once, anyway, you will have to decide between violet and umber. You won't allow yourself to mix the two.

To get the most out of this exploit, choose subject matter that you would usually handle with many modifications, that is, one for which you wouldn't squeeze paint directly from its tube without combining it with something else. A rocky ledge, perhaps. Or weather-beaten buildings. Or a human figure. Conversely, a still life might be too easy to do, and therefore less of a challenge. Apples in red, and oranges in orange would hardly be different from the customary way of handling them. A human figure in Impressionist reds, oranges, and greens—now that would be a departure for the realist from familiar flesh-tone mixtures.

Even more ingenuity will be needed in extracting intense color from a rocky ledge. Long ago you probably realized that there is no such thing as "plain gray." What looks to nonartists like a mass of gray rocks is, to you, full of colorful tints, reflections, and shadows, as well as differences in local color. You hitherto have used color, but as grayed color, to give a general impression of gray rocks.

This time eliminate the gray. Use pure color rather than grayed mixtures. Extract the color you are accustomed to use in the grayed mixture and let that color stand by itself.

Work wet-in-wet if you like, but if you do, try to avoid colors mixing on the paper so that they become grayed. Keep your colors as separate as possible. You will still get wide variety. There are all those colors in your kit, to begin with. Then the amount of water carried by your brush will create an infinite range of value. Color selection will be limited, but not variation in value. Modulations will make their appearance as they always do, since modulation is an inevitable blessing unique to the medium of watercolor.

You will be getting arresting juxtapositions. Vibrating relationships will take the place of more usual harmony. You won't be able to soften the contrast between two neighboring colors; they will sing in louder voices than they usually do. True, you may get some discordant notes, or what were thought once to be discordant. Modern painters for a century or more have realized that there can be more validity to vibration than to saccharine harmony. Look to the work of the Fauves for a precedent. André Derain said they used colors "like sticks of dynamite."

Your imagination will be called into play more often when you use pure color than when you rely on careful mixtures to get a "just right" color. You will find yourself torn between two colors, neither of which is "just right." Which will you choose? Your own sense of color exaltation will be forced to make the decision.

As you exercise this sense more and more, you should find yourself getting away from safer, more conventional choices. You will place increasing confidence in what you elect to do, as opposed to what other watercolorists might do.

A side effect could be better appreciation of the powers of your individual colors. You will see them more starkly. Whereas you formerly always mixed them with something else, you will learn how they perform alone. This may inspire you to let them have their way in future paintings. More likely you will be mixing them again in the future. Painting from pure color is not for most watercolorists most of the time. But when you do return to mixing colors, you will do so with a finer regard for their individual qualities.

Invent a Color Scheme

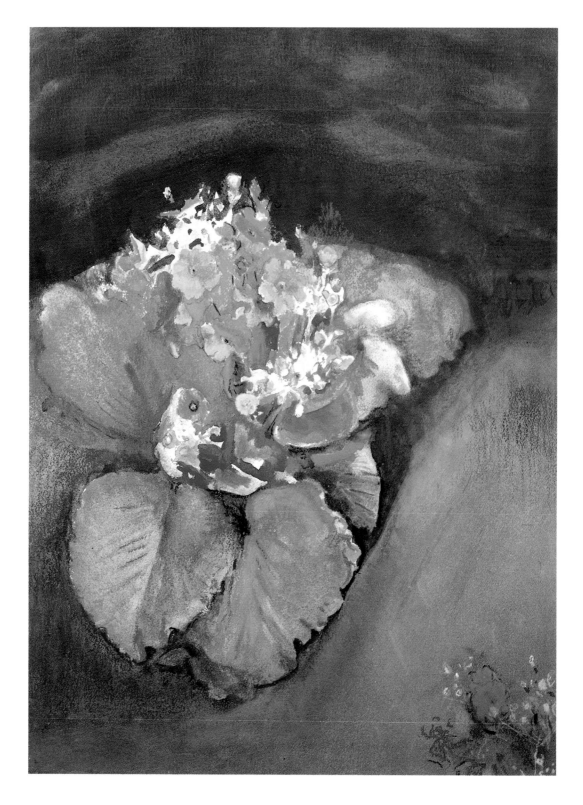

PRIMULA, *by Ian Woodner, 30 × 22 in. (76 × 56 cm). Collection of Ella Macey.*

The artist invents a color scheme as one of his departures from realism in this study of early primroses. The flowers themselves are depicted accurately, but with many improvisations in color, shape, and texture. The dramatic leap into invention takes place in the foliage. Greens are barely indicated. Instead, Woodner has seized upon colors that are unlikely to be found in nature. Cobalt blues and violets predominate, built into a mass that itself suggests a flower. With wet washes for a base, the artist has introduced stabbing hard edges toward the center of his arrangement. Thus the blues and violets gain nearly as much attention as the flower shapes. A further innovation is the dark violet/burnt umber background, silhouetting the arrangement and then echoing it as the background moves forward into the foreground. Woodner's floral paintings, as typified by this one, are highly dramatic, with the subject matter always recognizable.

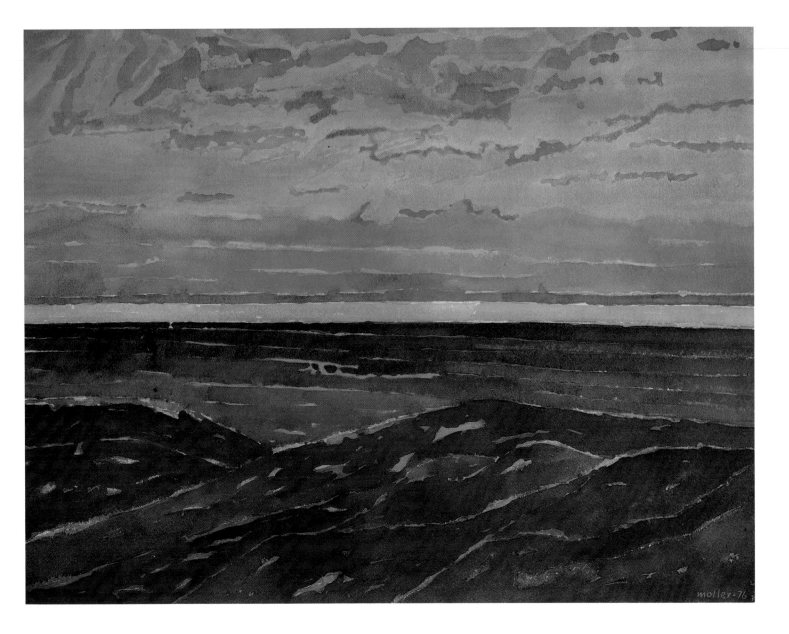

ORANGE HORIZON, *by Hans Moller, 18 × 24 in. (46 × 61 cm). Courtesy of Midtown Galleries, New York.*

This painting testifies to the brilliant capabilities of pure color. Especially in his sky and in the band of undiluted orange along the horizon, Moller has used colors with almost no modification. Even the darks that compose his sea in the middle section of the work depend for their richness on the pure light of the colors that surround them and shine through them. Moller uses a generous assortment of watercolors in tubes. Often he goes a considerable way in a painting without mixing colors, getting them directly from the tubes. Some mixing does take place occasionally where two colors meet on the paper. The vividness of his pigment is heightened by confining a color to a mosaiclike shape. Each of these shapes is neatly isolated from the others and together they build a composite structure independent of light and shadow. These mosaic "tiles" are the artist's personal signature in his work. Moller lives in eastern Pennsylvania and spends his summers in Maine.

Experiment 21

Gray Field with Bright Accents

With all the nuances of brilliant color available on a watercolor palette, it's easy to neglect the more somber range of grays. The purpose of this experiment is to expand your vocabulary of color in quite a different way than in the experiment "Paint With Pure Color." Here try to build your painting in grays and neglect the more brilliant hues until the very end.

Grays have beauty in themselves. Some artists have found them so versatile that they seldom stray far away from grays and grayed colors. James McNeil Whistler's foggy cityscapes of London come to mind. For most other watercolorists, grays serve not as substitutes for bright colors but as a means of enhancing them. Place a gray around a yellow, for example, and that yellow will shine far more brilliantly than if the gray were absent. Gray acts as a foil to other primary and secondary colors as well.

For this pursuit of the possibilities of gray, pick a logical theme, one in which atmospheric grays play a natural part. Here are several ideas. Fog—as in Whistler's cityscapes—is a popular subject, although one that is rather difficult to capture. A smoky industrial scene provides provocative material. Consider dawn or dusk. They are the times of day most often lighted by soft haze, eliminating the glare of midday and subduing the colors of the land. A colony of weathered, unpainted or shingled shacks offers all sorts of variations in grays. Going beyond these obvious choices, you could find a motif of your own where bright color is reasonably avoided. What about a dozen white eggs in a white bowl?

Which grays should you use? Most palettes contain Payne's gray or Davey's gray, or both, and there's always black. Some watercolorists dislike the black in the tube. Others make their own grays and not only do not use black, but seldom resort to *any* gray in a tube. Therefore, for the fullest possible exploration of grayed colors, it might be wise to put aside your tubes of gray for this experiment and join those who create their own grays. In addition, whatever else you have hitherto done to provide yourself with gray, do something different now.

Going at it systematically, try combining every color on the color wheel with its opposite. The pair will always produce a grayed color and some of the pairs will make what might be called a true gray. A good deal depends on the chemical composition of your pigments. See what happens when your colors combine.

Violet and yellow should result in a grayed violet. Orange and cerulean blue will give you a gray-green, similar to the combination of orange and ultramarine blue, but not so cool or sooty. Each pair of opposites will have its own characteristics.

Then try combinations of *three* colors. Cerulean blue, orange, and ultramarine blue, for instance. Or warm sepia, olive green, and thalo blue. Alizarin crimson, thalo green, and cobalt blue. Choose unlikely threesomes from your palette. Vary the quantities of the three in your mix. You will obviously get a truly infinite number of grays as well as warm and cool grayed colors.

Take a look especially at colors that are exceptionally grainy, such as cerulean blue, manganese blue, cobalt green, and cobalt violet. The grains separate out from the other combined pigments, giving a rough-textured, more interesting gray.

It takes a keen memory to keep track of just what went into every gray in a painting—but it's worth the attempt. You'll want to repeat certain grays in later paintings. Don't let yourself become frustrated in recording your formulas. If you don't get every one of them jotted down (and even if you do, how can you measure the proportions?) you can always enjoy experimenting again another time.

Essentially, a painting in gray obeys the same principles as a painting in bright color. Bear in mind, though, that you will be applying bright touches at the end of this painting process, so leave places for them. Let each one pull the eye to it, setting up a system of tension that enlivens the whole composition. These small, electric accents will stand out from the sea of grays, and will appear brighter than they would appear in a work where bright colors predominate. They will also have the effect of bringing out the luminosity of your grays. You will see richer variations in your grays, thanks to the illuminating bright accents.

This experiment, then, should extend your awareness of what grays have to offer. Have you found new ways of making grayed combinations? Have you detected more subtle nuances in the grays themselves? Have you made a mental note of heightened effects created by positioning grays next to bright colors? Gray, properly used, is never dull. It can even be said that without gray a watercolorist's palette is indeed likely to be dull.

Make Restful Areas Count

Restful passages are the concern of this experiment. Naturally every watercolor needs some restful areas. Conversely, no painting will hold together if it is composed entirely of them. You don't want to provide your viewer with a sedative. Like many other experiments here, this one doesn't exclude other elements while stressing one essential—in this case those quiet places in a painting.

What makes for quiet? Basically, restfulness for the eye is invited by fairly large, mostly undifferentiated areas of paint. Their color should harmonize rather closely with the rest of the painting, or at least with surrounding areas. A wash of light scarlet will not appear quiet in a scheme of predominant blues, yet it could seem relatively quiet amid reds, burnt sienna, and yellow ochre, depending upon how all those colors are treated. The key factor is a minimum of activity in the quiet zone.

Plan a painting in the usual way, but this time pay special attention to the areas you intend to leave quiet. Program your active brushwork and your lines and accents somewhere else, making sure to apportion less of your sheet than usual to them. Don't let yourself be tempted to invade those restful areas.

Natural places for rest are near the edges of the paper. This time, try to find other places for them as well, nearer the central focus of your design. A particularly daring idea would be to leave the center, the bull's-eye of the sheet, quiet, surrounding it with activity.

Lay gentle, high-key washes into the quiet areas. Then leave them alone. Work your activity around them. They need not be completely isolated. One restful area can melt into another, creating a continuous zone of quiet without being devoid of interest. Quiet interest is quite different from blank space. It has the quality of playing a backup role, not seen or inspected until the intense areas on your paper have commanded full attention. Then the interest in these quiet areas will be enjoyed at a leisurely pace.

Exaggerate this restfulness by increasing the intensity of your more active areas. Stop often in the process of painting to see if you have structured this contrast between the two. If you have not, give more punch to the busier sections.

Don't add secondary washes to restful areas. That would make them not quieter, but more active. The same caution applies to scratching, or scrubbing with a sponge or tissue. Just leave the restful areas as they are. When successful, you will find that they will be appreciated in their own way. The eye of the viewer will settle on them, pause, become refreshed, and then move on to a more lively passage. The change of pace makes for a richer experience. Such a combination of mood is essential in any work of art. Overall activity brings confusion and defeat. Rest is needed to give the eye time to consider and reconsider the meaning of what you have done.

In this experiment, see if you can respond to your watercolor as an observer would. Are you really aware of a balance between movement and pause, activity and rest? Does one increase the enjoyment of the other?

Gray Field with Bright Accents

SPANISH WALL, *by Vincent A. Hartgen, 24 × 36 in. (61 × 91 cm).*

A few notes of color, rather than a shouting volume, give this watercolor its special quality. Essentially done in grays and enriched blacks, with much of the white of the paper showing, the judiciously placed bright accents sparkle with exceptional vibrancy. Each is applied with a different kind of brushstroke, and the hues vary somewhat, although the artist has kept all his accents close to Indian red or Venetian red. In some places, he has allowed these warmer colors to fuse with his grays and blacks. While using wide brushes in the early stages of painting, Hartgen favors a minute 00 brush, from which some hairs have been plucked, for his final details. At this point, he often puts his painting onto an easel, working with it in a vertical position so as to get stand-off perspective. He describes his approach as "neither realistic nor reportorial, but one which accepts change as the predominating value in the face of nature. As I see it, art is not a matter of recording; rather, it is an interchange of artist and subject, the personal and the remote." Hartgen teaches at the University of Maine in Orono.

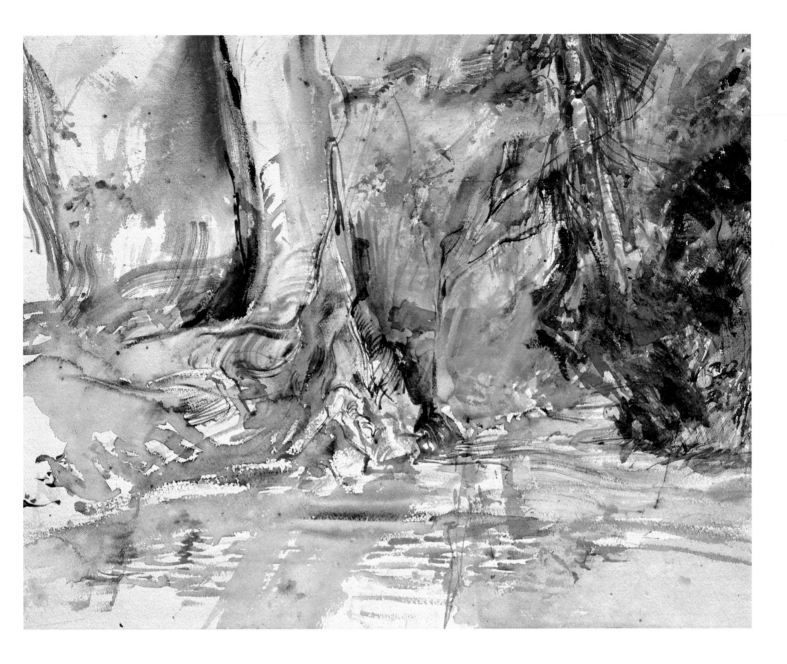

ENVIRONS OF PAMAJERA #27, *by Alex McKibbin, 22 × 30 in. (56 × 76 cm).*

By planning restful areas with especial care, the artist is able to give extra vigor to his more active passages. In this brookside motif, McKibbin has alternated the two most successfully. Not only is the water quiet, but portions of the background contribute stations of relaxation. Played against these restful zones are the thrusting movements of the tree trunks. "My brush seems guided less directly by my eye," explains the artist, "than by a kind of motor empathy with the rhythms, weight, and tensions of the elements of the landscape before me—trying always to grasp objects by their centers as opposed to just capturing their optical surfaces." McKibbin's techniques include submerging a work in progress in a tray and waiting "for just the right remoistening in order to push one color area through another, or even to try to retrieve an earlier color area from beneath subsequent ones." He says he prefers to use bristle brushes and even their metal edges for this procedure. The artist teaches at Miami University in Oxford, Ohio.

Experiment 23

Concentrate on One Shape

The purpose of this experiment is to find out what happens when you put all your emphasis on one element. In this case, the single element will be shape. As with most of the ideas in this book, this idea cannot be completely isolated. It is obvious that a single element cannot produce a painting. For example, you can't deal in shape without also dealing in color, line, and texture. Still, shape can be the one factor to focus on.

To sharpen your concentration even further, the goal will be to use only *one* type of shape, allowing yourself the freedom to enlarge it where you repeat or modify it, but not to compete with it by including some markedly different shape. If you choose squarish shapes, don't also use roundish shapes. Instead, see how versatile your squarish shapes can become.

Look at the works of Paul Klee on paper. In many, he confined himself to variations on a square. Masses of squares butt up against one another in rows that read left to right and top to bottom, but never in a rigid, mechanical way, such as you see on a checkerboard. His squares are shaped individually. Their colors are in graceful combinations, mostly in analogous color schemes, with seldom any exact duplications. They create the feeling of natural light reflected in a host of windowpanes, dancing and glinting as if the light were in motion.

Choose a shape you find challenging. It could be one that is clean-cut and identifiable, equally recognizable to engineers and artists—the square, the cube, the rectangle, the cylinder, or the cone. Another choice would be a shape seen in nature and not uniform. The shape of a pear could be a possibility—round, full, opulent, and recognizable, but with each individual pear having its own personality. Other fruit shapes, or an acorn, a raindrop, a leaf, a bud—almost anything in nature—could be used if its shape is definite. Simple man-made objects are also worth considering—bricks, doorknobs, nails, belts, boards, buttons, jelly beans.

Once you have decided on your shape, ponder all the ways you can imagine drawing and painting it. Even with only a single shape, you will soon have a far longer list of possibilities than you can exploit in even a dozen paintings. You will need to limit yourself, but do this only after you have confronted yourself with as many alternatives as you can imagine. Here are some possibilities. Your single shape can be handled repetitively, with slight variation in the shape itself. Or it can be handled repetitively, varying mostly the colors you use. Also, quite a different work will result from letting your variations be in the size of your repetitions. You could have one large shape, a few very small ones, and some in the middle range. Or a large one and a trail of tiny ones. I don't need to spell out all the possible combinations.

Another alternative would be to let repetitions of the shape overlap rather than stand side by side. Your variation could also be in value. Some of the examples of the shape could be high-key and thus recede into the distance and some could be darker and more prominent.

Do you want only one range of variation, or several? Do you want to design your paper with variations only in size (or color, or position, or value, or small changes in the shape itself) or do you want to vary *both* size and color? Or size, color, *and* value? Or any combination of the types of changes that you have listed in going through the possibilities that this single shape affords?

Your field is wide open.

Try to make your decisions in advance. Naturally, new opportunities will develop as you get into painting, and some of your earlier plans might fizzle as others develop. But starting with preconceived ideas, you will be better able to judge which of these new opportunities you should accept and which you should reject as you go along. However, be faithful to your one shape in whatever variations you have chosen. Don't let yourself be sidetracked into other directions. Your single shape, as you now realize, offers you plenty of leeway and will be as much to cope with as you will want.

Josef Albers dedicated himself for years to his *Homage to the Square* series. He actually didn't vary his shapes at all, using the same stencils to apportion his space. His variation was all in color. Even with only this one variable, he never depleted all the creative possibilities awaiting him.

Let Painted Lines Dominate

Think of this project as the creation of a forceful drawing done with a paintbrush. Whatever else you do on your paper will be subordinate to that drawing. Thus the work will have a maximum of definition and clarity. Atmospheric qualities will be kept to a minimum. This concept in watercolor has a few skilled adherents. They value the painted drawing as their *dominant* theme.

Since an important purpose of this book is to suggest alternatives, this one is included because it is comparatively rarely seen—possibly because it is difficult to do well. There is little place in this concept for the artist to obscure indecision behind a screen of virtuoso performance. The value of being brave enough to try it is in the confidence it will eventually give you in your drawing ability. Think *drawing* as you go about this project.

Choose a brush that will give you powerful lines. I would suggest a round brush, preferably sable, in a large size. A round brush is capable of holding a larger load of pigment than a flat, single-stroke brush (although I wouldn't rule out using a ¼-inch or ⅜-inch brush of this type if you don't possess a large round brush). Smaller brushes should be avoided, as they can lead you into pettiness in your strokes.

Work with dry paper. You can always wet portions of your paper as you go along when you want to include some washes. Washes, however, should be kept subservient to your primary purpose, which is drawing with the brush. The dryness of the paper will hold paint in place. You will therefore get stronger color both from the dryness of the paper and the roundness of your brush. Pigment will not spread into airy passages.

Pick a motif that lends itself to the definiteness you will be seeking—a subject that is tangible, not elusive. You have many options. As I am writing this paragraph, I am looking at an imposing, once white but now yellowed, wicker Victorian porch chair. Curlicues whirl in the elliptical openings between struts and around the ornate cane spiderweb of the blunted oval that forms the chair's back. A flattened round pillow of pink velvet lies on the seat. Triangles of tucked velvet form a wheel pattern on the pillow's face. Faded color gives evidence of the comfort that pillow and chair have given to generations of sitters. Numerous people have done painted drawings, portraits of this expressive chair, working large on full sheets of paper to convey the essence of the chair's dignity.

This type of domestic motif is often available. Animate subjects would also be just as desirable. In general, seek something that has a clear, unified structure suited to a drawing. You are out to make a *definite* statement. Coherence is essential.

Let your brush dwell on the structure. Use color to build it. Marked color changes will add interest. You could let a color in one segment of a line butt against another color in another segment of the same line. This way you get color interest without sacrificing clarity. Color creates shape too, and can be used in place of value changes.

Keep your technique consistent throughout the painting. Apply the same type of bold brushwork you used for your major shapes to other shapes you introduce elsewhere on the sheet, rather than resort to some other use of your brush. Painted lines should tell your story everywhere.

As always, you will be striving for personality in those lines. The experienced artist puts down a line with forethought. If the line slashes across his paper without variations along the way, that is because he planned it so, not because of neglect. Generally, he would want a line of more interest. Drawing with a brush is no different in this respect from drawing with any other implement. Personality shows through, giving enrichment to the viewer.

Take a look at your drawing to see if you feel you have somehow expressed *yourself* as well as being true to your subject matter. Regarding this experiment specifically, check whether or not the drawing has been largely responsible for the act of expression. Does the drawing hold interest everywhere? Are individual lines exciting in themselves? Do they contribute to the integrity of the whole?

Concentrate on One Shape

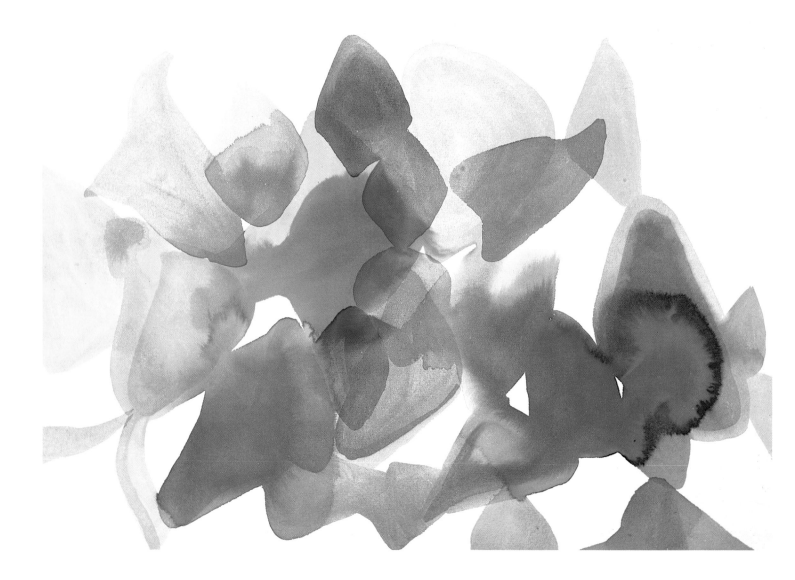

THE SOUND OF THE WIND (SACRED SPACE SERIES), *by Alice Baber, 30 × 41 in. (76 × 104 cm).*

Concentrating on a single shape, somewhat protozoan, this artist has structured an arrangement full of variety and vibration. She has superimposed some shapes and let others overlap, but most are clearly visible. In contrast, she has faded the outlines of just one. Her orchestration of color is mainly in a range of blues. The red and brown-violet shapes therefore offer pleasing shocks. Her plain background allows for a range of value changes, and lets each shape be seen with lucidity. The work is trans-fused with the transparency of watercolor, illuminating a colony of forms floating gracefully. Thus her deliberate economy in the choice of one shape granted her the utmost freedom in all other directions. Baber, who has traveled in South America, enjoys working with "tropical light, when possible by water." In her New York stu-dio, she remembers "the light of my travels."

Let Painted Lines Dominate

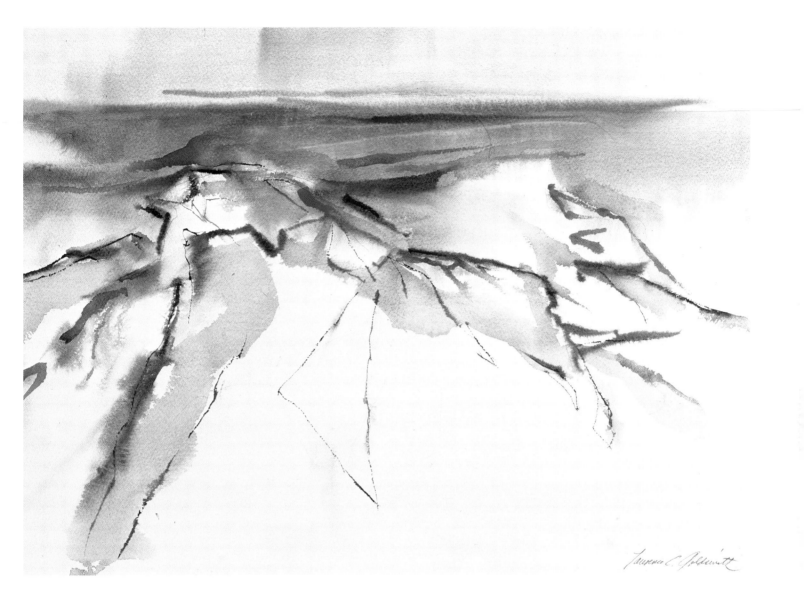

DEFIANT LEDGE, *by Lawrence C. Goldsmith, 18 × 24 in. (46 × 61 cm).*

Painted lines dominate this conception. The idea was to see if both the jaggedness of the rocks and the surging, swelling motion of the sea could be expressed in line with a minimum reliance on washes. The washes mainly serve as an underlying support for the horizontal linework that establishes the sea (with an echoing line in the sky). Those sea lines are purposely heavy in contrast to the finest of lines used to suggest dry rock masses. However, other rock masses, especially those in zig-zag patterns breaking through the surface of the surf, are rendered heavily. Variety in strength was intentionally created for greater interest. The initial decision to concentrate on line had an emotional target—to establish the drama of rocks defying the incoming sea. Lines could quickly convey that sensation. Color has its role in this painting, but lines dominate.

Experiment 25

Paint Without Drawing First

Artists have so long been saying that a painting is never stronger than its underlying drawing that we wouldn't be surprised to learn that the master of the cave dweller school delivered that message to his pupils at work on those charging beasts scratched and then dyed on the cave walls. There's no quarreling with advice on the primacy of drawing. It *is* sound. Having said that, I am now proposing that you for once ignore the advice. In this experiment, produce a watercolor without any pencil drawing to guide you.

What do you stand to gain by this deliberate neglect of standard procedure? First, you will be forcing yourself to compose a purely mental image of your ultimate painting, without depending on lines of drawing that "will take care of things later" in an area you're not sure of from the start. You will need to visualize every area in advance. You will have thought through your problems before they arise.

But suppose you don't succeed in this utopian endeavor? Suppose your work doesn't proceed quite as planned? Then you can take advantage of the second asset of this experiment: not having a drawing leaves you much freer to change your concept in midstream. Some highly successful watercolors—probably including a few of your own—have resulted from the artist having reached an impasse. His original concept has been blocked—perhaps by his ineptitude, but more likely by unresolved problems where the solution seemed to lie in another direction than that of the original plan. Again, a happy accident might be the stumbling block, presenting an unforeseen opportunity too good to miss. What to do? Plug away at the original idea, or embark on a new course?

The artist who sees the impasse as a turning point rather than as a barrier may be breaking new frontiers for himself, making the daring decision to replace his earlier concept. His new concept could be a matter of a different color scheme. He might decide to bathe his composition almost literally in one range of color, discarding other colors previously planned and used. He might, more drastically, even change his subject matter. What appeared before as a minor note, nevertheless interesting him greatly, might be enlarged so that it takes over his full space. Or he might transform the mood of the work. A quiet painting may become a stormy one, or vice versa.

Of course it goes without saying that change of concept requires a good deal of thought. You can't *keep on* changing your ideas in the process of making a painting without producing a hodgepodge. One change of direction is enough. But in this experiment, there's no underlying drawing to hinder you from taking the liberating step of changing your concept.

Occasionally working without a drawing has an additional advantage for some artists. They are the ones who suffer, perversely, from drawing too diligently. You have no doubt seen people, students as a rule, spend such a long time over a beautifully explicit drawing that it seems a shame to cover it with paint. Watercolor does partially obliterate any drawing. Very often the person making the careful drawing is more skilled with a pencil than with a brush, and his watercolor doesn't measure up to his drawing. He needs to be encouraged to rely more on pigment. For him, doing without a drawing is something like amputation—a necessary piece of surgery to get him to develop his other skills. And even those whose dependence on pencil drawing is not excessive benefit from an occasional opportunity to let the brush do the drawing. By its very nature, the brush is bolder.

But remember that even in a painting done without a preliminary drawing, you will still have to go through every step except the first one. You will simply have to imagine that step without actually taking it, and you will be deprived of its aid in taking the remaining steps, so that you have to take them without guidance. This will leave you to pursue your *mental* sketch of your idea or to be free to depart radically from it at some point along the way.

Change Colors Only Slightly

The idea of this approach is a simple one: work out a plan for a watercolor that will have the novelty of using a very, very narrow range of color. Pick any color that appeals to you. Then use that color and slight variations of it. Your painting will look as if it came from only about thirty degrees on the color wheel. Or think of the color wheel as the face of a clock. Use color, say, from only five minutes past the hour to ten minutes past.

What do you gain from this?

Because your watercolor essentially will be a vast expanse of a single color, its impression will be undiluted. Yours will be one big color field with plenty of impact at first glance.

Furthermore, you gain a technical advantage. A successful watercolor always embodies restraint in some direction. You can't put everything in a single painting without creating confusion, with one factor battling another—you can't have a multitude of color changes, value changes, differing brushwork, linework, and a full arsenal of stunts in technique, just as you can't successfully put in *all* the subject matter of one scene. For example, you know that you defeat your purposes by including in a seascape not only sky and water, but boats, people swimming, and, on the shore, wharfs, shacks, billboards, rocks, fences, islands, clouds, that seaplane, a couple of bridges, gulls, herons, sandpipers, shells, and that cute dog sitting on someone's bicycle. Too much! So you select.

Just so, you must limit your technical components. By cutting down on one component, you give yourself more freedom to exploit others. Here you will be narrowing your range of color. That allows you wider versatility in *applying* your paint; you can use a rich mixture of techniques that both you and your audience will enjoy. Here's a chance to let loose, employing skills you cull from other portions of this book as well as elsewhere.

You can also practice subtle variations of the one color you have chosen. Hewing close to that small segment of the color wheel, you still have many chances to exercise your color sense. Let's say cadmium red is your basic color. You can inch over to the red-violets on one side and the red-oranges on the other. You can gray your reds, using a touch of thalo green. You can

use other, closely related reds, such as rose madder. Then you have the infinite scale of values to work with, from the red as intense as you can get it to a tint that barely breathes red. Your variations will extend only through a narrow range, but within that range the possibilities are plentiful.

Since restraint with color opens the gate to freedom elsewhere, your painting can be enriched by the use of a combination of technical devices that will give tactile interest without making your work too busy. Try spatter, perhaps together with drops that you let run, and maybe a network of small lines. You could use salt, knife marks, and masking liquid (frisket). You could use your brush negatively as well as positively, painting shapes from the outside. None of these devices is synonymous with monochromatic painting but, on the other hand, none need be considered out-of-bounds. The point is that you can use more of them in this kind of work than in other types that may already be very complex because of your use of color variety. For further guidance on these techniques, see experiments forty-eight through sixty-four for Experiments in Technique.

Your technical devices will help you find the action you want in the painting, but its mood will largely be determined by your initial choice of color. Colors have integral moods, and when you cover your paper with a field of one color, there isn't much you can do (or would want to do) to alter that mood. It wouldn't be easy to make a somber work of art from it if you choose cadmium red, but it could be very boisterous. You would have to pick a quieter color for a somber work.

You might find it rewarding to paint a pair of watercolors as nearly identical as you can make them, in every respect except color. Use a quiet color for one, and a loud one for the other. There's bound to be sharp contrast in the moods that you create.

In any monochromatic painting, your concern should be to keep it monochromatic while you use your freedom in other areas. In viewing your finished painting, ask yourself if you have kept this principle. Have you found sensitive, pleasurable variations of color within your narrow range? Have you made the most of your opportunities to indulge in the assortment of techniques that concentration in color made possible?

Paint Without Drawing First

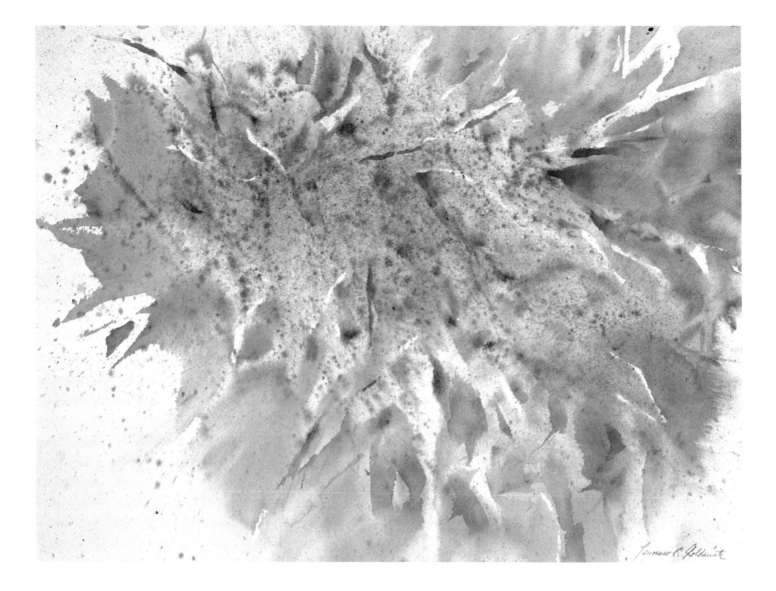

LICHEN-STARRED, *by Lawrence C. Goldsmith, 18 × 24 in. (46 × 61 cm).*

Started without a drawing to guide it, this watercolor was free to develop pretty much as the flow of pigment dictated. It did begin with an idea. Lichen quickly coats the bark of dead trees—in this case a copse of spruce—with a film of silvery green. Fog perhaps encourages the process, especially in coastal Maine where this painting was made. To capture the haunting quality of lichen on these dead trees became the challenge. The first step was to flood in a large wash over most of the paper, using grays, grayed blues, and modified greens. Then paint was lifted by strands of folded and twisted facial tissue, to suggest light-drenched boughs. Pigment was spattered while the wash was still wet and as it began to dry. These impositions began to evoke a mood, and the rest of the painting process was devoted to heightening that mood. With no drawing to inhibit the artist, drastic changes could be made. The focus of interest, for example, began to seem more logically placed near the top of the sheet than lower down. Spotting a whirl of warm-colored accents helped to make this change. More spatter was then added. The process came to an end while the flow of paint was still in command, and the mood of the lichen seemed to pervade it.

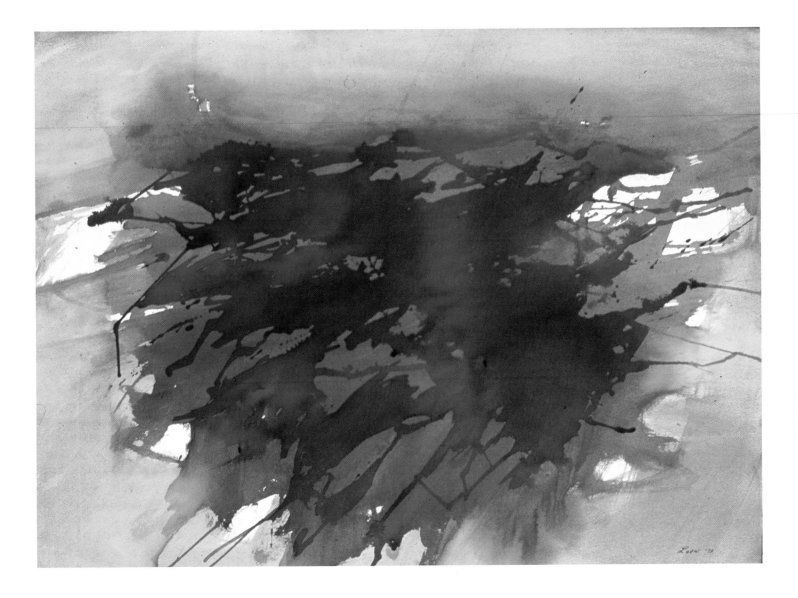

RED ECLIPSE, *by Michael Loew, 22 × 30 in. (56 × 76 cm). Collection of the author.*

This painting illustrates the powerful statement that can be made when one works within the limitation of a very small color change. Loew has chosen here to restrict his palette to a reddened earth color, exploited with infinite variations in value. These range from the pale tints of the surrounding areas to the very dark values of the prismlike shapes that are collected in the central mass. Middle values unite the mass with its pale outskirts. Lines in the same color, with large, irregular patches of white, help build a feeling of structure. There is a suggestion of the face of the earth as seen from afar. The only color change is in the ochre tones of the top left corner of the work, and even these veer only slightly on the color wheel from the dominant color. Loew, who paints in Maine when he is not teaching at the School of Visual Arts in New York, likes to develop a series of watercolors rather than confine himself to a single work. He will come back with new thoughts to a recurrent theme, even after considerable time.

Experiment 27

Convey a Gray Day

Can you capture atmospheric conditions without resorting to trite symbols? That is the problem to be faced in this undertaking. Specifically, the concept here is to convey the mood of a gray day, relying entirely on your colors and values and, more especially, on the character of your strokes. You don't need a prop like a puddle in a street gutter reflecting overcast skies.

Some hints have already been covered in the experiment "Gray Field with Bright Accents." An abundance of richly varied grays and grayed colors that you mix yourself is a prime necessity. A painting of a gray day is expected to be a gray painting (although it need not be). But the use of gray alone will not express the full nature of this kind of day. Other artistic measures are needed.

Before planning your painting, review the characteristics of a gray day that set it apart from other days. Its light is soft rather than crisp. There is no direct sunlight to separate light from shadow, so everything is bathed in a relatively consistent middle value. The mood is quiet rather than full of excitement. Intimacy of view takes priority in the grayness. A farther view is made impossible by the thick weather, since distance is shrouded in cloud or fog. One is more conscious of what is happening close by. White light forms a backdrop that focuses attention on the immediate scene.

The way you handle paint and your choice of colors will determine how you express these characteristics. To get the softness of the light, keep your value range rather narrow. Light-to-middle values will be most effective. Work wet so that one wash can flow smoothly into another.

Quiet can be achieved by using your brush to create gradual changes in color and value, as contrasted to impetuous, independent stabs. Let your brush speak quietly. Soften edges of darker strokes even more often than you would do ordinarily. Blend passages to join one another instead of letting them stand in isolation.

There are many ways of achieving intimacy, but the characteristic they have in common is that more concrete details should loom out of the gray atmospheric background. Details, realistic or not, then come at the viewer as fleeting surprises. Perhaps, he imagines, they will disappear into the mist as suddenly as they arrived. Such details belong either in the center of the watercolor or in the foreground. For example, on a gray day, no sharp detail would appear on the horizon. By definition intimacy is near at hand.

As mentioned, grays would be a first choice among colors for the purpose in mind. Not just one, flat gray, but a wide assortment. The artist's ability as a colorist can be judged by the extent of his palette of grays.

You can go beyond grays and still produce the mood of grayness you are seeking. Colors of brighter hues used in very light washes will give the atmospheric effects that dominate a gray day. It is only when they are used in heavy saturation or in vibrating contrast that they are unsuitable. Then they have the crispness of a day drenched in sunlight. Even a series of light washes in yellow might summon up overcast weather. It would be worth a try.

Grays used along with primary or secondary colors will, of course, extend your range of possibilities. Generally hues that are neither extremely hot nor cold will serve best. Try others if you like, but be prepared to moderate their temperatures (cooling the hot colors, warming the cool ones) if necessary.

The very softness of a gray day presents the artist with hazards. You don't want a work that fades away in all areas. Your skill will be in finding details and passages in color and value that give the viewer *some* definition with which to appreciate the softness of the rest of the work. Sources can be found in nature, like the ripe berries that look even brighter on a gray day. By paying attention to those accents and handling your washes gently, you will get at the essence of the weather. The painting will have a persuasive unity, despite its general mildness. Unity is perhaps more difficult to achieve under such conditions, but you aren't looking for easy ways out.

Convey a Bright Day

In the same spirit that you used your ingenuity to create the impression of a gray day, use this experiment to test ways of expressing a bright day. Again, try to avoid subject matter that bluntly tells the viewer what he is seeing. Obviously, a glaring sun turning buildings into cubes of dark and light will signify the artist's intention without any guesswork. Can't this be accomplished more subtly? Basically, a bright, crisp, sunny day is expressed by bright, crisp, sunny watercolor devices. These are the devices to lean upon. Once you recognize them, their use should be relatively easy.

Try to examine your full range of skills to see how those adjectives might apply to them. This will require considerable thought, because so much of what we do is generally unconscious. Still, it can be done. Look at a number of your watercolors and examine objectively this brushstroke as compared with that one, this wash as against that one, and so on. Is this stroke a crisp one, or is that one, or are neither? Maybe you will have to invent a stroke of greater clarity. Does this juxtaposition of two colors give a sunny feeling? Which is the brighter of these two colors? Ask yourself questions like these.

Study the problem another way, too. Analyze areas of those paintings for their total effect. Visualize each area as if it were separate from the painting as a whole. Then ask yourself if you would be able to use similar techniques to express a day we have described in those three adjectives, "bright, crisp, and sunny." If the answer is "yes," see if you can define exactly what you did to create that general effect. Conversely, if the answer is "no," perhaps you'll be able to detect ways in which you could alter your techniques to get what you want in this experiment. In general, you need quick, decisive brushwork and intense, vividly contrasted colors. Finally, you need marked value changes.

When you have fully analyzed the *quality* of the ingredients that will go into your motif, pick your specific examples and then plan your painting. In your design, include an array of movement. Movement suggests brightness, joy, zest. You won't want much quiet in this one. Think of the exhilaration you feel on a sunny day and give vent to it with your brush. Diagonals are helpful, as are exuberant swirls.

As for colors, emphatic ones anywhere along the spectrum are congenial choices. Don't automatically rule out grays and earth colors. You wouldn't want them to dominate your composition, yet they can be useful in intensifying the brightness of other colors when placed next to them. Gray brings out luminosity in yellows, for example.

The Impressionists, who were dealing with glints of pure sunlight, turned away from somber hues as a rule. Here and there, however, as in many of Cézanne's watercolors, they used them to enliven the impact of clearer colors. See if an occasional touch of this sort will make the general impression of your painting brighter.

You might also follow the Impressionists' example by leaving bits of white—that is, accents created by the whiteness of paper left unpainted. There is nothing brighter than pristine white. ·

It goes without saying that subject matter can help create a mood. Look for material that suggest sunniness to you personally. Avoid the obvious. Let cheerful light tell the story for you, no matter what objects you have chosen.

Overworking is always a bugaboo. It is especially destructive when you are striving for spontaneity, as you are here. Better to quit and use another sheet of paper if you start overworking your theme than to attempt to rescue a painting that has gone too far. Look carefully at your work when you come to a moment of indecision. Perhaps you have already accomplished what you set out to do. Have you a brisk, glittering image? Then you have done a successful job of trapping a sunny day.

Convey a Gray Day

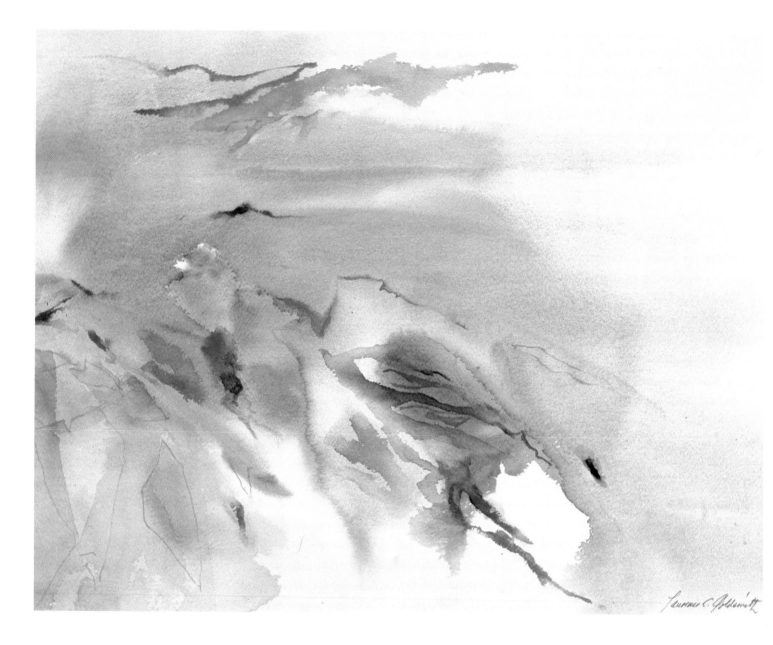

JAGGY COAST, *by Lawrence C. Goldsmith, 18 × 24 in. (46 × 61 cm).*

A gray day is suggested more by the tones of this painting than by any of its prominent features. Colors of fog pervade the sky, and the sea has the leaden stillness typical of overcast weather. Even the rocks in the foreground are bathed in quiet light. Having established this mood, it was possible to play more freely with the colors in the sky and in the reefs and to dwell on their jagged shapes. Greens, blue, red, and earth colors were introduced. A variety of brushwork was used. Clear edges and minute lines are counteracted by strokes of spreading pigment, done wet-in-wet. This variety suggests the sharpness of rock formations, seen one minute and half-hidden the next by incoming waves. The painting was done on a small island off the coast of Maine where the sea is never still. Even when its surface is quiet, underlying power is always evident. Response to this power dictated the use of the strong diagonals in the lower half of the painting.

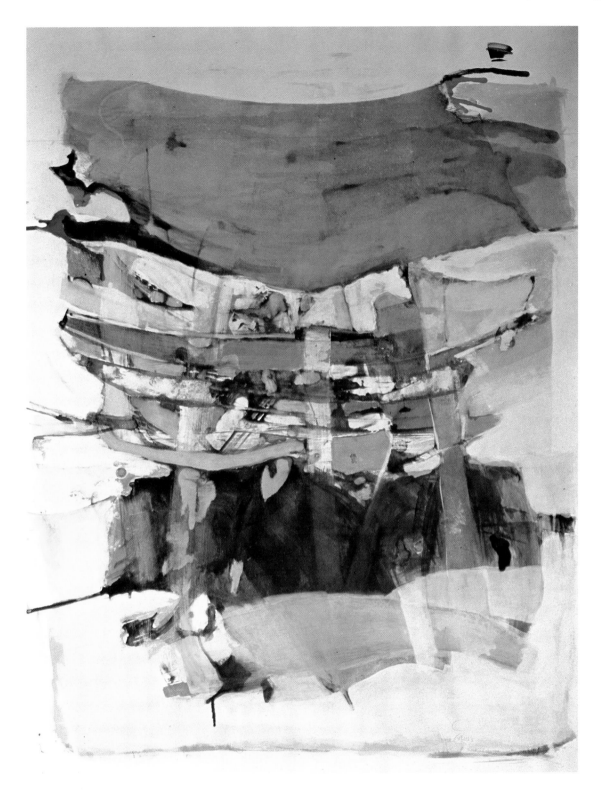

COLORADO SKY WITH ORANGE, *by Joyce Eakins, 40 × 32 in. (102 × 81 cm). Collection of PTI Corporation.*

Sunlight pervades this painting, yet the artist resorts to no familiar clichés. In fact, cool blues and greens occupy far more space than the warmer colors usually associated with a bright day. What gives sparkle to the work, in part, is Eakins' lively placement of bits of red, pink, and orange. They vibrate against the cool colors and play an active part in the painting. Her painting concept and process are "far from the traditional watercolor technique. Technique is never an end in itself—only a means to an end. Content is of utmost concern. I use a variety of water-soluble media; acrylics, permanent inks, dry pigment, pure watercolors, pastel, and anything else that is handy and might create an effect I want to achieve. My tools are brushes, brayers, squeegees, fingers, sandpaper, paper toweling, etc. I work on dry surfaces, wet surfaces, wet and dry surfaces combined, scrubbed surfaces, surfaces made to resist in some way, and on surfaces made to absorb."

Experiment 29

Aim for Pure Abstraction

Abstraction as a goal is frequently cited by watercolorists who feel hampered by particulars. Brilliant, untrammeled work has been achieved in abstraction but total abstraction is a goal seldom fully realized. It implies the avoidance of any even faintly recognizable subject matter, replaced by the artist's own inventions. But can a human being visualize a shape that isn't anywhere in nature? His inventions must be derivations of things seen or remembered in his unconscious mind. Here we will consider abstraction as painting without *deliberate* use of known material. The object is to get as close to pure abstraction as is possible.

When you attempt to avoid recognizable subject matter, what is left to consider? Everything. All the fundamentals of composition and design come into play—value, color, balance, motion, texture, and technique. More, not less, attention must be given to them than ever. The artist cannot rely on subject matter to cover up inadequacies. Every element in his work is conspicuous.

Let's say the artist wants upsurging movement. Falling back on subject matter, he might paint one of countless *things*. But without dependence on real objects, he must devise ways of using his *paint* to carry the eye in the desired direction.

Abstraction thus embodies a maximum of artistic effort, which will be apparent in the work. Philip Guston, who went through a period devoted to lyrical abstractions before he returned to figurative painting of people and objects, said he went into abstraction because recognizable art *excludes* too much. What he meant is that it can gloss over emotional exertion. "I want my work to include more," he said. "And 'more' also comprises one's doubts about the object, plus the problem, the dilemma, of recognizing it."

Executing an abstract idea, then, cannot be a haphazard venture. Give all your elements careful thought. Despite this need for premeditation, or possibly because of it, creation of your own shapes and color arrangements can be sheer joy. There is excitement in pioneering on a path untrodden by anyone else.

Here are a few hints. A satisfying abstraction works pretty close to the picture plane. Anything that takes the eye deep into the distance tends to pull it away from the artist's network of shapes and colors,

and atmosphere begins to take over. The viewer starts to contemplate realistic forms in a natural setting. One way of avoiding this movement into depth is to be wary of cool blues. They suggest sky or distant water. Some abstractionists get around the problem by always enclosing blue areas in warm color, and others avoid cool blues entirely.

Definite shapes are more useful than fuzzy ones. Your objective is to make original shapes. If you begin to see gulls or rhinoceroses on your paper, imagine what more literal-minded viewers will find! Try to make all your shapes unlike anything seen in nature.

Organize shape, color, value, movement, and balance as you would in planning any other watercolor. Develop the painting in the same fashion, but make your total concern the relationship of one element to another.

Proceed slowly from step to step. Stop at a sensible point (when you don't have to consider wetness or dryness of your paper) and assess the relationships. What, if anything, do they need for strengthening? Is there a balance in their weight, color, and vigor? One way of testing this is to view your paper upside down and then view it standing on either side. An abstraction is more likely than other kinds of paintings to work as well from another direction as it does from the one in which it was planned. It could be equally effective upside down or when either side is switched around to become the base.

People joke about an abstract painting being hung upside down, as if the artist didn't know what he was about. But the painting could look well reversed just *because* the artist knew what he was about. (Even when your painting doesn't look quite successful upside down, the new perspective should enable you to spot things in it you otherwise might have missed.)

Keith Crown, whose work is illustrated in this book, often signs a painting on two or even three sides. He explains that this compels the viewer to devote his energies to looking in several different directions, making decisions on his own instead of relying passively on the artist.

By focusing your attention on other elements besides subject matter, your concept of painting will become freer and more individual.

Use Mostly Hard-Edged Shapes

Simplicity of shape and clear definition are two aspirations uppermost in the minds of artists in watercolor who desire to make their statements loud and clear. To do this, they compose with large, strongly painted—even flatly painted—shapes and lean toward hard edges. The emphasis in this experiment is on those clear hard-edged shapes above all else.

Milton Avery's watercolors set an example. His work is unique. He followed his own bent, and his clear shapes are eminently worth studying by growing artists. Avery would take the shape of a sheep, a chicken, or the brow of a sand dune and simplify it, letting it occupy a major portion of his space. He applied color—original in choice—rather flatly. His positive shapes were crisply outlined against background shapes and were also flatly rendered for the most part.

Another use of large, clear shapes was developed by Raoul Dufy. In his watercolor work, he planned huge background panels, often rectangular, in brilliant color. Bright reds, oranges, sometimes Prussian blue. Then on top of these panels he would boldly and economically draw his specific motif with a brush. Thus he would transform very familiar material. There's no mistaking his harbor scenes and cityscapes. He made the subject his own.

Your own experiments with hard-edged shapes will benefit from the use of cold-pressed paper. The smoother surface of cold-pressed gives less diffusion than rough paper and your edges will have sharper definition. This is especially true when working with your paper dry.

You may want to *start* wet, floating in light background color and letting that dry before you proceed to paint your large shapes on top of the wash. You could do without the underlying wash if you keep in mind the brilliant effect the white of the paper will have on your completed design. Unpainted paper may be more powerful than any painted section.

Plan the apportionment of your space carefully. Hard-edged shapes quickly take on importance. When you want maximum clarity, you will have little opportunity for scrubbing out or for softening with clear water.

Choose material that lends itself to largeness. Like Avery, you can select uncommon subjects or, like Dufy, familiar ones. Whatever you pick should be presented in a prominent way. True, a small shape can be effective, but only when it looms large because you have surrounded it with vastness. A small figure, treated simply, will attain dominance, for example, when there is no clutter to interfere with it. Abstract shapes can be handled in the same way. In general, stress large shapes.

Use clear color. You are seeking clarity. Grayed or muddied colors, often useful for other moods, will not suffice here. Emphasize color contrast, too. A harmonious color scheme will give you less startling qualities than colors that are opposite on the color wheel. Opposite colors are a good deal more difficult to work with, of course, but well worth trying. Courage has its rewards.

Softening edges with a damp brush is standard procedure in most watercolor painting. Its importance usually can't be overemphasized. Here, for once, go easy on it. Hard-edged painting is an exception to the rule. Soft edges are what you don't want—at least on most of your paper. Let your edges stand free and clear.

More often than usual, your accidents will show conspicuously. Don't let this discourage you. If you can turn them into shapes that contribute to your purpose, fine. If not, there's always the option to start anew with a fresh sheet of paper.

What can massing of hard-edged shapes do for you? If resolved, they will build a strong structure. One shape will vibrate against another. When the shapes are closely related, they won't seem isolated; together they will contribute to one unified impact. When you are finished examine your work to see if you have achieved this impression. See also if you have made strides in defining your shapes without their edges fading away.

Aim for Pure Abstraction

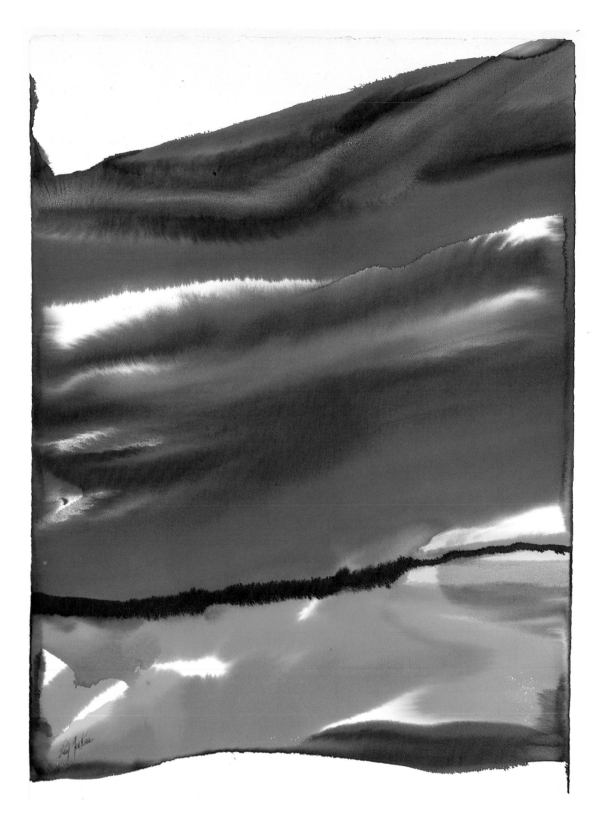

PHENOMENA BUCK ISLAND NEAR, *by Paul Jenkins, 43¼ × 31⅛ in. (84 × 79 cm). Courtesy of Gimpel & Weitzenhoffer Ltd., New York.*

Abstraction, as this artist sees it, is a distillation of reality seen without recourse to local color or superficialities of subject matter. His concern is with color as phenomena. In his terms, "For me the color spectrum is a means of finding what I experience from outer nature as well as inner nature. Color is a fact of science; it is not an abstraction in itself and color variables which reflect and stratify in the prism have become my constants. My paintings, then, are extractions from nature. I think of them as concentrates from reality." Guided by his philosophy, he produces watercolors that are at once lyrical and bold.

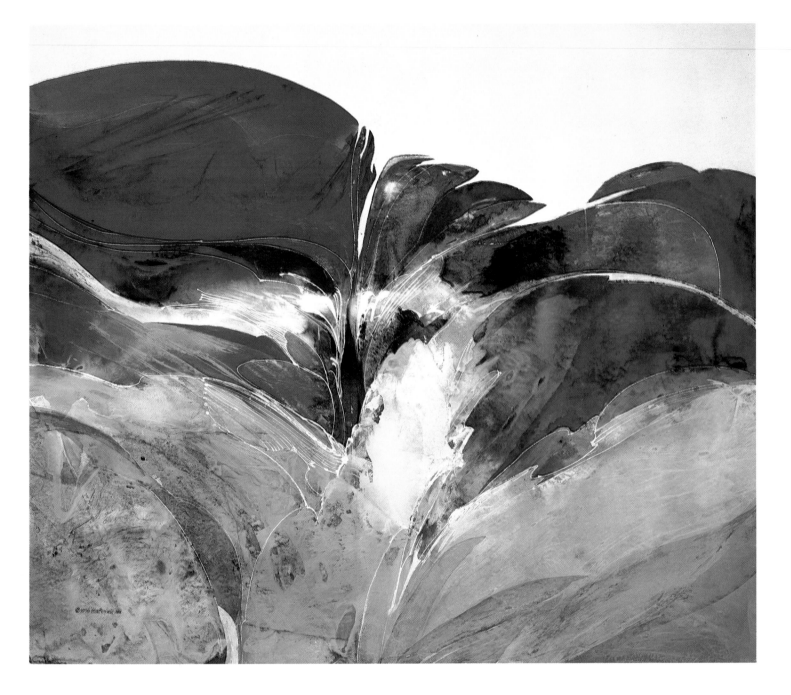

RETURN TO LIFE, *by Maxine Masterfield, 40 × 46 in. (102 × 117 cm).*

Massiveness and lyricism are usually considered opposing qualities in a painting, yet here the artist has combined them in a uniquely successful way. Working with an abundance of massive, hard-edged shapes, she has unmistakably struck a lyrical note in the work as a whole. Her dominating hard-edged images are offset by the most fragile lines sweeping out from the center and the modulated light areas lower in the painting. The artist reveals that here she was inspired by Georgia O'Keeffe's larger-than-life flower forms, but her subject matter is her own. She prefers to let her paintings take their own course. "Although the painting is accidental in the beginning," she says, "I work toward a design that suggests a subject." Her method of encouraging happenstance is to work on a table that she can spin and tilt. Once she finds a desirable direction emerging, she obviously exerts a good measure of control. She feels her work has been influenced by her study of Oriental drawing and classical piano music (she listens to classical music while she paints). She lives and works near Cleveland.

Four Variations on a Theme: I

Settle on a favorite motif. Return to it again and again. Look for new things in it each time, or develop previously observed elements in a different way. Most likely you will feel you can never exhaust its possibilities.

I spend summers on an often-painted island. One of the artists there—one who has put in more than two dozen seasons—was naively asked by a visitor how he could keep finding paintable scenes on the island (it is one and one-half miles long). The artist replied with no hesitation, "Take this meadow where we are standing. One could paint it every day of one's life and still not run out of ideas."

You don't have to search far for precedents in the history of art. Those who come to mind immediately are Monet with his pond at Giverny; Cézanne and his "own" mountain, Mont Sainte-Victoire; Jim Dine's hearts; Andrew Wyeth's billowing curtains; and John Marin, who bought a Maine coastal island, named it Marin's Island, and presented it in watercolor again and again, each time in a new light.

If you haven't yet gone back to one of your own chosen locales or bodies of material, do it now. Even if you have already done it, try a new series. Four paintings is merely a random figure. A dozen might be more rewarding. Try to look at your theme each time with new eyes. You know it literally, so view it instead with your mind's eye. See it as productive of original concepts rather than for its conventional pictorial virtues. Make it your own motif.

The watercolors shown here may give you suggestions to apply to your own work, but, better still, draw on your recent painting experience. See how ideas you have developed elsewhere can be adapted to this theme. What you have hitherto seen in one way, now look at in others.

The scene from which my four watercolor paintings are derived is a rather typical Vermont countryside vista, which you can see in the accompanying photograph. In the distance is a range of imposing mountains, dominated by one that I humbly call my own Mont Sainte-Victoire. Closer at hand are rolling hills, wooded for the most part, but broken up by a patchwork of farm fields. The woods are neighboring wedges of conifers and rock maple. Through the fields runs a river. Then, in the foreground is a swamp, rich with clumps of grasses in ochres and other earth colors, bordered by tillable fields and large expanses of brush. Marsh marigolds sing with yellow in the Spring, scraggly berry bushes afford accents in alizarin crimson, and grasses give a variety of surface texture.

Too much to paint? Of course. Too much, that is, to compress into a single painting. For that reason alone the scene—like almost any other scene you might choose—lends itself to a variety of treatment. Each time you return to it there are other elements you can concentrate on and exploit. Selection is always the first consideration.

In the first of the four variations, I stuck fairly close to the actual geographic divisions of the view. The hills, a glimpse of the river, and the expanse of the nearby vegetation approximate the proportions they actually have. I have disregarded the farm buildings in all four variations. Not that they are devoid of interest. Other artists might fasten upon their homespun shapes and planes to the exclusion of almost everything else. I am more taken with the romantic qualities of the natural elements and therefore selected them.

While not deviating fundamentally from the structure of the land in *Head-on Prospect*, I did take liberties with color. The central, dark band of hills is executed in deep blues, not wholly invented but departing from the actual blued greens of the trees. The foreground shows further deviation. Brush is merely suggested in warm hues alternating with soft blue grays. The sky echoes those colors, with an accent of strong red and another of strong blue, with warm sepia clouds offering a variant to add interest. These colors were chosen to create a harmonic whole, true to the feeling of the scene, but not to literal truth.

Actual scene from which the Four Variations were derived.

Four Variations on a Theme: II

When you emancipate yourself from allowing subject matter to dictate results, you must activate your imagination and let it play freely with the suggestions that present themselves. In this second variation, I was even more concerned with the romantic balminess of the rural scene than in the first painting. This became my paramount purpose. All else, including fidelity to the actual scene, had to be abandoned.

In painting an emotional work of this kind, I was immediately faced with a hurdle: how could I be romantic without becoming banal? It is all too easy to slide into the sentimental, soft, prettified version of a pleasant scene. Fortunately, the fanciful fluidity of the medium of watercolor lends itself readily to a *personal* expression. When you allow your paint to flow freely, it will inevitably reflect your own mood. Your own emotions begin to show on the paper automatically, although not consciously. A tighter rendering will be a more conscious effort. It is then far more difficult to avoid a stereotyped product. With these considerations in mind, allow your paint to flow freely. Develop and extend what takes place on your paper. You will begin to get an exposition of your feeling that is both genuine and highly personal.

The painting *Soft Focus* is an attempt to do this. The chief tool employed was quantities of water. Paint flowed across the paper and swept down in wide arcs as I tilted my block of 140 lb. d'Arches, rough. I then injected large drops of colored water, contrasting in color with the major wash, and allowed them to spread. I later defined these more carefully to suggest trees on the lower hillsides, usually painting negatively, from the outside of the shapes.

Then I painted in blues and grays in irregular patterns above the lighter washes. Painted when the paper was becoming dry, they are comparatively more definite than the lower shapes, yet they are not sharp and dry. They still spread in many places. I used deeper pigment for those blues and grays than in the lower sections. Because they are drier and deeper, they make a stronger statement—one I needed to give a sense of structure to the top of the hills. Compositionally, they anchor the lower areas and keep them from fading away. This was necessary because the tone of the entire painting is soft. My aim was to express the dreaminess of the hill and valley—this was an emotional response of the heart, not the reportage of the mind. Dreaminess is soft and elusive, hence I kept the technique soft throughout. Yet elements are always needed to hold a painting together, even a deliberately soft painting.

The color scheme was purely a personal preference. I paid little attention to the actual colors of the scene. In spirit they were there (in most scenes in nature, any color can be found if you look diligently enough). But the decisive factor was whether or not a color on the palette would help identify the emotion that was desired.

I chose the grays, including those with blue overtones, for another reason as well. Gray is often an antidote to clear color. It has a calming influence on the portion of the paper where it is applied. This allows for the purer colors to shine more brilliantly in *their* places. Also, the passages of purer colors are less likely to compete with one another when there is an oasis of gray to give the eye some rest. Grays in this painting are not completely isolated. They thread into the more brightly colored areas, so there is some give-and-take between rest and activity. This was done to preserve the overriding softness of the painting as a whole.

Four Variations on a Theme: I

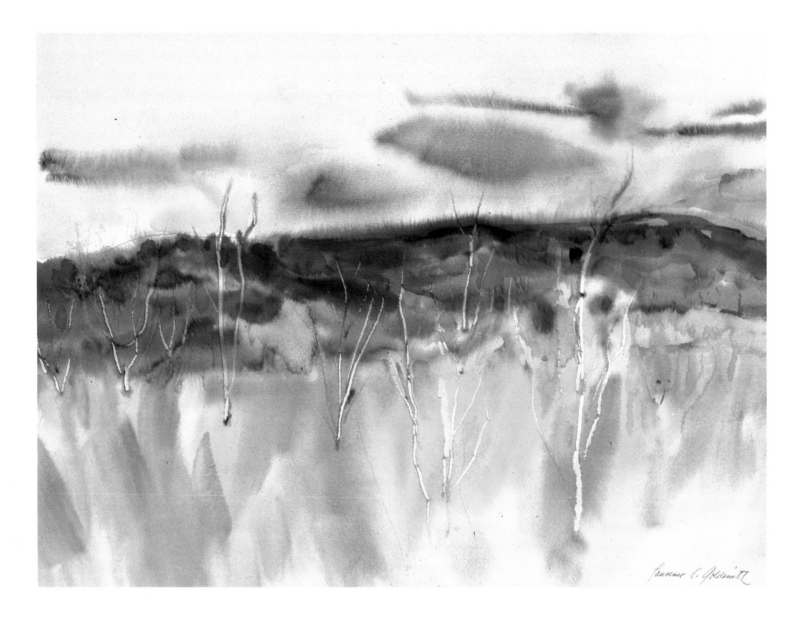

HEAD-ON PROSPECT, *by Lawrence C. Goldsmith, 18 × 24 in. (46 × 61 cm).*

The first of four variations on a theme, this one bears the closest resemblance to the actual dimensions of the locale—a series of low Vermont hills backed by some of the higher peaks of the Green Mountains, with a slow stream bisecting the scene, and a marsh and scramble of brush in the foreground. Despite the resemblance, comparison with the photograph of the actual scene that is shown on page 92 reveals several liberties taken. The painting entails consolidation of some features, such as the hills, and a vitalization of others, particularly the trunks and branches of the trees. The buildings have been shunted aside entirely. Attractive as they are, their workaday quality seemed to detract from the romantic illusion that was sought in this watercolor. Another improvisation was the substitution of reds and blues for more natural colors.

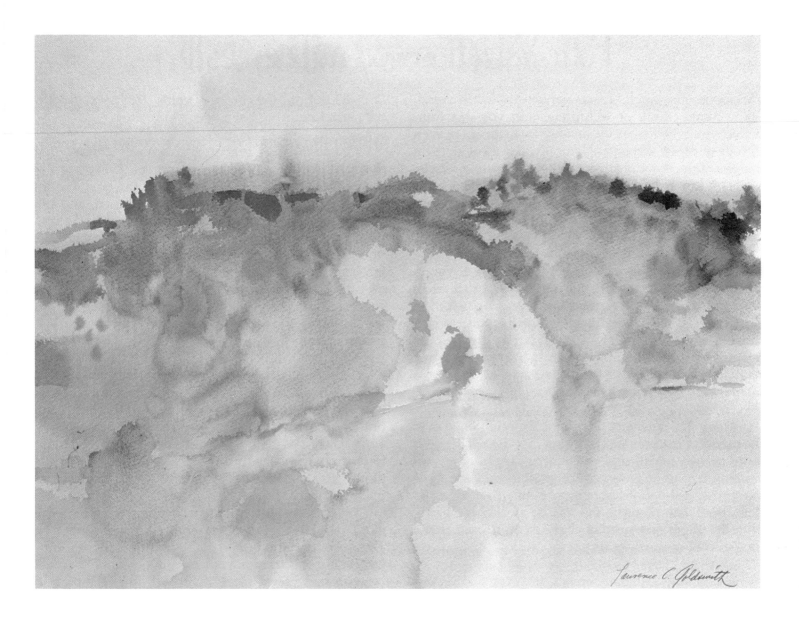

Soft Focus, *by Lawrence C. Goldsmith, 18 × 24 in. (46 × 61 cm).*

In this second variation, greater concentration on the mood of the subject became of first importance. Structural aspects of the landscape were subordinated to permit freer flow of pigment. This fluidity was enlisted as a technique to achieve an ephemeral quality in the work as a whole. Colors similarly were chosen for their emotional content, not for accuracy in depicting objects.

Four Variations on a Theme: III

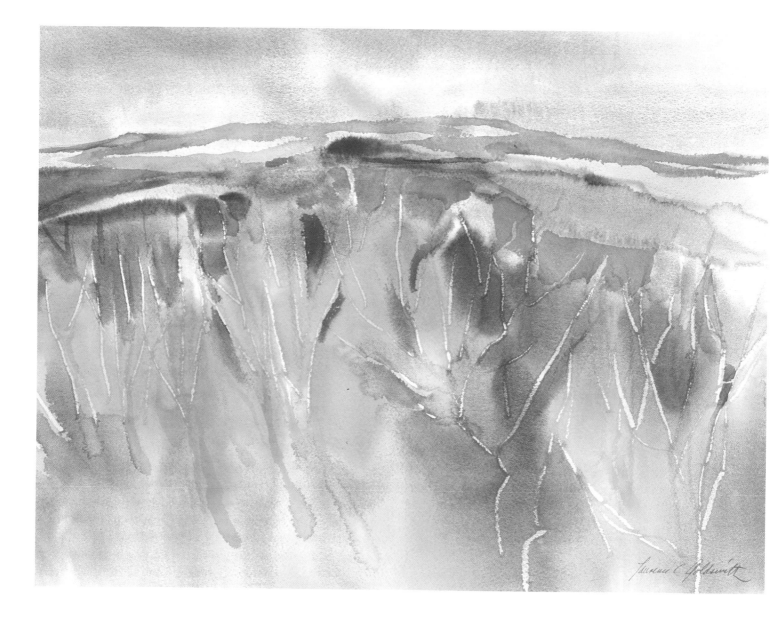

MOLTEN RANGE, *by Lawrence C. Goldsmith, 18 × 24 in. (46 × 61 cm).*

The same hills and river valley of the other watercolors in this quartet were used in this third variation of the theme, but here their energy-giving vibrations have been stepped up. Hotter and deeper color, sharper definition, and a pronounced confrontation between verticals and horizontals in the composition were all designed to increase the vitality of the work. Not serenity, but vigor, was sought. The motif was used in this case to express the reawakening of natural impulses after lying dormant throughout the winter.

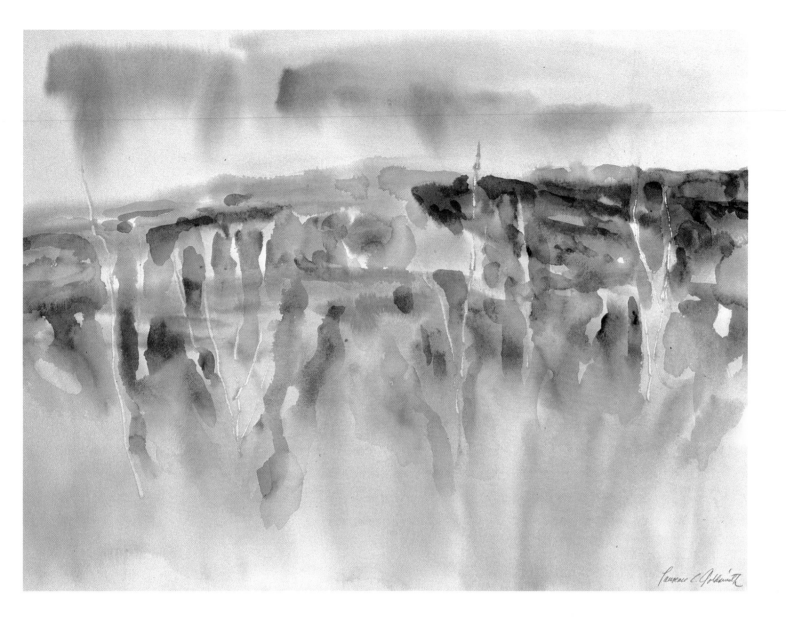

Urgent Greens, *by Lawrence C. Goldsmith, 18 × 24 in. (46 × 61 cm).*

This fourth variation was a bit of bravado: to see what relationships could be found within a family of greens. Other colors were excluded almost entirely, except for minor accents. Greens being indigenous to the scene, they can be interpreted as natural colors. On another level of appreciation, however, they may be seen as evoking sensations characteristic of the pigments themselves. Colors, in a sense, live their own lives, and the attempt in this painting was to make those effects visible. Differences in intensity and value serve to produce further interaction. Thus, much variety is evident in what is essentially a monochromatic conception.

Experiment 35

Subtly Suggest Shapes

This is an exercise in forming a partnership between artist and viewer. Freedom of imagination is called for on both sides. The artist offers a host of aesthetic experiences for the viewer. The viewer, not the artist, provides the interpretations. The artist respects the ability of the viewer to find his own meanings in what he sees, without the artist rendering his material so precisely that there isn't any room for personal response. In short, he does not answer the question, "What *is* it?"

Many approaches could be used to establish this philosophic partnership. One approach is to paint shapes full of suggestion. The suggestion stops short of definition. Here again the medium of watercolor is rich in opportunity. Although watercolor is often used for exactness, it is even more appropriate for conveying mystery. Its fluidity and transparency carry the power of suggestion, wasted all too often when the practitioner is overly concerned with control. In this exercise, the hope is to let suggestiveness run free.

What does the artist contribute when he lets suggestion take over? A raft of sensation. Every brushstroke can be enjoyed for its own sake. The artist twists his brush, pushes his washes, varies his lines, adds and takes away, melts, and combines for maximum sensory impact. This is his deep concern. Let the viewer find subject matter. The artist barely implies it.

Once I observed a procession of people stop at a particular watercolor painting in a gallery. Their comments were curious. One saw a flight of birds in the sky. Another talked about ice floes. Still another found darting movement in a turbulent sea. Other responses were emotional. One person felt an exaltation from an image of the soul's liberation from earthly concerns. Each viewer brought his own personal equation to the experience of contemplating that painting. They were all captivated.

How does one go about providing this kind of involvement? Try, if you can, to put yourself in a mood where you care more about the beauty of your effects than about their literal meaning. Plan a painting where you start with only the semblance of objects seen in nature. Then, as they develop, exploit them for the sensations they evoke in you. Push those sensations. Let yourself go.

Your point of departure should give you just enough meaning in your shapes and lines so that you don't lose contact with your material. But your absorption should be in what is emotionally felt, not in what is literally seen. Does that cloud shape *feel* like a cloud? Pursue that feeling without dwelling on the exact confines of any real cloud. Concentrate on the beauty of that passage in paint.

"Using paint as paint is different from using paint to paint a picture," John Marin wrote. "I'm calling my pictures this year 'Movements in Paint' and not Movements of Boat, Sea or Sky, because in these new paintings—although I use objects—I am representing paint first of all and not the motif primarily."

You are intuitively aware of the integrity of any work of art. Balance, movement, contrast, weight—all these essentials are always indispensable. I am not for one moment proposing any absence of discipline, but your emphasis is to be shifted, as was Marin's.

You will find that to suggest shapes is far more taxing than to render them. Knowing what to leave out becomes more important than what to put in. Look at your work from time to time to see what degree of definition you have allowed. Observe if some shapes disappear in places and push forward in others, providing wanted mystery. Think about how passages could be variously interpreted.

Not that you will be able to see *all* you have done. The thrill in this kind of painting is that, when you deliberately have been subtle, others will discover sensations in your work that aren't apparent to you. Only later will you know the full range of those sensations as viewers call your attention to them.

The amateur might feel defeated. He tried for one set of sensations and "they" don't get them. "They" see something quite different. The experienced painter working for freedom of expression knows this as a measure of arrival. People react differently, as we all know. While everyone can identify a literal work—a lighthouse is a lighthouse, after all—emotional content is never uniformly experienced. Your barely suggested shapes *should* evoke differing responses. Otherwise, a contribution is made solely by the artist, not by both artist and viewer.

Select Unique Subject Matter

Certain artists face a dilemma. They are blessed (or cursed) with the gift of absolute fidelity to detail, and yet they want to paint loosely. This is especially true of artists who have used their talents in earning a livelihood in advertising or illustration. The client wants them to show his product clearly. You may be one of these artists, and certainly know their problem. Try as they may, they can't break away from rendering with precision.

This book proposes many ways out of this dilemma. But for those who still can't respond to painting loosely and boldly, there is yet another path to individuality. It involves exploiting your abilities, not replacing them. This solution is simply to find *unique* material.

Abandon those wharfs and fishing boats, those lighthouses and adobe houses. Ditto with covered bridges and mission compounds, along with bowls of fruit and vases of flowers. The seated model, holding a book, with a reading lamp at the side, would also be ruled out. Not that any of this material is unproductive under normal circumstances. It just is too commonly used to qualify for the subject with your exclusive label on it.

What might qualify? Look first immediately around you at what, unnoticed as an art subject, is right under your nose. John S. Ingle found such a subject for a painting that won an award at the "Watercolor U.S.A. 1977" show at the Springfield, Missouri, Art Museum. A glass Mason jar of stewed tomatoes, succulently depicted, stands alone, fully twenty-nine inches high. The background is a uniform warm gray. There is nothing else in the painting, nothing to detract from his unique motif.

Similar objects, or groups of objects, are all around us. Commonplace though they may be, they are not commonly painted. The artist gives them dignity and originality when he singles them out.

Here are a few random ideas:

A breakfast tray. A kitchen appliance. The *interior* of an automobile. The underside of a truck. The cockpit of a plane. A baby's rattles and toys. A stand of toothbrushes. A portion of a rug. A washing machine or dryer. A box of lipsticks. Dentist's models of teeth. A town dump. A wrapping and shipping center. A checkout counter. A morgue. Gasoline pumps. Computers. A warehouse loft. Knitting yarn. A switchboard. A church organ. A human foot. A slaughterhouse. Traffic lights. Snow plows. Old billboards. Cigarette butts. Clothespins. Shoes.

The material is without end, of course. It's impossible to imagine anything that could not be adapted to the artist's needs, given his rendering craftsmanship and his enthusiasm for the subject. The task is to present material boldly. Compositional balance and positioning become of great importance. Andy Warhol's famous soup cans have shock value, not only because he chose such commonplace items, but because he painted them as if they were giants.

Large scale is often helpful. Wise proportioning can be equally effective. Your objects should dominate your painting, whatever its dimensions.

A fresh color scheme offers a way of assuring that the subject becomes truly your own. Another gambit is to place it in an unusual perspective. Look down on it if the conventional view is up at it, or in some other way force your viewer to see it differently.

Having chosen something other artists neglect, and designed your space so that you offer a fresh look at it, your skill in representation becomes your prized asset. It will give you clarity, definition, and authenticity. Spontaneity would be out of place. Accidents are to be avoided scrupulously.

The measure of success in this endeavor is not whether you have developed new, freer skills in applying watercolor paint, but in your ability to use your existing skills to glorify an unsung subject. Selection of that subject is at least half the battle.

Could the same subject be painted more freely? Surely that is a real possibility. For the artist inclined in that direction, the same search for a little-used subject could be undertaken. He could then *use* the subject, not *reproduce* it. He could employ whatever free-flowing methods of painting he thought most pertinent. His would be a double challenge, well worth confronting.

Subtly Suggest Shapes

SUMMER DAY, *by Ruth Cobb, 30 × 21 in. (76 × 53 cm).*

The viewer is granted manifold opportunities here to make his own interpretations. The artist simply implies, hints, and otherwise lightly whispers the reactions that he experiences. Cobb is superb at this offering of illusions. In this painting, only the figures—significantly centered—are definitely recognizable. Even the architecture of the porch is rendered in a dreamlike manner. Planes must be imagined more than perceived. Barely suggested as they are, the elements in the painting still work together structurally. The artist has built her composition on preconceived lines, but without thrusting her convictions on her viewer. He must sense her impressions—or find his own. The mysteriousness of the work is heightened by the introduction of bars and globules of glowing color.

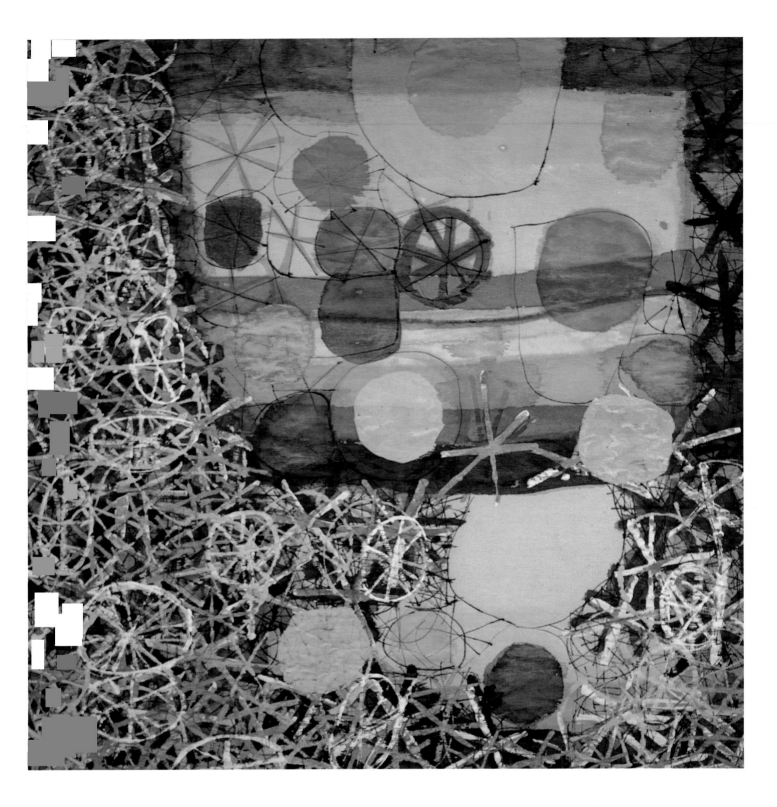

FUGUE IN THE SILENCE # 1A, *by Hilda Levy, 20 × 20 in. (51 × 51 cm).*

Uniqueness of subject matter stands out among the several unusual aspects of this work. The artist is enraptured with wheels. Wheels with spokes, wheels without spokes, and spokes without rims spin throughout her surface or are piled in heaps. Wheels are executed in transparent watercolor pigment, Chinese white, and ink. These are clearly visible. Others are suggested by her mesh of varied textures. Pulling the host of wheels together is a shape possibly derived from a cart, certainly some form of wheeled vehicle. Out of this seldom-regarded motif of the wheel, Levy has built a painting that tingles with vibration. Another rare ingredient is her ground; she uses a sheet of hospital paper. She explains this as very strong paper used to wrap surgical instruments for sterilizing in autoclaves at very high temperatures. It is crepelike, with an "enticing texture," and has a way of crinkling up that produces unexpected effects. Hospital paper is now being supplanted by plastics in clinical use. Pasadena, California, is the home of this artist.

Experiment 37

Position Tension Spots

The eye's pleasurable sensation of dancing around a painting is the result of an act of calculation on the part of the artist. He shrewdly motivates the eye, often intuitively. In this project, the eye will be caught by carefully positioned spots that build a felt but unseen network of tension. As always, freedom implies forethought.

What kinds of spots? While they need never be uniform, and will reveal the artist's own vocabulary, they should have two general characteristics: they should be both startling and small.

Think small. Small doesn't mean insignificant. A small child wearing a red cap stands on a grand, snow-covered hillside. His speck of color immediately attracts attention. Out at sea, a tiny sail pricks the horizon. A lobster trap buoy breaks the expanse of the water. Though only an infinitesimal fraction of the space in which they appear, these fragments command the eye. In a painting, spots can be equally insistent. Placement and color, not size, are responsible.

Those factors make them startling. A bit of bright color deftly placed in a large wash of opposite, or at least different, color will stand out, while a spot of similar color will be far less noticeable. Spots will vibrate with one another even when they are extreme distances apart on the paper. These spots need not be of identical hue. Each one, however, must be startling.

In the painting planned for this experiment, zero in on those spots. Naturally they alone cannot produce a wholly satisfying work of art. All the other elements are necessary (as with virtually all the experiments in this book). The spots, nevertheless, will be your special concern.

A wise procedure is to lay down your initial washes. Let them dry. Then paint dabs of color on a scrap piece of paper, using bright colors that contrast with the colors of your washes. When these dabs are dry, cut or tear them out. Or, for the same purpose, find spots in a colored advertisement in a discarded magazine. Cut or tear them out. Place them at various points on your paper. Keep repositioning them until you find the places where they create the most tension.

Try one or two near the top, others closer to the bottom and sides. Switch colors. Set them into an informal pattern where the eye dances from one to another. There are no rules. Each artist will compose differently. But the kinetic effect of any successful combination will be to keep the eye moving throughout your painting surface. If any spot leads the eye out of the painting, reposition it so that it catches the eye and moves it back into the interior. Get some of the movement across the center. You don't want a circular movement that disregards your center of major interest.

When you have found where your scraps of colored paper work best, replace them with accents actually painted on your sheet of paper. Soften one or more edges of each spot with a damp brush, moving from the dry surrounding area into the spot. This softening will relate that spot to the surface. Otherwise you run the risk of getting a spot that looks like a cutout silhouette. That would fracture the unity of the painting. You want each spot to stand out, while remaining a part of the composition.

Don't worry about literal meaning. Suppose you are working with a forest scene in summer. A speck of orange will not convert the scene into an image of fall foliage. It will enliven those greens, not overwhelm them. And even if it does alter a conventional concept, you will get a more exciting result.

Additional spots of color can be added if needed. Go back to your scraps of paper and place new ones to see what, if anything, they contribute. As always, economy is desirable. Too many spots cause confusion. If in doubt, leave the spot out. You can always put your painting aside until later, when you can take a fresh view of it and make a more considered judgment. Then you'll know better what to do.

You might find that you have just the right spots but that they need brightening. Or that they need some elaboration to increase their interest.

When you are satisfied with interest, color, brightness, and position, reevaluate the total effect. Your spots, small as they are, should dominate the whole painting. They should organize movement of the eye so that it darts hither and yon, giving maximum pleasure everywhere. They should be seen, not as isolated bits of color, but as switching points, beautiful in themselves but always contributing to a flow of interest.

Compose with a Letter

The alphabet offers a design motif that everyone has carried in his head since early childhood. No need for research. Twenty-six distinct choices are ready for use, plus infinite variations, angular and curvaceous, in the lettering style of each one. This is an exercise in versatility.

A notable example, for reference, is in the pen-and-ink drawings of theatrical personalities by Al Hirschfeld. For many years he has hidden the name of his daughter, Nina, in folds of costume, coils of hair, and elsewhere in his sketches. He jots down the number to reveal how many times the name appears. Readers of the newspapers and magazines where his drawings appear enjoy the game of playing sleuth.

Puzzles aside, letters are intriguing in themselves. What can be done in a drawing can be done with more elaborations in watercolor. The watercolorist commands a battery of colors and a full complement of personalized sweeps of his brush.

The suggestion here is to pick a letter and work it into your design, using dexterity to produce an assortment of sizes, colors, styles, and textures. In doing so, you will have to make a conscious effort to manipulate your brush in ways that differ from your everyday habits. Don't worry about recognizable rendering. The letter is merely your starting point, and you can make it recognizable or not, as you wish.

What motif? This is of little consequence. The employment of letters can add appeal to most subject matter—landscape, still life, or nonobjective material. Even movement in the atmosphere could be handled innovatively with soaring and billowing letters. What does it matter if each viewer reads your letters in a different way, seeing his own subjects, so long as he derives aesthetic emotion from your painting? Give him ample opportunity for his interpretations. Let your letters flow as you will. Mystery is a far more provocative quality in art than exactitude. Of course I'm not advocating sloppiness—simply individuality.

"An artist sees things not as they are, but as he is," said Robert Beverly Hale, the artist—teacher of anatomy. This is true even when the artist employs precise images such as letters (or muscles).

Each letter in the alphabet possesses its own personality. Taking only block capital letters, forgetting for a moment the lowercase letters and cursive lettering, you can experiment with a range of forms. A few examples will make the point. "A" has angular rigidity, as in a tripod. "I" has the form of a cross-section of a steel truss. "L" makes a stalwart right turn. "S" is serpentine. "O" is a self-contained circle, with "U" an open-ended variation. "Z" gives you both horizontal stability and an oblique thrust. "Q" has the most personality of all.

Thumb through a printer's catalog of typefaces and you will be reminded of the surprising number of styles that designers have created. Not that you need be bound by those. You are free to improvise your own.

If you become entranced by the idea of using letters, you could easily paint a series of watercolors, using the same motif, but each time employing a different capital letter as your principal instrument of design. Then you could go on to another series of twenty-six, this time working with the small letters.

Letters can be used here and there to form accents in your composition. Another way of handling them is to work with them exclusively, creating an overall pattern. Mark Tobey's work shows the nuances that can be attained in limitless tracery, suggesting depth and complexity. Letters could produce similar sensations.

Like so many other tools, letters become projections of the artist's feelings. As such, they may be brusque, forceful, or poetic. Much of the charm comes from seeing what character surfaces from the impulses of your own hand.

There is no "right" way of performing. There never is—either in this or any other approach to art. Certain fundamentals must always be respected. When these are understood and embedded in a painting, the artist is at liberty to take any of countless directions.

Judge your work by seeing if your letters are as fanciful as you can make them, while still abiding by the fundamentals of good design. Balance, unity, interest, and movement should all be apparent. Your letters should add, not detract. Then they can be thoroughly enjoyed. Quite literally, they may provide you with a new language in your art.

Position Tension Spots

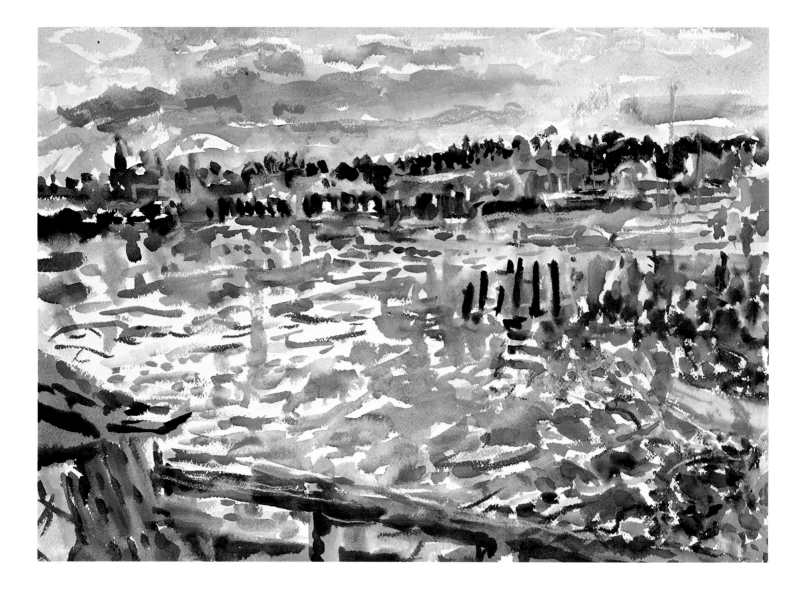

BRISK DAY, *by Nell Blaine, 14 × 20 in. (36 × 51 cm). Courtesy of Fischbach Gallery, New York. Photo by Eeva-Inkeri.*

The free gestures that govern this painting look so spontaneous that one isn't aware at first glance of the spots that build the tension. Yet they are positioned with discrimination. The reds in the cloud at the upper left and in the eye-arresting rectangle along the upper right edge are appreciated first. Then one notices the vibrating greens, poised next to the red and interspersed in the lower right. Spots of yellow also contribute excitement. Alan Gussow calls the artist the "Queen of Unpolluted Color" in his book, *A Sense of Place* (Saturday Review Press, New York). Coincidentally, he notes, she paints in unpolluted places such as the Caribbean islands and in rural New York and New England. Blaine says that "the moment of the dying of the light is my favorite moment to paint landscape. For me this time is a great flaring up of life and illumination and revelation. I become more alive too. I'm physically more alert to my surroundings. . . . The main reason, I believe, is the excitement that the color takes on—it illuminates everything." She responds to what she calls a "blast of color" that saturates the out-of-doors.

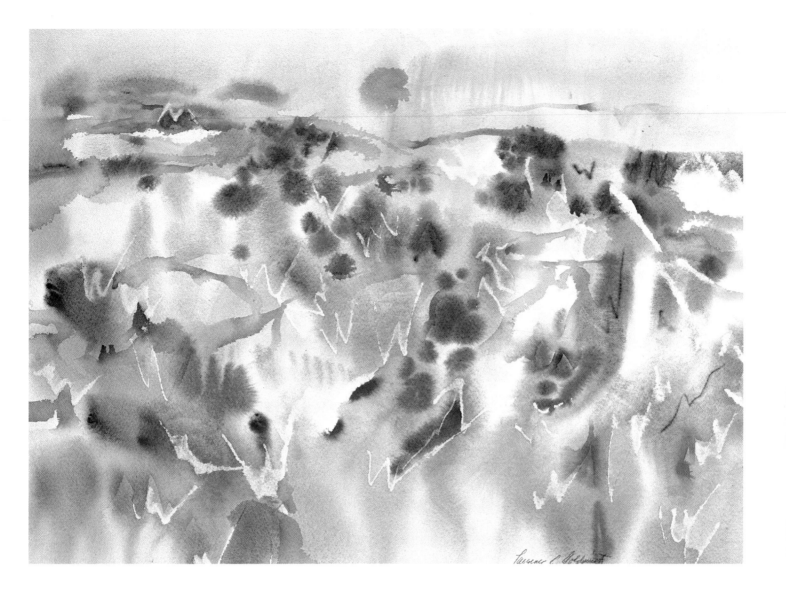

CALLIGRAPHIC HILL, *by Lawrence C. Goldsmith, 18 × 24 in. (46 × 61 cm).*

The sporadic energy of this work comes, in part, from repetition of a single letter in the alphabet. The hill is well populated with W's. They can be seen painted in line-work. More often, they appear near-white, where paint has been lifted from washes. No attempt was made to render them mechanically. Some are scarcely legible. Others are free gestures. This variety was intentional. It was felt that each letter had to be interesting in its own right. The overall purpose was to take a look at living matter on a familiar hillside and see if a new note could be struck. W seemed to mark the right spot. Aside from its use, energy is also expressed in other ways. Triangles and rounded shapes in middle values protrude from the blanket of tints that underlies the composition. These repeated value changes give liveliness to the motif. There is no real sense of mass. Instead, brief passages of warm color were applied to pull together all the separated elements, including the W's.

Experiment 39

Combine the Figure with Land Forms

The human figure is often used as a point of departure by the artist inventing fanciful concepts. So are forms seen in nature. A few artists have combined both in one painting. They fuse human and land formations so that they interact, without actually separating the two. This kind of interplay is the object of this experiment.

The idea is to exaggerate human forms suggested in landscape so that the hills, or whatever, seem to have the rhythmic sweep of a live body—and simultaneously to introduce aspects of the figure into the landscape so that the figure partakes of the permanence and earthiness of the land. It is this dual communication that creates the interest. Both land and figure are seen and felt.

For those to whom this concept is new, it is easier to grasp by seeing actual examples than to follow a written description. Hunt in a good art library for the work of Carol Summers. An imaginative printmaker, his bold forms of hills and caves suggest heaving, undulating human limbs, often done in intense violets or warm earth colors. You can sense life in all his work. There are no static forms. Or see if you can find a painting by Joseph DeMartini in which he, more consciously perhaps, embodies a figure in his rock formations. As you look at such a work, you will fluctuate between being aware mainly of the rock and mainly of the figure. Forms look human at times, inert at others. This swaying back and forth gives endless thrills. Summers is noted for his woodcuts, and DeMartini works in oil and mixed media, but both use ideas that could be translated effectively into watercolor.

Even without these examples before you, you can seek your own combinations (and possibly attain greater freshness because there would be no temptation to imitate what has already been done). Think in terms of features of the landscape that rise and swell with the voluptuousness of the human figure. Then draw, and later paint, a figure with a solid relationship to the earth—lying on it, squatting on it, or straddling an outcropping of ground. See how the two—earth and body—can be intertwined. Let the one lead into the other. Give some of the same qualities to each.

While you should be clear in your own mind which is which, there need be no sharp separation. Let your viewer find his own interpretations. You will be dwelling on the earthiness of both components. The feeling you will evoke has far greater importance than any specifics. Let most of the work speak for itself. Take heart in Braque's perceptive words: "The only thing that matters in art is the part that cannot be explained."

Use whichever of your watercolor techniques you find most appropriate. The concept is all-important. Achievement of that concept can be gotten through all kinds of application of paint. There's none that needs to be ruled out. The same generalization holds true of value, composition design, and color saturation.

As for color itself, perhaps the easiest formula is to use colors that are most closely associated with skin tones—warm yellows, raw sienna, pale sepia, modified reds, and mixtures of earth colors. More daringly, you could try other colors, even blues and violets. Painters of the human figure know there is hardly a color that doesn't have an effective use.

Even more than usual, a watercolor of this sort must be built upon a strong drawing, carefully planned, whether rendered in detail or not. Start with a definite idea of where your land lies and how your figure will be incorporated into it. Then, as you develop that idea, you can begin to improvise with greater assurance. Your point of departure will give you a base that will underlie any of your improvisations.

Look at your painting now and again to make sure you have not lost your original concept. See how you can strengthen it, making it bolder while still retaining some sense of mystery.

This balance of fact and fancy is one of the delights of the experience. It should be apparent in the final outcome. Study your work to see if you have done justice to both land mass and human form. Do the two sometimes merge? Do both partake of the same qualities? At the same time, does each have individual characteristics of its own? A delicate balance of all these properties will tell you that you have accomplished what is, admittedly, no mean feat.

Try No Concept at All

Watercolorists are habitually advised to have a mental image clearly in mind before they start a painting. Few would quarrel with this advice. It is presented repeatedly in this book in one way or another. Establish your concept, plan ahead to accomplish it, try to anticipate problems, etc. In this experiment, however, avoid any preconceived notion of how this painting will look.

Why this contrary method? Is it only a feat of blind boldness?

It could be useful to two kinds of experienced painters. (I would not recommend it to novices. Formulating initial concepts is imperative for them. They cannot expect to succeed without doing so.) One kind is the person who is adept at a particular style of painting. He has reached a plateau where the possibilities in that style are at least temporarily at a standstill. He may feel hesitant about moving in another direction. This experiment may force him to *leap* into another direction.

The second kind is the person who, having established his concept, clings to it no matter what happens. Opportunities may arise for him to shift his concept to a better one, but he doggedly dismisses those opportunities. Accidents happen. He tries to overcome them, never exploiting them, remaining faithful to his concept. This experiment could add a bit of flexibility to his repertoire. How can you stay bound by a concept that isn't there?

Should you recognize any of these characteristics as your own, this experience could be helpful. It might be fun to try even if you don't feel any special need for it. Strange as it sounds, starting a painting without any advance notion of what it will be like is a difficult trick. It's like thinking of "nothing." Ideas seem to get in the way. Anyway, try starting without any *conscious* thought. Get going and then see *where* you are going.

One easy way to take the plunge is to wet your paper thoroughly (assuming you generally start by working wet). Then pick up a large brush, dip it into the water, *close your eyes*, and make a stab somewhere on your palette. Then make another blind stab, this time on your paper, with your loaded brush. There!

Your painting has begun. You have started it with a surprising color in a surprising spot. You go forward from that point on.

As you develop your painting, you begin to see the workable concepts appearing before your eyes. Seize one of them and let it guide the rest of the painting process. Hold to it if it works out. Change it if it doesn't.

Actually, there is no such thing as a *fixed* concept. Even the most carefully thought-out concept changes with every brushstroke. That new brushstroke, no matter how minute, affects the totality of your work in some way. Your concept has been transformed by the measure of that change. A concept is fluid; it is a moving target. Its value is as a visual ideal, subject to alteration on the way to attainment.

This capacity for a concept to be changed, or even abandoned, while a painting develops, is one of the prime beauties of watercolor. Given the mercurial nature of the medium—the quick flows, the spreading, the imprecise mixing of colors—the artist who requires predictability is far better off working with *some other* material. But no medium except watercolor will satisfy the artist who savors instant changeability with all its challenges. Spontaneous decision is often called for, and while these decisions may seem to pertain to other matters than the basic concept, they do affect that concept. A watercolor concept often changes so rapidly the artist may not even realize it. The dedicated watercolorist relishes this highly movable feast.

As you complete the watercolor done in this manner, try to put into words the concept that has emerged. What has governed the final stages of painting, if not the earlier ones? Somewhere along the way you did find a steering wheel and a rudder. Did you feel uneasy before this happened? Did this uneasiness, if it did occur, force you back into familiar paths or did it prod you into finding a new one? Did working without an initial concept lead you to inventing a more advanced concept that you will continue to pursue? Did it give you more confidence in your ability to improvise?

Combine the Figure with Land Forms

THE DANCER, *by Nathan Oliveira, 8 × 11 in. (20 × 28 cm). Collection of Meyer Friedman, M.D. Photo by Ramell, Inc.*

This painting suggests an alternative to the experiment "Combine the Figure with Land Forms." Here intimations of the land are actually perceived within the figure itself. The pose might be seen as resembling a topographic landmark, perhaps a rounded knoll or hummock. The colors—especially the bice green of the girl's hair and the red of her forearm—would be expected in features of the earth. In a figure they are delightfully surprising. This work, however, need not be interpreted in any such precise way. It needs no literal analysis. The economy of its forms and the exquisite manipulation of light-suffused pigment make their own statement. Oliveira uses watercolor with extraordinary delicacy. Note how he lets his blue-grays infiltrate his flesh tones, implying shadow without insisting upon it. The toes and sole of the foot are executed with swift, rounded strokes in a mixture of earth colors. Oliveira is a California artist noted, among other achievements, for his highly individual approach to figuration.

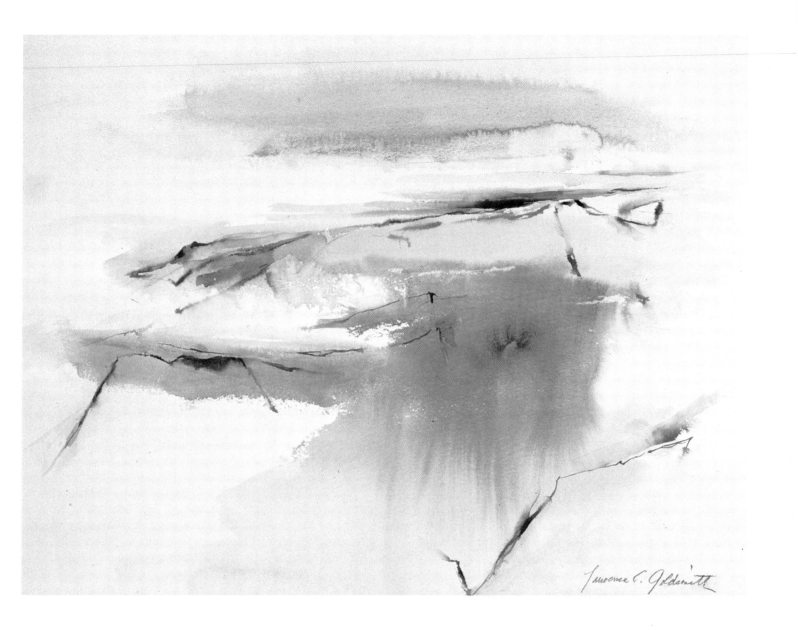

IMMERSION, *by Lawrence C. Goldsmith, 19 × 24 in. (48 × 61 cm).*

This watercolor began without a prior concept. Inevitably, only one thing is assured in this chancy procedure. There are bound to be surprises. One such surprise was in the early bursting out of the central wash. The flood of cobalt green surrounding the free-form in warm sepia immediately commanded attention. Another surprise was the accident that invaded the upper wash. It suggested a cloud, and was left as such. Once these two areas began to assert themselves, a concept emerged. Sky, water, and rocks could be imagined. From there on, the painting process came under greater control. More cobalt green was used to extend the expanse of water. Lines were painted, both in and out of the washes, as suggestive of ledges. Other lines were added purely to imply a large, angular shape that would coordinate the loosely connected washes. To enliven the sea of cobalt green, touches of grayed reds were included. What had started as a watercolor painting without any concept grew into one where the concept ultimately became clearly established in the mind of the artist.

Experiment 41

Light Foreground, Dark Background

Why paint a light foreground against a dark background? What changes come about on the picture plane because of this reversal of the more usual combination of a dark foreground with the background receding into ever-lighter tones in the distance?

Changes come about in all work, although they are more apparent in a landscape. Your best bet for this experiment would, therefore, be a landscape. Select a theme with features well known to you—a distinctive range of hills or mountains, a cliff, a forest, woods, fields, or swamp in the foreground. A foreground of water would answer the purpose too. Desert-dwellers could make their own adaptations.

Plan consciously for deep color and full saturation in your background, with very much lighter values in the foreground.

Here is what this plan will produce. Knowing what results to look for will help you decide what means will get you there. Light foreground, dark background accomplishes these things:

1. Dark dominates, especially in watercolor. Therefore, the band of greatest interest in this kind of painting will be higher on your working space than it would usually be.

2. The dominant darks will pull your background somewhat forward. You will not get that far-away atmospheric effect of distance. Instead, your background material will come closer to your picture plane than ordinarily, but not so close as your foreground material.

3. Background color will be more important than ever, since your backdrop has become your center of interest. Richness of color will enhance the feeling of *some* distance.

4. This backdrop of dark, rich color will create the illusion of greater lightness and brightness in your foreground.

5. With the background looming out, stopping the eye, the viewer will feel a more intimate connection with what's going on in your foreground. There's opportunity for suggesting all sorts of tactile sensations in this area, supplied either in graphic detail or more vaguely.

6. Since both background and foreground planes are less widely separated than usual, with everything going on closer to your picture plane itself, the picture plane assumes new importance. Your watercolor will have greater immediacy and unity.

Make your decisions in terms of those objectives. Should you have a high or low horizon? Obviously a high horizon will enable you to give fuller scope to your darks. Should you have more detail in your foreground than in your background? Here the answer should be governed by what the details will do, not by their quantity. They should help enrich your darks, or your lights, without interfering with the total effect. That is, your background should remain generally dark and your foreground generally light.

All your questions and answers should relate to achieving the six qualities listed above. Within those broad limits, you have ample leeway. Color, texture, brushwork, line—all can be as you prefer. For example, you can use any color combination for your background so long as it is *dark*, and vice versa for your foreground. Try rich blues, violets, and greens for your darks. For lights, you could use pinks, ochres, or yellows—or even light washes of cool colors.

Because your darks clearly identify your background, and your foreground lights are locked in by those darks, you are free to deviate from natural colors. This comes about because those darks and lights take over the usual function of color in explaining subject matter. Not having to explain, you can go your own way. Original colors will still look as if they belong. Try them. It may be easier to *see* that they work than to digest the theory that makes them acceptable.

The success of this experiment naturally depends on taking advantage of the six factors we have outlined. And it follows that the test of attainment is whether or not all six are clearly evident in your painting. Study it to make sure that you have done all of them justice.

Cool Subject, Hot Colors

This is not an exercise in obstinacy, much as it may sound so in the title. The purpose of switching over from customary to unusual colors is to dwell on the importance of other factors besides color. What causes a cool subject to look cool? Very often the effect is obtained as much by movement, texture, line, and value as by color. There are cool ways to work with each of those factors. By experimenting here to find the best of them, your watercolor will evoke a familiar mood in a decidedly original, more daring way.

Let's agree first on the characteristics of a cool subject. To me, both temperature and mood are involved. Cool is quiet. A quiet sea is cooler than a stormy sea, regardless of its place on the globe. A clearing in the woods is quiet, and therefore cool. A restful scene on a summer porch, implying relief from the direct rays of the sun, would seem cool. So would a dark cavern where the air would be still. Snow and ice are obvious; our reaction to their chill comes automatically.

Pick a theme, like any of these, with which you generally associate coolness. Then line up the colors you would *ordinarily* expect to use. Instead of using them, however, substitute something opposite. Instead of thalo blue, choose vermilion or a scarlet. Instead of cerulean blue, perhaps use burnt sienna. Put together a color scheme that pleases you, but one that is definitely hot. Mix these colors as you would any other combination. No special handling is needed.

You *must* make special efforts, however, in everything else you do. Every brushstroke should contribute tranquility, poise, an absence of turmoil. For example, position your major shapes so that your composition emphasizes the horizontal. Avoid those uplifting verticals and tension-building diagonals. Horizontals offer the coolness of earthbound stability. And organize your darks and lights so that they, too, strengthen your horizontals.

When you lay down your washes, pay special attention to edges. Let most of them melt away. Soften most places that become sharp, using a damp brush to tone down edges. Let one wash drift into another. Soft, quiet, cool—the moods are closely related. Soft and quiet treatment in your washes will establish coolness.

Brushwork and linework, again, should lean toward horizontals. Not always, of course, since that way lies monotony. A preponderance of the work, however, should lie down rather than soar up.

Another critical factor is the character of your lines and brushstrokes. Character means the emotional climate of the work, regardless of the direction in which it runs. Easy, flowing, graceful strokes give the feeling you are after, as opposed to abrupt, sharp, agitated strokes. They would produce a state of excitement and heat, not cool calm. Try to be conscious of the desired mood when you put down every stroke. Let strokes melt away at either or both ends. Softness, again.

Texture also makes a contribution. As before, seek quiet interest rather than agitation. Emphasize harmony in color and wetness in technique; make slow changes rather than exaggerated ones.

As you bring the painting process to a close, study the interaction of your compositional movement, shapes, brushwork, line, and texture. Are they coordinated? Do they together create a cool mood (or does some factor pull away from that mood)? When they do pull together, they should bring cool and quiet *despite* your hot colors. Do they succeed in doing this? A decisive test would be to repeat your watercolor with the same material and techniques, but this time resorting to the usual cool colors. Compare the two paintings. You'll see how close you came in mood. You should also be able to see that color, while always important, is not always all-powerful.

Light Foreground, Dark Background

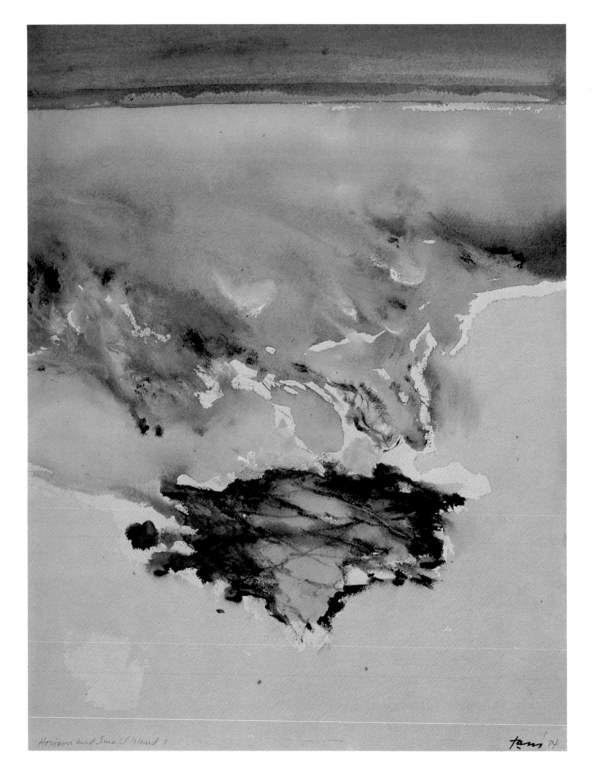

HORIZON AND SMALL ISLAND, *by Reuben Tam, 16 × 12 in. (41 × 30 cm). Courtesy of Coe Kerr Gallery, New York.*

Light foreground, dark background give a refreshingly new look to familiar coastal features in this painting. The dark sky area anchors the work at the top of his sheet, with the lighter sea area rushing toward the foreground. The small island, partly isolated by the white of the paper at the bottom, arrests the action of the surf and keeps interest well up in the composition. Whites artistically injected into the surf relate to the white areas left unpainted. Tam has intensified movement in the painting by using his paper vertically; the surge of sea starts from the dark strip at the top and is funneled downward in a narrower channel than would be the case in a horizontal work. The medium is acrylic, used so fluently and with such generous quantities of water that the effect resembles that of transparent watercolor. Most of Tam's work springs from his informed preoccupation with the geologic structure of land forms, especially along the Maine coast. Even when working in New York in winter, Maine is his constant motif. He believes each artist sees reality in his own way.

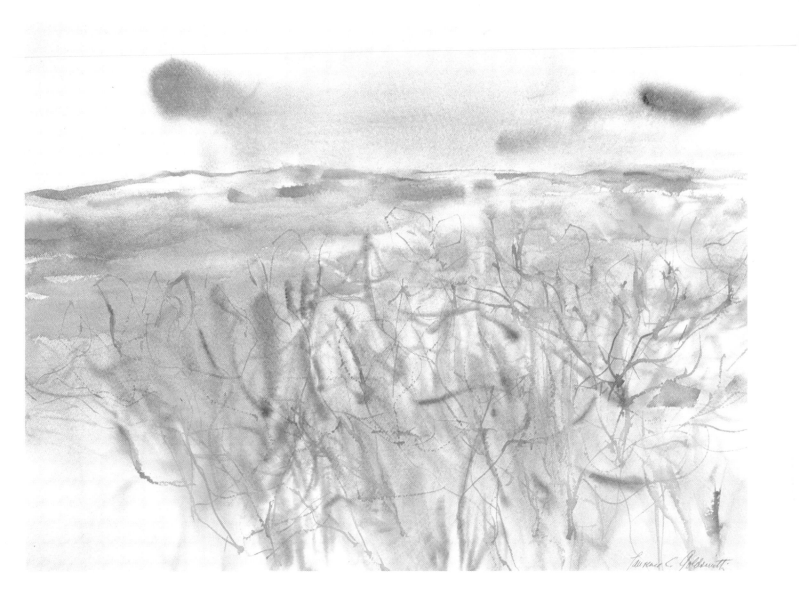

Softly Growing, *by Lawrence C. Goldsmith, 18 × 24 in. (46 × 61 cm).*

The effect of this painting is cool in spite of its abundance of hot colors. A mood of calm was sought, through the flat pastures and the barely rising hills, with a placid sky above them. The gesture in warm sepia, needed compositionally, offers another horizontal note. Other tones in the sky are even quieter. Everywhere else there is a profusion of warm-to-hot pigment: overwashes in grayed reds; lines in alizarin crimson, alizarin carmine, pure red, burnt sienna; and some of those colors mixed with cadmium scarlet comprise a source of heat in the foreground thicket. Red-orange swipes vibrating against cerulean blue establish the slopes of the hills. Yet because all the hot colors are held in place by the horizontals of the skyline, the painting is relatively cool in spirit. Boldness here is in the choice of color rather than in the flamboyance of brushstroke.

Experiment 43

Create Elusive Planes

The object here is to free yourself from the constraint of rigid planes. Traditionally we are told to confine ourselves to two or at the most three planes in a painting. Well and good. It is a valid rule but, like most rules, it has its limitations. Here we will try for a handful of planes, some definite, some vague, and some—it could be—that seem to change as you keep looking at your work.

You will lose some definition. On the other hand, you should gain a feeling of mystery, wonder, a delight in the unknown. The viewer could get pleasurably lost in your painting. He may not know exactly where he is at any particular point, but he will be surrounded by the poignant atmosphere that you have created for his enjoyment.

Choose a theme that lends itself to a fusion, an intermingling of planes. A field of grasses, brush, and wild flowers, where territorial boundaries are indistinct, would be a possibility. You could also use a man-made theme. Try a busy street intersection where one is visually confused by the multitude of impressions, the sudden changes in neon and other lights, the pedestrians and vehicles moving in spurts of varying speeds. Mondrian's famous *Broadway Boogie Woogie* plays with the limitless, elusive planes of such a theme. Another subject might be the clutter of an attic. There the semidarkness would hide some objects and change the appearance of others, allowing you to create a feeling of mysticism out of perfectly ordinary things.

Because you are going to allow your planes to intermingle as you move from foreground to background, you will want to start with very wet washes. Use your widest brushes, and let your washes run together. As a further means of creating interplay between planes, keep your color range fairly narrow. A wide range of color—running, say, from a cool cobalt blue to a hot orange—would give you clear definition between one plane and another. You don't want this, not in *this* adventure.

The elusiveness of your planes will gain interest when you contrast them with some sharp, definite strokes. The viewer should have *some* orientation. He's in the midst of the city, or in the woods, or in the attic, or on the edge of the field. Try for some distinct touches that will give him this awareness. The planes—which you have left indistinct—will then envelop him.

When successful, your painting will evoke an atmosphere rather than render a scene. Ask yourself what emotional response you would get from this painting if it were not your own (and therefore as familiar to you as the back of your hand). Do the planes seem to lead you into and out of various corners of your subject? Do they offer some doubt, some hesitation, some resolution that the viewer himself must apply?

If everything is perfectly clear to the viewer, try again. The virtue of this experiment is that it leads you to avenues that are not, at first or even second glance, perfectly clear. Like a brilliant piece of poetic music, your painting should have its share of understatement.

Watercolor as a medium is ideal for this. It behaves best when used loosely. Studied elusiveness is a quality in a work of watercolor that would come about far less naturally in a work in some other medium. That truth should be apparent in your painting.

Abstract from a Commonplace Object

Pure abstraction, as discussed earlier, is rarely attainable because of the inability of the human mind to conceive of shapes that aren't found somewhere in nature. The degree of his inventiveness is therefore of more importance to the artist than his absolute originality. In this experiment, the directive is to find a commonplace object (or other ordinary motif) and explore to the fullest its capacity for abstract design.

Why something ordinary? Simply because it will provide a standard to measure the liberties you have taken with it. You will be working with an object universally known, seen daily by multitudes, and painted endlessly. What in it can be seen with a fresh eye? What shapes can be abstracted from it that will suddenly lift it out of the commonplace? There should be a wide gap between what you ordinarily see and what you see *now*.

It's not difficult to find something ordinary. You need not search beyond your view at this very moment. It does take a little concentration to avoid automatically overlooking things one takes for granted. But those are the very objects that are most promising for this type of study.

A telephone, for example. Simple shapes, precisely formed, clearly colored, and reflected light to play with, if you choose. A detached telephone with its innards visible would be even richer in material, although for most of us, that would take it beyond the realm of a familiar object. We know the instrument best when it is intact.

A bicycle or other functional machine with parts exposed to the eye (not sheathed) would also make a good starting point. Geometric shapes are there in abundance for abstracting. The pedaling apparatus of a bicycle alone might provide sufficient inspiration.

Even simpler—and therefore more open to your invention—are everyday objects without machinery. Take the cylinder of a spool of thread, for one. Or the thread itself, that thin filament of cotton ready to twirl in any direction. Color choice is limitless. Try a single spool exploded to gigantic size or an assortment in various sizes; you can visualize an infinity of abstract patterns here.

Another approach to the problem is to choose the most overworked subject matter that occurs to you. What does "everybody" paint that would challenge you to paint differently? They are mostly concerned with pictorial aspects of the subject. You would depart from them.

At one of the New England coastal ports, on every permissible day of the year, as you might expect, a dozen or more persons are at work sketching fishing boats and other craft in the harbor. Nothing strange about that. Boats have attracted artists for centuries, although only a few, such as John Marin, handle them in a highly personal way. The artists at the port I'm citing are little different from those elsewhere. Except for one man.

He's there with his watercolor equipment plus a pair of designers' transparent triangles. With those triangles, he reduces the shapes of hulls, superstructure, and sails to simple geometric shapes. He overlays some of these on one another and butts some of them in unusual ways. He uses still others to add interest to negative spaces. He manipulates these same shapes differently in each watercolor, and he works daily. What he produces are geometric abstractions with a suggestion of the sea. He has elevated everyday subject matter so that it's no longer commonplace. His selection of material is almost incidental to the result, since he supplies the crucial insight that develops his material.

See how far you can get from the actuality in front of you. Study the shapes themselves. Build your painting by using them solely for invention and improvisation. Use color in the same imaginative way. Local color might be appropriate to your concept but feel free to reach elsewhere on your palette. The very inappropriateness of a color could give your painting authentic originality.

"Authentic" is the key word here. Every work of art has its artistic validity. It must *work* as a painting. Sound relationships are always vital. Study your relationships until you can *see* that they work. Until then, what I have just said will be only a hypothesis. Try again on another sheet of paper if you sense that this painting misses the mark. When you have created a painting with satisfying relationships in color, value, and movement, you will see new opportunities arising. The beauty of this experiment, as with so much in art, is that the basic material lies everywhere about you.

Create Elusive Planes

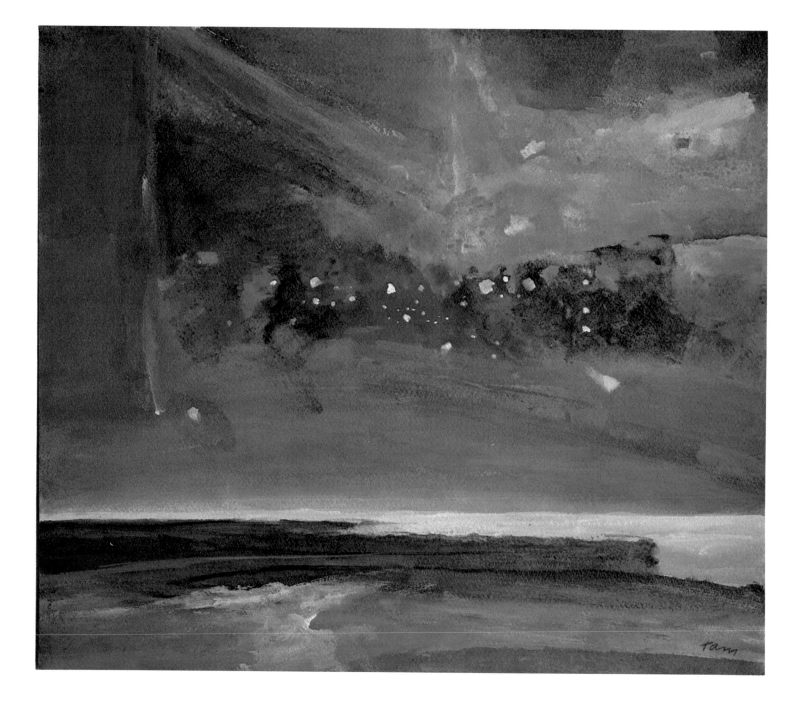

STARS 11—DARK IRON, *by Reuben Tam, 11 × 13 in. (28 × 33 cm). Courtesy of Coe Kerr Gallery, New York.*

The elusive planes of this haunting watercolor are wholly intentional. They were conceived and then patiently executed. This conscious elusiveness pervades the entire upper four-fifths of the paper—the night sky—with a more solid foundation below in the land masses. But even the land masses can be described as more suggested than defined. Detail has been avoided. In the vastness of the heavens, the eye becomes bewitchingly lost. Depth is everywhere, yet there is no clue to specific distances. One plane dissolves into another. This calculated indefiniteness results, technically, from the artist's application of thin washes, each imposed upon the previous one but letting that one shine through. Tam's medium here is acrylic, with generous use of whites to illuminate his abiding darks. His discipline in confining himself to a very narrow range of color allows his whites to perform without interference. The whites appear and then almost disappear. The resounding impact is that of the mystifying universe.

Abstract from a Commonplace Object

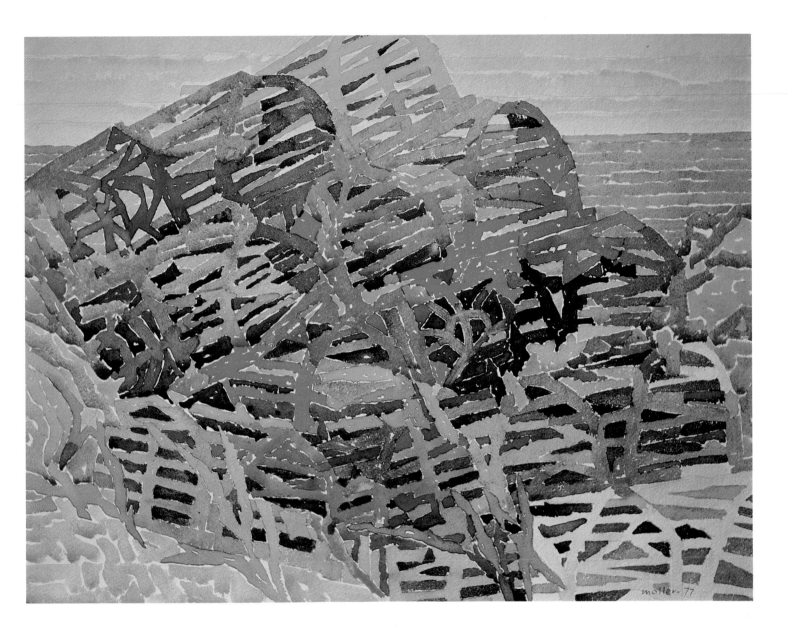

LOBSTER TRAPS, *by Hans Moller, 18 × 24 in. (46 × 61 cm). Courtesy of Midtown Galleries, New York.*

Few subjects are more commonplace than lobster traps in the output of Down East painters, as Moller, who summers in Maine, recognizes. Undaunted, he saw possibilities in them that other artists overlook. This prismatic work elevates the subject to a highly original abstract conception. The traps are merely used as a starting point, mostly for the geometric shapes of their oak lathes, fastened together for utilitarian needs. Artistic needs are fulfilled by copious injection of bright color, illuminating the natural weathered grays of the initial material used in contrast. The shapes themselves are extended, varied, and rearranged. Definition comes from light-over-dark as well as dark-over-light. The sea in the background repeats the dimensions of the lathe. Unity is a strong feature of this watercolor, growing out of the consistency of the abstract shapes. Picturesqueness has been entirely avoided.

Experiment 45

Suggest Vast Distance

Fluidity is one of the blessings of watercolor. No other medium compares to it in this respect. In this project, you will take advantage of one particular quality of fluidity—its readiness to produce an illusion of endless space. Your painting will entice the observer back into vast distance.

Boldness in painting could be defined as taking some familiar element used by many other artists and pushing it to an extreme. That extension of the path that is pursued by the pioneer becomes his own, his discovery. Distance is of course common in a watercolor painting. In fact, it is a feat to *avoid* a sense of distance. The fluidity of the paint makes this all but impossible. Ordinary distance is therefore not what we're after in this concept. Here we are seeking penetration into infinite, ethereal space where the eye becomes lost.

This illusion can be staged through the use of nonobjective shapes, but because we are striving to reach the horizon and beyond, subject matter specifically suggesting the actual curve of the earth would be more feasible. Four possibilities quickly confront us. Undoubtedly others will occur to you.

The land: sighting across flatlands, marshes, prairie, or low hills. *The sea*: looking out to where the water disappears over the rim of the globe. *Cities and highways*: from some elevation, you can follow lines of man-made structures receding to the horizon. *The air*: looking from above, as in an airplane, the earth's surface forms abstract patterns bewitching in variety, color, and shape (as discussed in the later experiment on "Paint from Aerial Perspective"). Aircraft have also opened up another new realm for the artist in the sky itself. Georgia O'Keeffe's cloudscapes are a notable example. Whatever material you use, the illusion of distance is mostly a matter of technique. Anything can appear far away if handled appropriately.

Decide first what you are going to use to carry the burden of this illusion—the earth's surface, or the sky? If you use the first, place your horizon high. You will be giving yourself generous working space to move the eye backward. If the second, do the reverse. Allow most space for the sky, as did so many Dutch masters.

The traditional rule of painting distance is to limit oneself to cooler, paler, grayer tones. This is a good, reliable rule. You will achieve distance more readily by obeying it. On the other hand, if you are careful to use clear washes, you could disobey the rule and still get a feeling of distance. Lighter application of pigment would be necessary, but warmer and brighter colors could replace cooler and grayer ones, making your work more original. Follow the rule in one painting. Break it in the next. See which performs best for you.

There are other rules that could be useful. Wetness in the distance is enormously valuable, as is vagueness. Details should be only lightly suggested, and often are best left out altogether. Narrow bands of color have an effect similar to detail. Wide bands are far more useful as you approach your horizon. Another device, particularly with land, is to add band above band, each varying slightly in color and to a lesser extent in value. Those pale bands suggest endless repetition, and therefore depth. The eye begins pleasurably to confuse what it sees in the distance and what, even farther, it cannot see but can only imagine. This illusion is heightened by keeping edges soft. Your last expanse of land should blend with your sky. This means, in technical terms, that no sharp definition should be allowed where the two washes meet.

Vastness is augmented by harmony between earth and sky. Keep the temperature of your colors and values similar. Your foreground will also make a contribution. It should come forward with warmth and detail. However, it should not demand so much attention that it turns your distance into an afterthought. Limit the number of details. Work out lines of flow that lead toward the horizon. The foreground thus serves a double function: it defines the space between your frontal plane and the horizon. It also starts the eye moving backward. Exploit its usefulness in both functions.

One more consideration: whether your horizon appears at the edge of sea or land, even at the summit of hills, it will appear quite level. This is an observable fact. Recognition of it in your painting will add to the illusion of distance.

Check all these points during the working process and again after your watercolor is finished. When well conceived, your painting will carry the mystery of a horizon that goes back far into the great beyond. Your sky will go to eternity. The seemingly limitless space of the earth's atmosphere will inspire wonder in those who view it.

Eliminate Distance

The previous experiment set the objective of luring the viewer into the farthest reaches of atmospheric distance. Now the attempt will be to strive for the elimination of distance. As explained before, transparent watercolor lends itself as no other medium does to a feeling of distance. Avoidance of distance is most difficult. Then why try?

The simplest answer is that it provides a useful method of breaking the hold of conventional thinking. Three-dimensional painting often leads to what is usually called academic painting (although this is certainly not always true). Regardless, tried-and-true methods are hardly revolutionary. This experiment may shake an artist into looking beyond the ordinary.

A more profound answer would be that to deemphasize depth brings the watercolorist more in line with significant trends in nonobjective art. In this century we have seen the rise of more than one school of painting in which the painting surface itself became paramount. What happens when *paint is put on paper* replaces the traditional scene as the purpose of the painting. The artist no longer renders what is out there in reality. He strives only for the essence of it. He does this through inventing his own shapes and hues. These speak for themselves. The viewer becomes involved in them for their own artistic qualities. He stops wondering how true to reality the creator has been. (We are talking about a knowledgeable viewer.)

Avoidance of distance focuses attention on the picture plane. Distance pulls the eye away. This is only one aspect of painting abstractly, but it is a crucial one.

How does one go about eliminating distance and concentrating on the surface of the paper? Several means should be considered. As a first step, look for a motif that can be handled in more or less flat passages, using pigment in strong intensities. Each brushstroke should cover its part of the paper thoroughly. Transparency should be minimized. Save that airy, ethereal quality for other types of paintings. Also, build connective tissue between all elements in your design. These should be bridges holding them all together. In this way, open spaces won't dissolve into the distance.

Another step is to choose colors that bring the eye forward and hold it there. Blues, especially the colder blues, are best avoided entirely or, if used, supported by warmer colors that will keep them from pushing backward. Blues should not be used to surround warm colors. Better the other way around. The safest advice is to discard cold blues altogether. Warmer colors will be more responsive.

Those warm colors should be clear and bright. Use grayed colors sparingly, and then only to intensify by contrast the neighboring brighter colors. Vivid reds, oranges, sienna, and acid greens would be your best colors. Strong yellows are helpful, too, when they are in places where they don't appear to fade off into the atmosphere.

Try also for more contrast than harmony in color. An analogous color scheme tends to be gentle rather than striking. Striking contrast will more readily rivet the eye to your painting's surface, and that is your objective now.

With these requirements in mind, let your imagination play with shapes that are vibrant in themselves. You will have your audience's attention on what you have done on the paper itself. Let the viewer explore your inventive shapes. Nuances will be quickly perceived (and monotony will dull the senses). Repetition is good so long as each repetition has its own variations.

Fluidity of paint is always a valuable asset in watercolor. Make full use of it. Let your pigment settle in its own way, following the basic shapes that you have contrived. Painting on wet paper will automatically increase variations in the way pigment flows and settles. Some painting when the paper is dry may be useful as well, especially for tightening passages that risk becoming too loose. When you have too much looseness, a sense of distance creeps in.

Wet and dry sections should be adroitly balanced. Both are useful in almost any watercolor work. In this type of painting, they have the extra responsibility of giving a two-dimensional instead of the customary three-dimensional effect.

When you have reached the stage where you feel your painting might be completed, examine it to see how close you have come to eliminating a sense of depth. Further tightening and bridge-building might be needed. Some intensification of color might be called for as well. Don't be disheartened if here and there hints of distance are still evident. As said earlier, complete avoidance is seldom achieved. What makes for a good result is to come as near to the goal as you possibly can.

Suggest Vast Distance

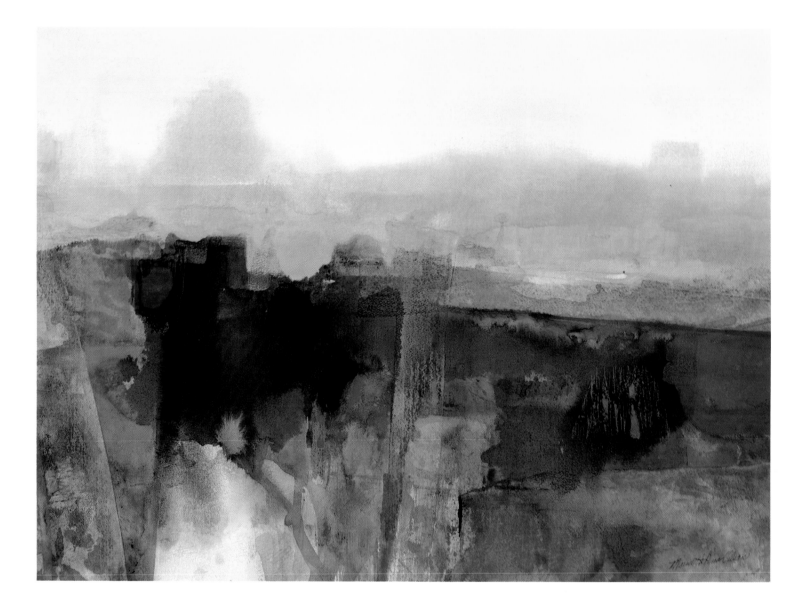

LANDSCAPE AND DISTANT CITY, *by Meredith Ann Olson, 20 × 28¼ in. (51 × 72 cm).*

Vast distance is implied here by the concentration of bold, almost geometric forms in the foreground and middle planes, with far lighter and more elusive horizontals washed in above them, fading into the distant haze. Shapes are merely suggested, and the viewer imagines what the distant city may really be like. The artist describes her method of working: "Because I love the fluid quality of paint and the light-filled landscape, it is only natural that I would start my painting with a wet-into-wet wash sky which flows into the foreground, establishing the basic atmospheric color harmony of the painting. Foreground areas are then painted. Texture is important and whatever method is applicable to achieve the desired effect is used: lift-out, blotting, glazing, scratching, stencil work, or poured ink. Suggested images are developed into trees, rocks, landforms, buildings, structures, lakes, other water, reflections, etc. Final adjustments of value and color modulation are made so that there is always a dominant light source and a gradation of values which establishes the depth within the painting."

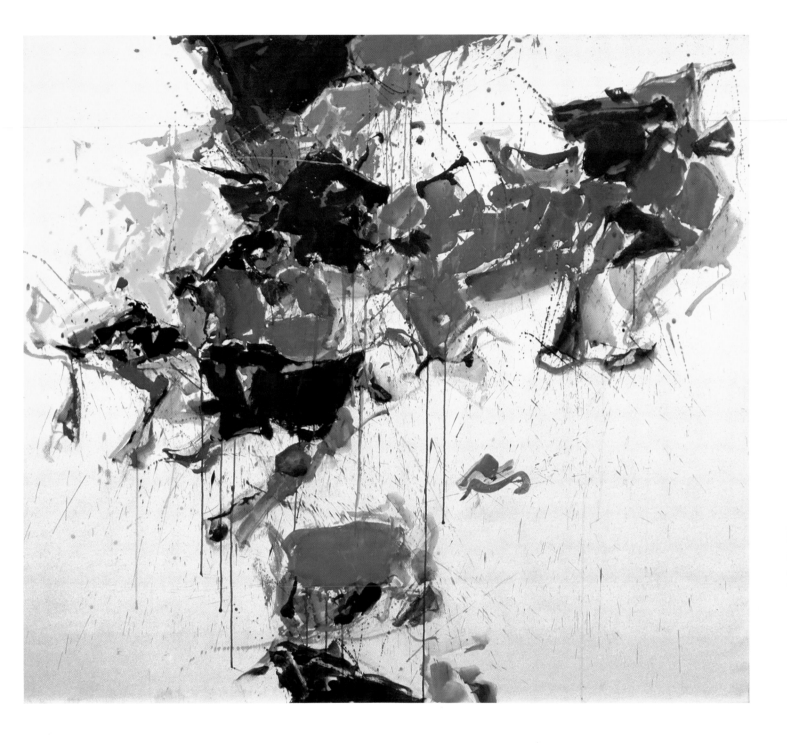

UNTITLED, *by Sam Francis, 42 × 47 in. (107 × 119 cm), William Elliott Collection.*

The artist's concern here is what takes place on the picture plane. Distance has virtually been eliminated, except that implied by light. Museum director James Johnson Sweeney, when preparing a Francis exhibition for the Museum of Fine Arts in Houston, recalled that Francis had said that one of the crucial events in his development as an artist occurred while he was recuperating in a hospital from a war wound. What began to fascinate him was the quality of light—"not just the play of light but the substance of which light is made." There is a sense in Francis' watercolors of light flowing forward from the inner depth of the work. The painting here reveals the artist's affinity to other Abstract Expressionists in his use of dripping color ánd free gesture. These devices give a deceptive air of being accidental. Actually they are well-considered elements in the construction of his composition. A Californian, Francis won his first recognition in Europe.

Experiment 47

Paint from Aerial Perspective

Try a new point of view, literally.

The sky has become a vantage point for the artist, thanks to the airplane and satellite craft. From them, everything on the earth's surface is seen in fresh ways. By imagining yourself painting from the sky looking down, you will of necessity go through an illuminating process of reconsidering any material you may have dealt with on the ground.

Refresh your memory of what the earth looks like from above. Most of us have been in flight and can recall images. For someone who has never flown, it would be provocative for him to imagine what it would be like. Truly original concepts would evolve.

Feel free to use various aids as reminders. Aerial photographs are becoming increasingly common. Surveyors, geologists, city planners, highway engineers, and meteorologists all use them. They are available in government offices and in any sizable public library. Newspapers and television display weather maps superimposed on photographs taken from satellites. A more personal aid would be quick sketches—really quick—that you made yourself while on a flight.

Aerial perspective turns commonplace material into abstract patterns. Even when handled pictorially, scenes will *appear* to be abstract. Clichés like running brooks, fishing boats, covered bridges, church steeples, mission compounds, lighthouses, and salt marshes can be converted into magical shapes and patterns. But remember that abstract forms, whether observed or invented, require the utmost organization of artistic skills. The artist cannot lean on the viewer's familiarity with his subject, because it won't be familiar. He must create a convincingly felt image on his own.

Selection is of first importance. So much is seen from the air! In your preliminary sketches, find a few simple shapes that interest you the most. Exploit those shapes and repeat them. Find bits of contrast such as spherical patches of snow surrounded by evergreen woods, rich in blues and violets, contrasted to thin ribbons of color representing frozen streams. Straight highways could intensify the effect of wide rectangles of fields, giving you a geometric concept where repetition is interrupted just enough to pique interest. Buildings offer specks of color, in cities and out in the countryside. Boats do the same when you are working with an expanse of water.

The sky itself is fascinating. Clouds lighted from above appear totally different from the way we see them from the ground. And the shadows they cast on the earth produce bold patterns. These lend themselves to the unique qualities of watercolor such as free-flowing washes with their capacity for ethereal gradations. Select what you need for the basis of your painting and ignore the rest.

Selection of color is also challenging, as always. Choose one or two to dominate, not the gamut. In an aerial view, you also have at your brush tip another quality in which watercolor excels, the opportunity to paint atmospherically. The transparency of the medium, with its soft and blending tones, lends itself beautifully to rendering color in the air. The atmosphere itself diffuses glowing color, and the earth seen through the atmosphere changes in tints not seen from the ground. Haze, mist, air layers, and clouds bathe the terrain in differing light and color. Don't overlook smog, either. Those grays seen by the artist, if not welcomed by the ecologist, are of aesthetic delight. Smog picks up and diffuses sunlight. A modern city transforms dawn and dusk in ways unknown in earlier times.

Again, be careful to select. The atmospheric qualities just described may appeal to you most, or you may be attracted by crisp patterns seen in clearer light. Don't try for both in one painting.

By the very nature of its theme, your painting should breathe expansively. Wide, sweeping vistas are what are seen from the sky. Nothing is piddling. Work for a high and wide horizon, if you are using the horizon, or for a feeling of vast depth in the distance to replace a visible horizon. Both sides of your watercolor should suggest that your theme extends infinitely, rather than being hemmed in by the limitations of your paper. Avoid any semblance of a vignette. Whatever accents you use should also dramatize the largeness of your subject.

Conventional handling of perspective does not pertain to sighting from the sky. The land immediately below is miles distant. Horizons are farther away than when seen from the ground. Curvature of the earth can often be noticed. You will want to imply these intrinsic differences.

Painting as if from the sky is obviously not something one masters in an afternoon. You will no doubt need to work at this experiment repeatedly until you get a satisfactory result. A painting that succeeds will appear abstract even if its material is pictorial. It may stress transparent atmospheric phenomena. It will certainly convey a feeling of vastness.

Let Your Paint Flow Freely

Big sweeps of intense color can stand alone. Painters in oil and acrylic have discovered that nothing else is needed when the forms are original and there is close relationship between positive and negative spaces. Two superb examples come to mind: Helen Frankenthaler and Morris Louis. Watercolorists exploring the same concept have an inherent advantage. No other medium possesses such fluidity. Witness the fluidity in the work of Paul Jenkins appearing in this book.

This experiment seeks to exploit fluidity. Self-discipline of two kinds are essential requirements. First, you must school yourself to avoid irrelevant details. One ill-conceived bit of busyness can spoil a painting's effect. Second, maximum forethought must guide your planning. You will be dealing with fast and free-flowing pigment. Therefore, accidents will happen rapidly. You must be able to react instinctively to sort them out, using what fits into your preplanned scheme and eliminating all others.

Freedom is never sloppiness. Only the disciplined artist has real freedom to take advantage of opportunities that arise, and this is especially true when you are handling flooding ribbons of paint. While flowing forms seem to take over, they always arise out of the artist's clear prior conception of what he is after. Working in this kind of extreme looseness, you must be prepared for endless failures. Be ready to discard more sheets of paper than you eventually preserve. The failures will help you prepare for the future successes.

Experiment with all-wet or all-dry paper first. Later you can combine the two. Use large sheets. Their scale will heighten the drama of your work. Also use plenty of pigment. Heavy saturation will be needed to avoid a faded, "pastel" look. Try first using a sheet fastened to a block or mounted on a board. Another time you may want to use an unmounted sheet, which I shall discuss later. The mounted sheet will offer sufficient challenge for a start.

With all-wet paper, your pigment will flow in all directions. Once you have applied a dash of intense color, or several dashes of different colors, tilt your paper in a predetermined direction. The pigment will flow pretty much as you have planned. Then try changing the direction of the tilt. Paint will also change direction, possibly flowing back upon itself, creating a variety of pools and rivers. Keep adding dashes of paint and keep tilting until you get the result you want.

All-dry paper will result in streams of color in more clearly defined paths and spread will be minimized. Therefore, you will need more paint. You will be wise to have your colors already mixed on your palette, in abundant quantity. Some artists assure themselves of a quick supply of sufficient paint by mixing it in cups or dishes. A muffin tin from the kitchen is a handy device for this purpose.

Again, as with wet paper, tilt your paper to let the pigment run in preconceived directions. One stream will most likely flow into another. This mixing on the paper will bring about dramatic variations in color where the two streams meet. Let this happen. If you don't like the results, a quick daub with your tissue or sponge will remove them. You can, of course, alter the color of a stream by adding new pigment with a loaded brush. This should be done only when really necessary. The original color usually works best—and you won't be in danger of losing the spontaneity.

After you have become reasonably comfortable working with all-wet and all-dry sheets, venture into a painting that combines the two. Start with your paper wet. Flow your paint into most areas, leaving others open until the paper starts to dry. Then flow new paint into those dry or drying areas. This is a highly complicated procedure. Failures will be frequent. Eventually you will discover the proportion of wet to dry that you can handle best.

You should be ready now for heavy unmounted paper. But remember that it is very tricky to handle. A sheet controlled only by your own hands requires extreme confidence as well as an aptitude for acrobatics. Now you will be controlling those rivers of paint by holding your sheet in your hands and manipulating it without the benefit of a rigid backing. The paper will dip and bend. There are bound to be troughs into which the paint will run. You will need all the agility you can command to get it to flow where you desire.

If and when you do you will have a fusion of color and value that cannot be produced in any other way. Nevertheless, an underlying control should be evident. Your innate sense of composition, along with your taste in color, will instinctively transmit signals to your hands. The result might be called an involuntary statement of freedom.

Paint from Aerial Perspective

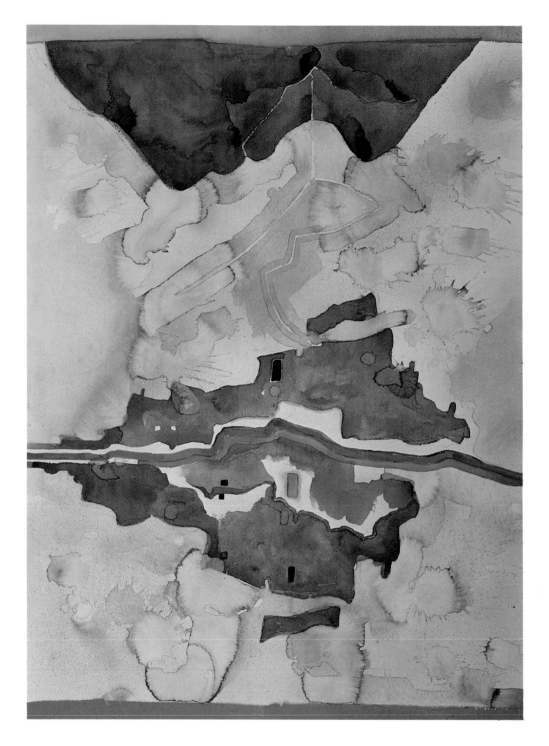

TAOS PUEBLO, *by Keith Crown, 30 × 22 in. (76 × 56 cm). Collection of Edward Baumann.*

Painting as if from the sky allows the artist to take his stance wherever he wishes, and even to take several positions. Multiple images are often used. Here the artist created a positive force at the top in the form of a mountain shape, painting it upside down so that it would lead the eye downward to the ancient adobe building in the center, which is painted twice, almost in a mirror image. "The painting is signed on both ends," the artist says, "indicating it can be hung both ways. Changing the way it is hung (many of my paintings are signed on two, three, or four sides) changes the effect of the painting and re-energizes its power of interesting us." His subject is generally "before, behind, above, below, on all sides. I endeavor to make visible much that cannot be seen but is there." Here the rhythmic contours of the adobe building help to make the unseen visible and the strong bands of color at the top and bottom prevent the eye from wandering aimlessly out of the picture. Crown's contrast between the expressive fluidity of his washes and the posterlike formality of his composition lifts his work far above the banality in which such touristic subjects are usually handled.

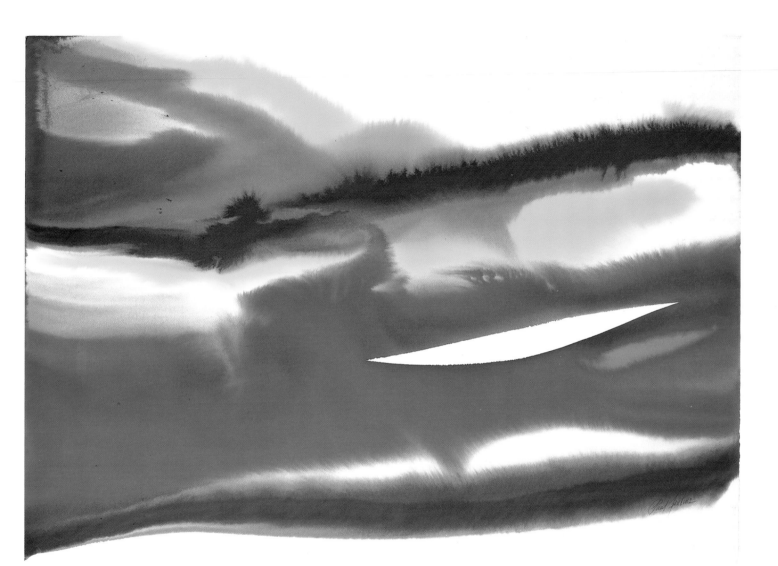

PHENOMENA UPPER NILE, *by Paul Jenkins, 29³/₄ × 41³/₄ in. (76 × 106 cm). Courtesy of Gimpel & Weitzenhoffer Ltd., New York.*

This large work shows the result of applying pigment in deep saturation and letting it flow freely on a wet base. The paper has been tilted with skill, producing four triangles that softly intrude upon neighboring shapes. In vivid contrast to these soft notes, the artist has composed a slender double-pointed ellipse on dry paper where the flow suddenly comes to a halt. This shape moves obliquely through the flowing strands of light-filled pigment. It serves as their focal point, removing any suggestion of randomness to the composition as a whole. One experiences a feeling of grandeur in Jenkins' work. His shapes and division of space are always large-scale, and his color intense. No passages are allowed to become opaque, however. The artist is faithful to the nature of watercolor as a medium. He accepts, rather than rejects, its capacity for luminosity, and exploits it to the fullest.

Experiment 49

Introduce Sparkle with Salt

This experiment deals with an aid that's frankly a piece of showmanship. Salt will give a watercolor a sparkle that can't be obtained in any other way, a sparkle that has a kind of stardust magic. But don't make the mistake of thinking you have stumbled on a secret that will revolutionize your work. It's probably just as well that there is no such secret. Artistry must depend on integrity and imagination more than on any technical aids you can summon. Without those greater values you are lost. With them, aids can be of considerable assistance. Bearing in mind this built-in limitation, I would recommend you try any feat of showmanship that could add new energy to a painting. Salt is one of them.

Ordinary table salt? No, that would just give a fine, granular texture to the surfaces of your washes, a texture barely visible unless you look closely. (On the other hand, painting entirely with salt water instead of fresh water does change the character of a painting. Sea water gives an interesting graininess. A drawback is that the brush moves a trifle sluggishly.)

The salt to be tried has heavier grains or crystals than the usual table salt. Still, they are not as coarse as rock salt. This in-between salt, and it is fairly common, is usually sold as kosher salt. Its household uses include canning, preserving, and pickling, which is the reason many stores that don't carry other kosher food products stock it. Kosher salt comes in a large box. It will last a long time, even if you get addicted to using it in your work. Dampness is less apt to cause it to solidify in the box than fine salt.

Briefly, what happens when you apply this salt to a wet area of a painting is that each of the multitude of salt particles absorbs a bit of paint, leaving a speck of either the underwash or bare paper showing.

Plan your painting in your usual way, keeping in mind the areas on which you are going to use salt. Paint those areas a bit heavily. The salt will pick up much of the pigment, giving you a lighter overall feeling than you would otherwise have. Salt must be applied while the area is wet. However, it need not be limited to a large wash. You could also use it on later, secondary washes and on individual brushstrokes, but always while they are still wet. Here the salt will pick up the top, wet coat, leaving specks of the underneath wash exposed.

Apply the salt by sprinkling it on the area where you want it. How much should you sprinkle? That's almost like asking how much salt in the soup. It's a matter of taste. It's also a matter of testing how much salt you need for the effect you want. Too much salt may give you a colorless glob. Too little may give you results that are hardly visible. Try a little at first. You can always add more while your area is still wet.

Leave the crystals until that portion of your paper is fully dry. The action of the salt will delay drying beyond the usual time. When the paper *is* dry, brush off the salt. You will note that this instantly changes the appearance of your painting. While the crystals were sitting there, they showed up as dark dots. Now that they have been brushed away they leave a lasting spray of sparkles.

You will discover that the salt works differently on different pigments. Sparkle will be intense with some, almost not worth using with others. The thalo (phthalocyanine) colors come to grips with the salt nicely. So do some alizarins. You will have fun testing the mixing properties of the contents of your tubes, but don't count on anything until you have tried them a number of times. The water you use may contain chemicals that will affect the reaction of the salt.

Study not only the various reactions, but how they contribute to your aesthetic intentions. You may decide that this new milky way effect gives you valuable reinforcement. Should this happen, it will be much more than just a trick.

Lift Out White Lines with Tissue

Freedom in painting includes the ability to follow one's special skills and then let oneself go in an appealing direction. One man's freedom is another man's poison. Some of the experiments in this book may be uncomfortable to some readers. The one to be discussed here is one that I find satisfying. Whether or not it is for you can only be tested by giving it a try.

What I have termed "returned white lines" are lines formed when a rolled or twisted fragment of facial tissue is firmly pressed upon a wash while it is still wet. The tissue will absorb most of the pigment, leaving a whitish line with crinkly edges. Sometimes all the paint comes up. In other places, a pale glaze will remain. The effect is somewhat like painting with Chinese white, but looks less mechanical, less contrived. In fact, the beauty of returned white lines made with tissue is in their informality. They may even appear erratic.

They should be used only in certain motifs. Try them first in a landscape or seascape. If they work there, you could then apply them to other motifs and perhaps pioneer new uses of your own. In a landscape, they will be particularly effective in picking out tree trunks and branches. In a seascape, they give a sharpness to distant surf and a vividness to wide movements of flowing water or foam.

Sketch your design as you would do ordinarily. Wet your paper thoroughly and apply your basic washes. Give these washes *more* pigment than usual. The tissue will absorb some of the pigment, so you must compensate for this in advance. Certain colors will be absorbed more readily than others. This depends more on the chemical composition of the brand you use than anything else. You will have to experiment with them. One manufacturer's thalo green, for instance, may have more staying power than another's.

Another factor is the absorbency of the brand of tissue. This may seem like a minor detail, and it is; but so often in watercolor, attention to detail may be decisive. Experiment with different brands and you will quickly find the one you like best.

Take whatever tissue you now have in hand and rip off a strip an inch or so wide. Roll or twist this into an irregular strand. Then, *while the wash is still wet*, place the strand on the wash where you want it, being careful not to let your fingers touch the paper. Then press the tissue down with your fingers or with the side of a brush handle. Remove the tissue, again avoiding touching the paper with your fingers. Use a clean, dry strand for your next returned line and for each succeeding one. A used, wet strand will muddy the wash and perhaps even leave a bit of unwanted color picked up from the area where it was previously used.

You can then add brushstrokes of deeper color up to the edges of your new returned lines. Perhaps you will want these strokes or perhaps not, or you may want them in some places but not in all. You will, of course, get different effects as you try the various possibilities.

Even more subtle and delicate returned lines can be obtained by using tissue in another way. Instead of rolling the tissue, lightly place the corner of a flat piece of tissue on a wet wash. Then take a brush handle or knife handle and impress lines on the tissue where you want them. The lines will show up as white, or near-white, on the wash.

Since you can't see through the tissue to your paper, you won't be able to count on placing the lines precisely. Some of them will appear in places slightly different from where you hoped they would be. This accounts for the informality or erratic quality mentioned earlier. Working partially blind, you will get some unpredictable results. Let's hope they will inspire you to alter your original concept a bit to take advantage of them. They may turn out to be pleasant surprises.

This method of using tissue works better with some colors than with others. Again you will have to experiment. Also, there's the danger that a wayward part of the tissue might pick up paint where you don't want it picked up, or even sully the purity of a wash that you wish left untouched. You will have to take your chances and judge whether or not a particular line is worth taking a risk to get.

Once you have gotten the lines as much to your liking as possible—and you will have to do this quickly before your washes dry—you can proceed more slowly. Finish your painting in the usual manner, working around and with your returned white lines. You will now see what the lines have done to give a new dimension to your theme. Being brightly white, they will stand out. If you enjoy this luminosity, you will have acquired a new tool.

Introduce Sparkle with Salt

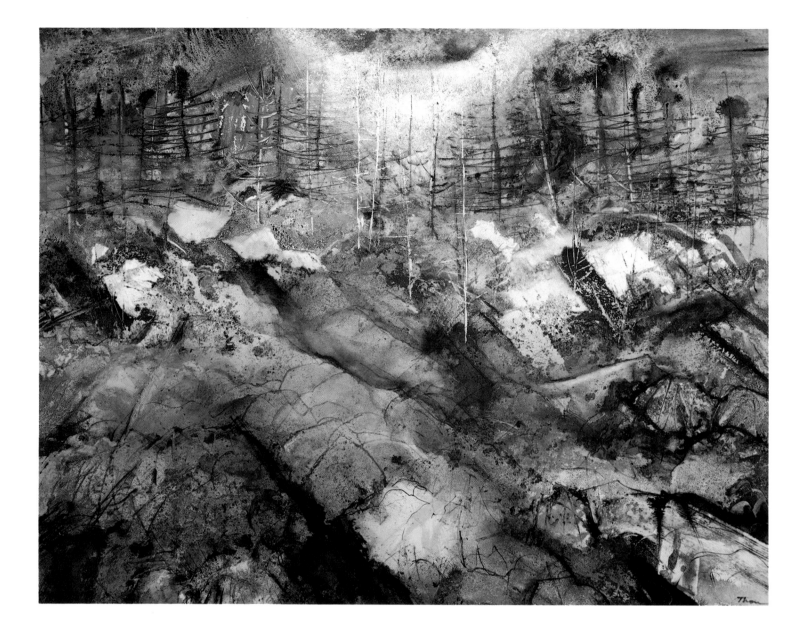

OUTER SHORE, *by William Thon, 20³/₈ × 27 in. (52 × 69 cm). Courtesy of Midtown Galleries, New York.*

Thon is a virtuoso of texture. His landscapes, such as this one, show tactile sensitivity in both the representation of forms and in the negative spaces surrounding them. Depth is evoked not only by the pigment itself but by cutting, blotting, sponging, sprinkling, inking, or spraying with an air gun, all insinuating a feeling of brooding mystery. Emphasis is on letting the white of his paper glow through his texture. Washes are given a maximum of modulation, through application of many materials, much as is suggested in the experiment on salt. Thon returns to rework passages repeatedly, but without ever permitting an appearance of fatigue to injure the freshness so essential in a watercolor. Scraping with a razor blade, he explains, will often renew a sensation of light. A native New Yorker, he is more closely identified with Maine, where his base is a fishing village along the coast. He also travels and paints extensively in Ireland, Italy, Greece, and Spain.

FOREST VIBRATIONS, *by Lawrence C. Goldsmith, 18 × 24 in. (46 × 61 cm). Collection of Betty Wineman.*

The whitened lines that stand out here were made with folded and twisted strips torn from sheets of facial tissue and pressed down on wet washes. They picked up most of the pigment, thus returning the white of the paper. These lines are not regular in shape. They respond to the irregular dimensions of the tissue and the random pressure exerted by the fingers of the artist. They were used here in conjunction with actually painted lines, with an occasional application of spatter, and with several more common technical procedures. The returned lines, however, give a special quality to a watercolor that is not easily obtained in any other way. Here they represent the light that sifts through a forest buffeted so constantly by heavy weather that few of the trees ever grow tall. The forest's limits are marked by a small, flattened triangle of deep thalo blue in the center of the work, identifying the distant ocean—one of the few touches of realism. Literal features of the locale were eliminated in favor of allowing fluidity to express the emotions felt by the artist while surrounded by the forest.

Experiment 51

Introduce Scraping and Scratching

Since the surface of watercolor paper is so delicate, whatever you do to it is immediately apparent. In this experiment, in addition to painting in the usual way, you will be using a knife, dental probe, plastic card, brush handle, or some other sharp or blunt instrument that will be applied to the surface. The objective will be to produce artistic scratches.

This technique can be tried with handsome results on many kinds of paintings. The subject doesn't matter. Quality of paper does. Heavy, compactly molded paper works best (as contrasted to softer papers). As for surface, interesting but different effects can be achieved on rough and cold-pressed papers, and still others on illustration board. You will encounter trouble with rice paper or other thin paper.

One general principle: the beauty and clarity of your scratches depend very much on the wetness of your painting area. Some of the instruments must be applied when a passage is wet or damp. Others are productive only when the paper is dry. You will have to experiment repeatedly to take advantage of the best moments. The instruments that perform best on wet or damp areas are a blunt knife, the pointed handle of a brush, and the corner of a plastic card. A sharp knife and any of a variety of dental probes are effective when the paper is dry.

Blunt knife. I like a cheap table or picnic knife with a handle that can be gripped easily and a steel blade that's never really sharp. Its point is somewhat rounded. The blade is flexible enough to bend with a variety of motions but is not so springy that it seems to have a mind of its own. Use the point with sweeping gestures, pressing fairly heavily on the paper while your paint is still wet. (Nothing will show if you scrape wet paper that has not yet been painted.) The knife makes a narrow gully, pushing pigment out of the trough onto either side. Thus you get a whitish line. You can repaint up to this line, or even cover it, but once you have applied the knife, some trace of the line will be permanently visible. Because this kind of knife pushes paint aside, you can sometimes get an interesting effect by continuing a line from a still-wet painted section into an unpainted wet section or even a neighboring dry one. In a wet section, some paint will spread. In a dry one, the knife will pull paint into it from the painted section to form a more definite line. The handle of the knife can also be used. When en-closed in a sheet of tissue, it makes a bulky line as you push it along the paper.

Brush handle. Some watercolor brushes are made with the end of the handle cut on a slant, leaving a sharp-edged oval surface. This is useful in pushing paint aside and restoring the white surface of the paper. You can get firmer control than with a knife blade, since the brush handle doesn't give. You could also try the handles of other watercolor brushes, but be sure the handle is strong enough for the pressure you exert on it. You won't want to break your favorite brush.

Plastic card. The card can be cut with a pair of scissors, and the resulting sharp corners make a useful tool for picking out lines on a wet surface.

Penknife blade. With extreme care, you may be able to use a penknife blade on a damp passage to scratch lines. On a dry area, the sharp point is especially helpful. The point will either give you a rather regular, thin line or a multitude of various dots in a line. The personality of your own touch will also be evident, making your line different from that of someone else. Once a line is scratched, it will stay, so try to put it where you want it the first time. If you don't quite succeed, it may be better to leave it alone rather than make another line close by. Lines like this are best used sparingly.

Dental probe. Dental probes or picks come in an astonishing variety. Some have fine points at the end of a springy or rigid prong. Others are more blunt. They are made so that the working end may be at almost any angle from the handle, and you'll have to discover what they can do for your watercolors. Use them after a passage has dried.

Ask your dentist to save you his discarded tools or buy a set of standard probes from a specialty hardware company. They may not be called dental probes—they may be called microprobes or some other coined name. You should be able to recognize them anyway.

Any of these devices for scraping is capable of giving variety to a watercolor. Quite the opposite of adding accents, you will be removing paint. Don't use all the devices in any one painting. Keeping track of the wetness and dryness required in the use of any single one of them is difficult enough; also, overdoing scratches gives a watercolor a busy, worried look.

Crumple Your Paper First

A watercolor often owes its success to the artist's ability to improvise. We are dealing here with the most unpredictable of media. The artist who can grasp a situation quickly and make profit out of it has a prize talent. Some methods, such as working with running streams of color (see the earlier experiment on "Let Your Paint Flow Freely"), are wholly feats of improvisation. Another method will be discussed here. Its basis is a sheet of crumpled paper.

Crumpling the paper in advance virtually nullifies any plans except very general ones. You can select a color scheme, of course, and stick fairly close to it, and you can have a broad notion of the impression you want your painting to give. Beyond that, you are wise to leave things to chance and to rely on your resourcefulness. Opportunities arise unexpectedly because of the random crevices and ridges produced on the surface of your crumpled paper, as well as for the usual reasons opportunities arise when working in watercolor.

To exploit these abundant opportunities, start with a large (half or full) sheet of quality, heavy paper. A high rag content is necessary so that the paper can take a beating and not pull apart. Considerable weight is desirable for much the same reason, so use 200 lb. paper or heavier.

You may feel this to be slightly costly, and so it is, especially when you consider how many of your efforts will be discarded. This method of painting has a high incidence of disappointment, so be prepared for numerous throwaways. You can hedge your investment, however, by using the reverse side of other paintings that didn't satisfy you. With quality stock, the reverse side will work as well as the face.

Block in some pencil drawing and then immerse your sheet in warm or cool water (you run the risk of deterioration with hot water). A bathtub or large sink is useful here. Let the paper soak for at least twenty minutes, turning it over occasionally to make sure all of it gets a good bath. Then reach in and crumple and squeeze with zest. Don't try to make folds. Let your palms crush the paper at will, just as if you were crumpling a paper bag to be thrown away. Then take the paper out of the water and lay it down on your drawing table. Allow it to flatten itself without much help from you. It will still be crumpled.

You now have your working surface—a crazy quilt of rises, creases, hollows, and ruts. Get started while it is still sopping wet. Apply strong washes. Use generous dashes of spatter. Squeeze drops of pigment out of your largest brushes. Mop up places with paper tissue, or press tissue down firmly to restore the white of your sheet. What I am suggesting is the use of any or all devices that appeal to you as you go about pulling a painting together out of the opportunities forming in front of you.

One improvisation will lead to the chance of making another. You can keep going for long spells, washing out areas and rewetting as you see fit. This is not an exercise in delicacy. Starting, in effect, by manhandling a sheet of paper, you continue to get volatile effects only by boldness. Meticulous efforts will be wasted. Look for ways of creating strong sensations.

Your work most likely will have an overall network of design. With color evenly distributed, it would qualify as a color-field painting. You could also make sure that your color is not evenly distributed. Either way, the marks in the paper made by the initial crumpling will be an important element in your design. Welcome their contribution.

Although your efforts may have been applied in what seemed a most random manner, the accumulation of those efforts is bound to create a complex work of art. Therefore, don't make a quick decision that the painting is finished. Let it dry thoroughly. Study it from time to time. Put it away and come back to it for a fresh look (it may spring surprises). You may decide it could stand another bath and further work. Conversely, you may feel that your improvisation has reached a happy ending. If so, review the steps you took that could be repeated at other times. How much did crumpling, as well as other technical ventures, contribute? What could they offer to new and even bolder concepts?

Introduce Scraping and Scratching

NORTHING, *by Lawrence C. Goldsmith, 18 × 24 in. (46 × 61 cm). Collection of Martha and Edward Slowik.*

Scraping and scratching are usually auxiliary devices to increase textural ornamentation, but here they become major contributors to the design, producing staccato effects. A wash of blues and grays was first spread over most of the paper, with some areas left bare so that they would relate to the white lines that would be etched later in two ways. Some were effected by pulling a knife blade (held obliquely) through the wash while it was still wet. Others were made after the wash had dried by scratching with an assortment of dental picks and probes. To provide value contrast to the white lines, still other lines were painted in fairly dark pigment. Thus some bright strands of color alleviate the more somber washes and the purity of the white, and fragments of color create accents. The motif behind this watercolor was the white light filtered through fog shrouding a particular stand of trees. Many of the trees were encrusted with lichen. The light of the lichen was so similar to the light of the fog that everything on the site seemed to fuse together visually. The aim was to transmit this all-engulfing light with only a few, spiky branches penetrating it.

Winter Day in Central Park, *by Dale Meyers, 21½ × 33½ in. (55 × 85 cm).*

The cold, blustery atmosphere so convincing in this watercolor results from a gamut of techniques. The artist (who lives just off Central Park in New York City) describes how she makes her choices: "I mix my acrylics or watercolor in jars, and, using various methods of application such as printing, or crushing, or you-name-it, I get an impression. Sometimes I study some of these impressions for years before I can make up my mind as to what direction I should go. I have been known to change my mind right in the middle of a painting—not always for the better." Her variety of techniques enables her to find new solutions to problems. "It is important to me not to become static in my work. Instead of using one formula with little change, I try to experiment with various techniques, always keeping in mind that the overall abstract pattern underlying any painting is far more important than a tricky surface technique, and more satisfying to one's artistic aims."

Experiment 53

Introduce India Ink

Pen and ink can be used in a variety of ways in a painting that's basically a watercolor painting. In this experiment, you'll concentrate on integrating the ink lines with the watercolor effects. This differs from merely imposing one medium over another.

India ink has come to be a generic term for any good black drawing ink, whether it originates in India or anywhere else. It can still be made from an ink stick moistened in water, with the artist doing the work himself. Much more handy are the bottles of drawing ink made for use in a fountain pen or straight pen, or infused into a pen-held felt tip. One of the most sensitive artists I know uses none of these. He whittles the twig of a spruce tree into a sharp point. Since each such implement is unique, it makes a highly individual, often-changing kind of line.

Brands of ink differ in the "color" of their blackness. Even in black there is coolness or warmth. You also have a choice between waterproof and nonwaterproof inks. Labels on the bottles identify the contents as one or the other. Both inks will dry completely and then cannot easily be smudged. The difference is that nonwaterproof ink can be moistened after it dries, and waterproof ink cannot. Were you to run a watercolor wash over the first, you would pick up or spread some black. Running a wash over the second would leave the lines intact. Both waterproof and nonwaterproof ink can be manipulated by a damp brush while the ink is still wet.

Since the idea here is to integrate ink drawing with watercolor, don't make your initial drawing in ink. (You would most likely wind up with an ink drawing with color patches, shifting the emphasis away from a fusion of the two media.) Start with a pencil drawing, perhaps a bit less detailed than usual. Mentally foresee where you will be drawing lines in ink later.

Apply your major watercolor washes, and start some development of middle-stage effects. At this point you will want to start injecting the first of your ink lines. Experiment with some on dried areas and others on wet. The ink will shoot out in fascinating ways on wet or damp paper. Let the ink run here and there into wet washes. In other places, use it to extend dark patterns, for outlines, or for conspicuous accents. Try as much as you can to connect ink with watercolor.

The ink lines may suggest places to pick up your brush and work again in watercolor. You can add ink work over watercolor, or do the opposite. Always consider which type of ink you are using. The dried waterproof ink will not budge. The dried nonwaterproof ink *will* (thus giving you a wider range).

I haven't said anything about paper because it would be wise to investigate first what ink lines can do for your customary line of watercolors. Later on you may become interested enough in ink to let that be your dominant medium. Then you may want to try paper that's smoother than your usual watercolor paper. Your pen will glide with more facility across the sheet. Conversely, a rough texture will cause exciting accidents.

Also try getting a sheet of rice paper with stiff fibers embedded in it. They will trip your pen point, cause it to jump, or trap it so that it spills a small pool of ink. All sorts of things can happen. With that kind of paper, your watercolor washes are likely to form puddles. Whether you find that challenging or frustrating rests with your own inclinations.

One of the advantages of working with ink is that it allows you the use of greater finger dexterity. As with a brush, it is *possible* with a pen to make blunt stabs, but their bluntness will be much more noticeable in a fine ink line than in a much wider watercolor brushstroke. Therefore you will quickly discard this rather crude approach and work toward more individual, graceful lines. Since your fingers more than your wrist come into play in guiding a pen, as compared with wielding a brush, you can work with great sensitivity, expressing your most subtly felt intentions. A by-product of this improved dexterity and finesse is that you can carry it over into your watercolor painting. Greater awareness of what your fingers are capable of with ink will extend to more expert handling of a brush. Almost automatically you may begin to orchestrate twisting and turnings, heavy and light pressure, in your strokes.

Practice Calligraphy

Calligraphy, a word derived from the Greek, literally means "beautiful writing." Writing with a brush is a well-known technique of the experienced watercolorist. Here I'm suggesting that you practice calligraphy in new ways to enlarge its potentials for you. Work out a painting or paintings in which it becomes the most noticeable feature.

Some artists—Mark Tobey is the best known—have pushed the frontiers of calligraphy so far that it has become their chief means of expression. Using script-like characters repeated with variations throughout their paintings, they build overall patterns of decoration. In feeling, the work is like mosaics made with a brush.

More commonly, calligraphy is used to heighten the effect of other elements in painting, serving to accent an already developed passage and to identify the nature of a particular spot. Although this kind of writing is not literal language, it *is* language. As John Marin said, "Art is just a series of natural gestures." These gestures say clearly to the viewer what the artist wants the viewer to recognize.

How is this done? And how can it be done in different ways so that it becomes a rich vocabulary? Like any other language, its powers of expression grow through dedication and practice.

Calligraphy can be produced with any nicely pointed brush. A particularly versatile one is a long, thin, pointed red sable brush that's called a script liner (or rigger). This brush makes a delicate line of varying thickness that, because of the flexibility of the long hairs, responds physically to the emotional tremors of the artist's fingers. Thus highly personal lines are produced. All calligraphy has this characteristic to a certain extent, but a script liner makes it most evident. Adding one to your equipment is a good investment.

Using this or another brush, practice on available scraps of quality watercolor paper. Decide initially upon the feeling you want to convey. Nervous tension? Lines with abrupt, jagged, sharp corners should get that feeling across. Rhythm? Here more rounded, bil-lowy lines are called for. Pleasure from a tactile surface? Try dots, dashes, or a field of short, slashing lines. Mysteriousness? Let ends of your strokes disappear into depth by dissolving them with a damp brush.

Next, see what calligraphy can accomplish in giving a sense of movement. Upward strokes, of course, push the eye skyward in a spirit of exaltation. Horizontal strokes move the eye across the field and expand your feeling of space. Diagonal strokes increase the action in your painting.

Practice color usage. Hot lines are more emphatic than cool ones. A calligraphic symbol in color can be used to increase tension when that color repeats one you used in some distant, larger area of your painting. A squiggle on a large area in the same but more intense color will quickly add definition to it.

Value changes—especially darker strokes—also vary the emphasis of a passage. Try similar squiggles in a dozen gradations from very light to very dark.

Invent your own alphabet. What, to you, best identifies a mass of pebbles, a crowd of faces, or the shapes in a particular kind of foliage?

After innumerable exercises of this sort, you will be ready to see what can be brought about when calligraphy is used as the *major* motif of a work of art. Wash in color on a large sheet of paper and let it dry. Then plot a design using much of the vocabulary you have already acquired in your practice discoveries. Vary color, value, and direction. This will be a painstaking operation. Your hieroglyphics—which is what pictorial characters really are—can be painted quickly and boldly, but they should not be done thoughtlessly. (Watch a sumi craftsman at work. He makes a quick, nimble stroke, but before he does, he pauses for a moment of contemplation.)

Your finished painting will be busy—harmoniously so, let's hope. It will then exemplify well-organized activity. The experience may lead you into deeper study of calligraphy. More likely, though, you will want to work a measure of it into other techniques.

Introduce India Ink

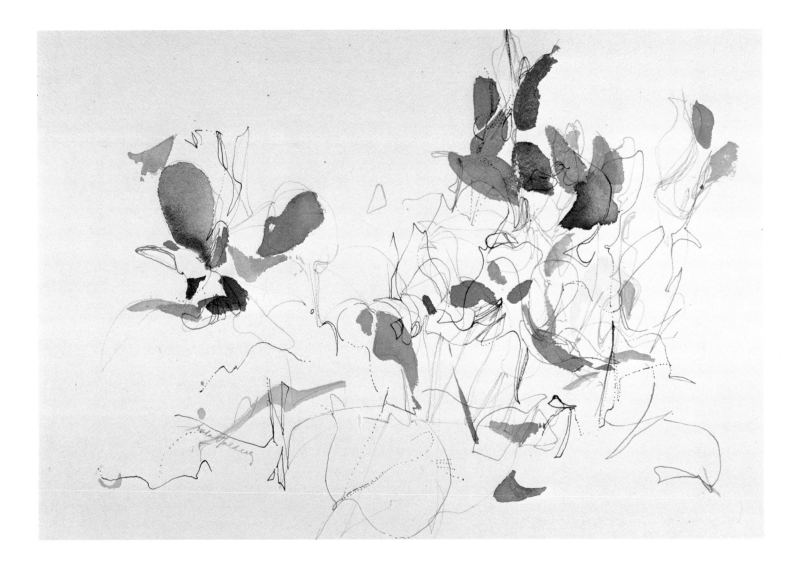

GARDEN BREEZE, *by Frieda Golding, 11½ × 14½ in. (29 × 37 cm).*

This artist sometimes begins by drawing in India ink, and sometimes introduces it later, but it is always essential to her painting process. She feels that initial line work gives her "movement and flow to establish the mood." When she saves it until later, it provides definition to the forms and patterns already contributed by her work with watercolor paint. Either way, she sees line as expressive and "when combined with the excitement and immediacy of watercolor gives a personal and emotional response" to the living things that inspire her. She favors a small sheet of paper so as to retain the intimate quality of her perceptions, which come about through glimpses of a garden or wild flowers growing along the roadside in Carmel, California, where she lives. Out of them evolve lyrical paintings, where imagination replaces literal observation. Forms capturing the essence of her material dance about on her paper, darting and fluttering. Her delicacy is neither static nor effete; one senses a celebration of life in her modestly scaled work.

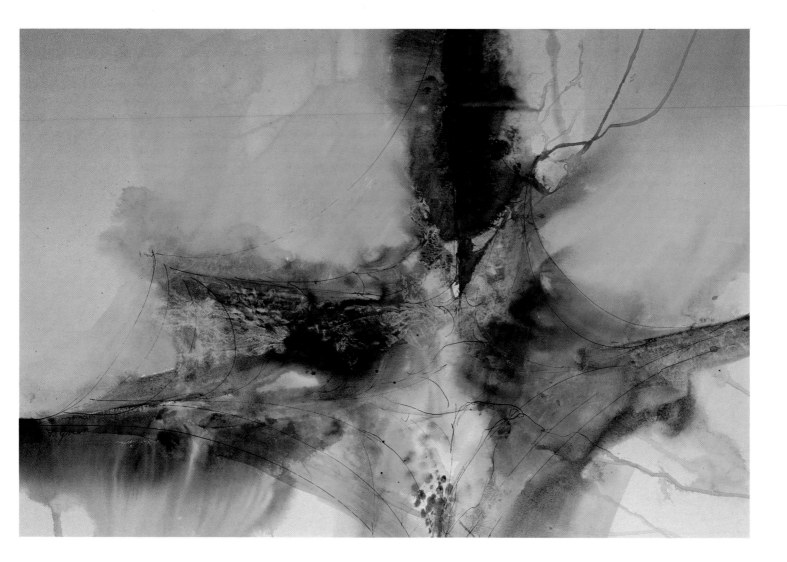

ATTIC, COBWEBS, LACE, *by Barbara L. Green, 30 × 35 in. (76 × 89 cm). Collection of the First National Bank of Boston.*

This artist handles a profusion of techniques with assurance. She has captured the petrified stillness of a long-undisturbed attic, using washes that spread until they disappear, strong punctuating spots, and some calligraphy. She obtained her feeling of lace, she explains, by lifting wet pigment. Although her calligraphy is restrained, it is vital. Its fine but tough threads bind together her more ethereal passages, as do her dark girderlike forms. The work as a whole reveals careful development of a concept freely imagined. Green was born in Schlochau, Germany, coming to the United States in 1953. She lived in the Midwest for many years, and makes her home in Rhode Island now.

Experiment 55

Add Work with Cray-Pas

Use of mixed media is now such an accepted practice that many art exhibitors have abandoned the former policy of identifying on a label the particular material used in the painting. Many materials now used with watercolor have long histories of their own. A few of them will be covered in other experiments in this book. Here we will be involved in a fairly new one—Cray-pas.

Cray-pas are an inspired scientific cross between crayons and pastels, as the name indicates. Like crayons, they are waxy, and, like pastels, they are chalky. The merging of these two qualities gives them a unique character.

Cray-pas pigment adheres to paper more easily than does a crayon's pigment, and the stick slides more readily. Colors are not so brash as those of crayons, and they give stronger, more definite color than pastels. They lack the etherealness of pastels, and two or three colors can't be rubbed together as successfully as can pastels, but they can be rubbed together more easily than can crayons. In short, they are a novel hybrid.

Cray-pas come in sticks in paper holders. A good assortment offers fifty-two sticks, giving you almost that many different colors. (A few are duplicates.) You will need that many to give yourself sufficient variety.

The object here is to exploit the possibilities of Cray-pas in enlivening a watercolor painting. The easiest way to do this is to look over your older paintings and find one that could stand more energy. Perhaps it got a bit overworked or suffers from muddiness. Since it is already in your pile of nonwinners, you will be willing to dare experimentation. You have little to lose. Cray-pas may be your life preserver.

Cray-pas pigment is opaque. Most of the colors are intense. Applied lightly, the Cray-pas will let your watercolor strokes underneath show through. Applied heavily, they will not. Using either method, or both, look for places on your painting where Cray-pas can supply needed accents—a bright line here and there;

hatching to fuse the Cray-pas color with the underlying watercolor; a new design element boldly drawn; twisting and turning a stick to add a calligraphic symbol. You will find many ways to bring out a painting.

Note, though, that Cray-pas are even less correctable than watercolor. Once you jot color down, it stays put. The only change you could make would be to put a darker color over a lighter one. The darker color will still be affected by the lighter one, however. Better to give yourself time to consider what you are going to do, rather than to plunge ahead impulsively. Unlike watercolors, Cray-pas color is in no danger of drying. Its consistency stays the same as when you first apply it. You can afford to take your time.

You may decide to add more watercolor washes after you have used the Cray-pas. This can be done without any problem. The wash will glide over the waxy marks, leaving them unchanged by the new paint, but with the paint settling in around them.

You could also go back and forth between the two media as long as you like. Whether you turn out a watercolor with Cray-pas accents, or a Cray-pas drawing with auxiliary watercolor washes, it is up to you. Either way it will technically be a work of mixed media. After sprucing up an old watercolor, you may enjoy working with Cray-pas so much that you will *start* with Cray-pas another time.

Bear in mind one caution: Cray-pas of some makes do not have the staying power of the best watercolor paints. Colors may fade, especially if a painting is exposed to sunlight.

Crayons and pastels are also worth a try. Pastels must be sprayed with fixative to give them permanence, and fixative adds a thin, yellowish glaze. There is also the chance of a droplet falling in the wrong place. And some artists don't like the waxy glare of crayons. Nonetheless, both have their enthusiasts.

For the middle way, Cray-pas are often the answer.

Spatter Freely

You can't help but limber up when you spatter. It's virtually impossible to do this tightly. You will get instantaneous effects that, no matter how well you have thought out your concept in advance, will be devilishly unpredictable. This, then, is an exercise in free choice. Each splash of dots of pigment will open up new opportunities that you are free to explore or not, as you choose. After every spatter, your concept will change, and you will be faced with a new choice of directions. Thus you will encounter as much freedom as you care to handle, and possibly a bit more.

Select a theme that's already familiar to you. You will be able to see how this technique will affect your previous handling of that theme. Almost any subject would be suitable, possibly with the exception of a subject requiring precision, like a portrait. A subject with a good deal of attention to texture will profit from spatter. Rocks, tree bark, clouds, flowers, fruit, shoreline, boards, brick, rust, stains—all could be considered.

Use your best grade of paper. Do this even though the experiment is a chancy one. You won't want to be completely at the mercy of your splashes. You'll want to remove some of your spatter in some places, or soften other areas, or pick up dots that have fallen where you don't want them. These endeavors are easier with quality paper than with poor paper, and there will be less chance of your bruising the paper's surface.

Spatter is often used as an auxiliary technique. Here it will be a major component. Mentally plan your concept with this in mind. Next, plan where and how to use the spatter.

Curiously, some of your paints, when diluted in water and thrown from the brush in specks, will have greater impact than others. Paints that require a good deal of water in order to splash may give you pale dots when they dry. You'll have to experiment to see how your various pigments behave.

Spatter can be used to fall on *unpainted* wet areas. In that case, you will get diffused wet spots. It can be used to fall on *painted* areas that are still wet. Here you will get wet diffused spots, but they will be changed by the color of the area and the degree of wetness. Spatter can also fall on dry areas. Obviously, the dots will be sharper, brighter, and will not run. You can use spatter on dry areas and then soften some of the dots with a damp brush.

You could also produce strings of dots, either on wet or dry areas, by briskly swinging your brush artfully over your paper. You could plant dots more precisely by holding your loaded brush over the desired spot, and, with your thumb and forefinger, squeezing the hairs downward until a drop falls. You'll enjoy inventing other variations. The possibilities are legion.

Before you start, pick your technique, decide where you want to apply it, and wet your paper accordingly. Try a number of brushes to see which work best for you. Generally, bristle brushes spatter most expertly. Borrow a few from your supply of oil or acrylic brushes. Make sure they are clean and not oily. A stiff typewriter brush or toothbrush also makes a versatile tool. It may become your favorite.

Before using any brush, determine where you *hope* the drops will fall. You can keep them from roaming elsewhere on your paper by gently placing tissues or lightweight rags over portions of your paper you want kept clean. If you have a wet wash and don't want to wait until it is dry before spattering, protect it with a piece of cardboard or something else you can put between the brush and paper, propping it up so that it doesn't touch the wet area.

To produce spatter, try running your fingernail along the tips of a loaded brush. This works particularly well with a toothbrush. Running a stick or the handle of another brush along the bristles may produce a different desirable result. Another trick is to hold the loaded brush horizontally over the place where you want the drops, and sharply hit the handle with anything handy that's hard, such as a pencil or the handle of a dry brush.

Types of spatter and types of application can be mingled in almost any order you want. They should be used along with other kinds of brushwork. Spatter alone will not suffice to make a complete painting. What spatter offers is a prime opportunity to create loosely. See if your sprayed dots give you depth and structure. Do they create sparkling, fragmented light—such as the pointillists among the French Impressionists obtained deliberately? Does your work have a pleasing glitter?

Add Work with Cray-Pas

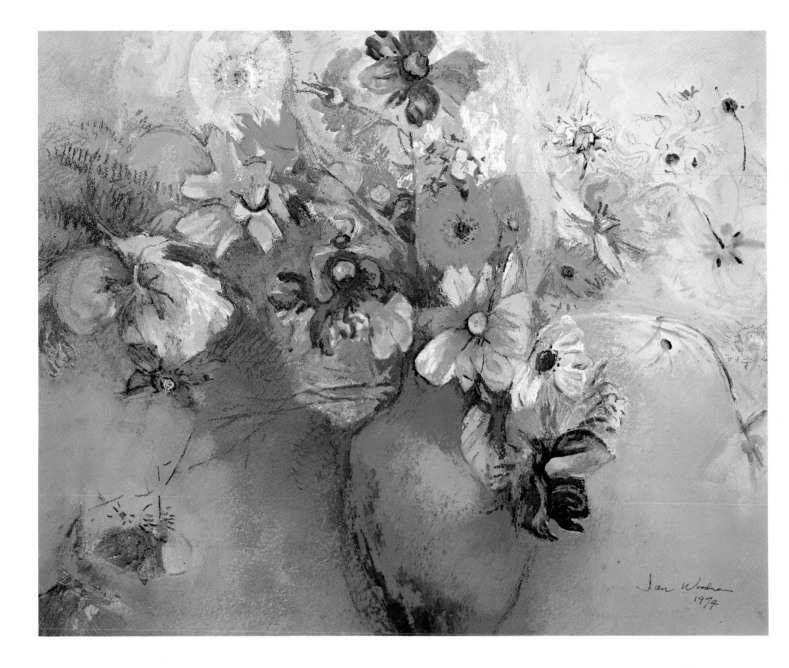

COSMOS, *by Ian Woodner, 22 × 30 in. (56 × 76 cm). Collection of Diane and Christopher Bamford.*

Cray-pas, like crayon and pastel, each in its own way, can add keenness to a watercolor. Woodner is one of many artists who rely on watercolor pigment for the larger concepts in their work, using a variety of other media for finishing touches. The lucidity of the watercolor is enhanced by these deftly applied additions. In this painting, Woodner's use of them is especially notable in his brisk, spikelike stems that stretch out into otherwise-empty portions of his composition, and in his treatment of foliage, where he achieves delicate textural effects. He has also used his sticks for other details where he felt they were needed. Tamped-down, softer passages are also evident, giving a glow to the underlying washes of watercolor. As a result of all these fine touches, the basic concept of the work—original in its own right—benefits from a wealth of technical proficiency.

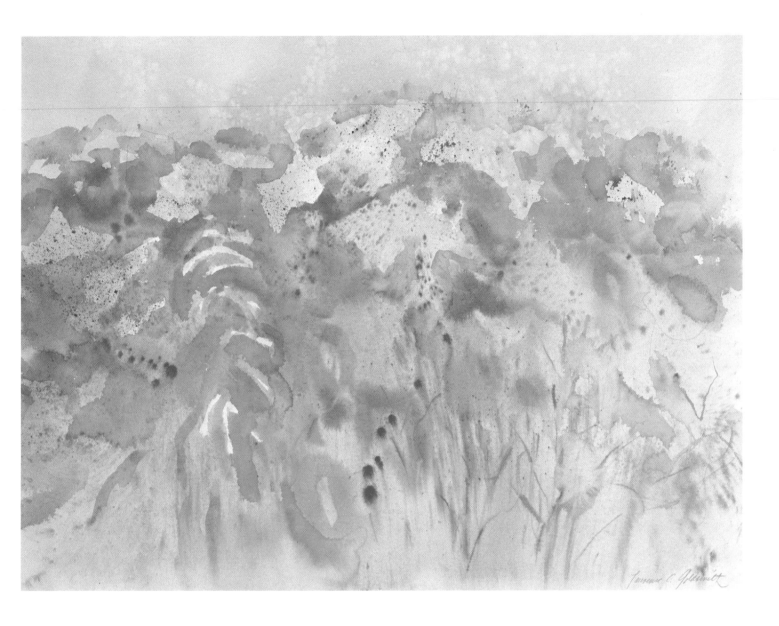

ANTHONY WATERER IV, *by Lawrence C. Goldsmith, 18 × 24 in. (46 × 61 cm). Collection of Martha and Edward Slowik.*

Here spatter is a trusted handmaiden, and the artist used it liberally. He hurled blobs of cobalt blue onto wash-covered wet paper, along with smaller blobs of mixtures of reds and burnt sienna. Then finer sprays of color were thrown over washes as they were starting to dry in the central band. Even later spatter was applied when the paper fully dried. The upper panel exclusively has a spray of clear-water spatter that arrived unexpectedly, heaven-sent: this painting was started outdoors, and a faint wash had just been applied to the upper panel when rain began to fall. Drops fell into the wash before the paper could be rushed into the studio. Fortunately, the raindrops created a positive effect. The remaining spatter was man-made. Much of what fell on the paper landed in places so that it could be manipulated into a growing design. Only after it had settled (or was removed) did the work of designing definite shapes begin. These became the rounded and elliptical suggestions of the clusters of blossoms of the Anthony Waterer spirea plant. A modicum of calligraphy acknowledges the existence of the stems.

Experiment 57

Work with Marking Pens

No watercolorist needs to be reminded of the hazard of being too picky. You are indeed fortunate in your artistic temperament if you have avoided the problem. The rest of us have had to face disappointment in the past, or are still facing it, when we overwork a painting with excessive detail. Fussiness has no doubt ruined more watercolors than anything else. Are you one of the rare exceptions? Then you can pass over this experiment to something else. It is designed for those who suffer from adding those last few finicky touches they wish they had never made.

There's no sure cure. Experience, of course, is your best ally. Another aid is to work with wide brushes rather than fine ones. Use these loaded with pigment and make quick stabs. The stab will be emphatic. Make a decision where to place it and then let it stand without modification. Continue with stabs throughout your design. Structure first seen in your mind's eye will quickly make itself apparent. An even more disciplined method would be to seek tools other than brushes that make for built-in boldness. That's where felt-tipped marking pens fit in. Practicing with them will help you be satisfied with forceful results. The usual marking pen has a wedge-shaped tip that's 3/8 inch wide. How can you get overly meticulous with a stroke that wide?

Marking pens don't lend themselves to faintheartedness in color either. Though they are not made only in the bright primary and secondary colors that graffiti artists relish, they still tend to be vigorous. You can't make any stroke with them that will fade into a timid blur.

For this exercise, I recommend that you acquire as wide an assortment of colors as you can. Some brands now come in as many as 225 different hues! That gives you bountiful leeway for varied color schemes. Smaller sets would be adequate for the purpose in mind here.

As with other examples of mixed media, start with a basic watercolor painting—lay down your washes fully and let them dry. Then, instead of the usual practice of developing the painting with watercolor techniques, rely on the markers. Plan your next steps with care, as work with markers is indelible.

Use markers for establishing your motif. Use them for calligraphy and line work. In final touches, use them for accents. The wide tips of the markers will produce lines of uniform thickness. This makes for some monotony as compared with the infinite flexibility of watercolor brushes, but this factor can be turned into an advantage. There will be a consistent pattern that will give your work unity.

As a counterpoint, you can try using the narrow side of the tips and even, using dexterity, squiggle them in some places for sharper and more personal lines. As with any other tool, push them to their limits.

You will not be able to get soft edges. Pigment in the markers is waterproof and sinks in immediately, not allowing you to melt strokes into adjacent passages. That is one of the limitations of the medium.

Another limitation is that the color is fugitive. A stroke stays put once you have applied it and cannot be budged. You can, however, run another stroke over it to get a crossing of color. A blue stroke made over a yellow one, for example, will turn green where the two cross. But *all* the colors will eventually fade. This doesn't bother anyone who is creating a design in commercial art where the color must hold only until the photographers or engravers record the design for its intended use. But it will drastically limit the permanence wanted in a work of art that aspires to look as fresh a few years hence as it did when it left the artist's hand. Avoid using markers when you want this permanence. This caution, however, doesn't apply to the kind of experiment recommended here. The colors will last long enough for you to see what can be accomplished without getting bogged down in detail. (They will last weeks or even months.) Marking pens will then have served you well in helping you discover more boldness and definitiveness in your strokes.

Introduce Bits of Collage

Collage is a kingdom of its own. A book on watercolor such as this one is not the place to explore its fascinations. There are books available that do this thoroughly. They provide the interested artist with the needed fundamentals so that he can go on to discover his own personal avenues of development. Here I will touch on collage only as an auxiliary tool in watercolor painting. Many watercolorists enjoy combining the two techniques.

This experiment is aimed at suggesting ways collage might be helpful to you as a watercolorist. Like so many of these experiments, this one could jolt you out of familiar methods, with an accompanying new sense of freedom. Even a single bit of collage applied to a watercolor demands a totally different outlook toward that painting. In this exercise, think of collage in its capacity to supplement watercolor, not as an independent medium.

Part of the fascination of collage is in the variety of materials that can be used. Many (but not all) can be applied effectively to a sheet of watercolor paper. Limit yourself to those that are feasible. These would be materials that are light enough to be glued easily to the paper—bits of other paper or even of watercolor paper itself, or parts of snapshots, printing, cloth, string, light pieces of plastic, foil, cellophane, and colored tissue. They can be cut or torn. A ripped piece of material can leave a handsome edge showing.

A sensible restraint is not to use too many different kinds of material in your first effort. Use two or three at the most. Later, when you have mastered your materials, you will be able to use a greater variety more effectively.

At least one artist creates her work out of torn fragments of her own discarded watercolors. She applies them to most of her surface, with some watercolor painted first on her sheet. The appliquéd pieces gently vibrate with the underlying areas of the painting. The cut edges of the collage set up a new pattern, carefully worked out so that it embellishes rather than conflicts with the basic structure of the painting.

In your first attempt, it would be wisest to use an already completed but expendable watercolor, most of which will still be visible when you have finished the project. Naturally, it will become transformed. You won't want to tamper with a watercolor that already satisfies you. Every piece of collage that you apply will change your image. Unless you are extremely careful, you will not be able to pick up a piece once you have applied it. There is little turning back. For that reason, don't use any glue or adhesive until you have placed the pieces on your painting and are satisfied with the effect. Study not only the positioning of the pieces, but their texture, color, size, and outlines. A pair of tweezers is useful in arranging and rearranging your pieces until you get the pattern you want. You can always add others later.

The adhesive itself will become part of your surface. Sometimes it will show through—with thin tissue paper especially. It might crinkle your material. This could be desirable. Try the adhesive first with scrap material on another sheet of paper to make sure you like the result. You will need to experiment with various adhesives. Colorless epoxy glue should be good as a starter. You can also try wheat paste, SOBO, or an acid-free glue that won't turn yellow or discolor with time. A small roller can be helpful to spread the adhesive uniformly. Your fingers, of course, will apply pressure in a more personal way.

Since this is still primarily a painting in watercolor, consider using additional watercolor touches to supplement the impact of the pieces of collage. If they stand out too roughly from your painting, adept brushstrokes can relate them in color or value to the painting. By their very nature, being attached to the surface, the collage pieces will add a three-dimensional image to your work. This will be a plus. But look over the work to make sure that one piece doesn't visually (if not actually) protrude excessively more than the rest. You will want to strive for harmony as well as drama.

What can be learned from this experiment? Obviously, you will be finding promising new textural effects in the collage itself. You should also be sensing new possibilities in the subject matter you are dealing with. Collage is not really appropriate for realism. By introducing bits of material made originally for other purposes than for art forms, you will be departing from pictorial rendering. The loss in accuracy will be fully compensated by what might be a much truer version of that subject.

Work with Marking Pens

SEATED FIGURE, *by Alex Minewski, 12 × 8³/₄ in. (30 × 22 cm). Photo by Tom Dunham.*

Stabs with a brush enable this quick study to chronicle the sensations of a few moments. The medium is transparent watercolor. (A wide felt-tipped pen would have made similar but perhaps more regular strokes.) Using only five colors and one large brush, the artist positioned his stabs to define the figure and at the same time unite the chair and background to it. Notice how one fast stroke establishes an eye; another outlines the mouth. Massive stabs mold essential parts of the body. Consistent use of such strokes fills the paper, so that the figure is seen as a part of an integrated painting and not as an isolated theme. Minewski's aesthetic creed is that "through inner force I hope to develop the physical image. By avoiding the picturesque, I want to reach beyond the image alone." For many years he taught at State University College at New Paltz, New York.

1, 2, 3, 4, 5, 6, by Raymond Saunders, 12½ × 14½ in. (31 × 37 cm). Courtesy of Terry Dintenfass Gallery, New York.

The introduction of bits of collage along with other art materials, including generous sections of watercolor pigment, load this work with energy. One gets a feeling of the vitality of a city with its graffiti-scarred walls and throbbing traffic. Another impression is that of random notes on a blackboard or bulletin board. The adroitly placed numerals of the collage stand at the hub of all the activity. Other influences can be felt as well. Victoria Donohoe, writing in the Philadelphia *Inquirer*, says he "shows some cognizance of mythical and magic traditions, including African ones" in the way he puts together his pictures. The artist, who was born in Pittsburgh and now works in Oakland, California, has traveled and painted in Africa. His special gift is in his ability to compose integrated works out of small elements, as shown here. Fragments are painted with a free use of materials in a composition filled with movement. Spurts of energy lead in different directions, coordinated in a massive sweep that relates each fragment to the rest.

Experiment 59

Use Just One Brush

As repeatedly stated, the biggest obstacle to boldness is overwork. The artist who starts a painting with wet paper and then lays in strong washes has produced boldness with a few quick strokes. Then he goes on to develop his work. This way lies achievement—and also pitfalls. Too many finishing details will diminish the boldness. The problem is all too prevalent. Many watercolorists reach a satisfying plateau in a painting and should call a halt. Instead, in search of an ideal, they destroy what they have already accomplished by injecting tired areas of fussiness. For artists with this problem, limiting themselves to a single large brush would prevent them from overworking, since who can be too fussy when working with a brush that produces only bold strokes?

The best brush for the purpose would be the largest one you own. Use either a flat, single-stroke brush or a round wash brush. You probably own (or should own) a single-stroke brush that's one inch wide. That would do well. Or use a large wash brush. Since these are numbered differently, depending on which line of brushes you have, the simplest rule is to pick any brush that is nearly as wide as your forefinger.

Think twice about what is known as a sky wash brush, however. These have rounded ends, and you will probably find that you won't get as much definition with this brush as you might like. It's made to be used in combination with other brushes, and here I'm talking about using one brush throughout the painting process.

You may discover that you can get a surprising degree of definition from the one brush you use, especially a single-stroke brush. Used sideways, the hairs form a fairly narrow line, so you can use linework to some extent. The line will be one inch long, or longer. This fortunately rules out meticulousness. With care, you can also let only a corner of the brush touch your paper. This will give you sharp bits of paint, which you may want.

One benefit from this experiment is that you will be able to practice finger dexterity. At first you may find your one brush clumsy, especially when, toward the end of your painting period, you yearn to tighten loose passages. Then you will find that, with agile manipulation of your fingers, the brush is not so clumsy after all. By twisting and turning it, you will be able to get subtleties that are not at all crude. And they will be highly personal.

The only real handicap will be a mental one. You will be tempted to resort to smaller brushes at the end. Resist the temptation. See what you can gain by sticking to the one brush from start to finish.

Occasionally an artist comes to the conclusion that he'd *rather* use one large brush permanently. More power to you, if this should happen to you. More likely, after getting accustomed to large brushwork, the result will be that you will become more firmly aware that the excess of detail that you were indulging in until now is not only unnecessary but destructive. You will then be able to use both large and small brushes without getting into that danger zone.

I have said nothing about composition, concept, and color schemes. Obviously, these must always be considered, but they have no particular bearing on the problem of pettiness. Handle those elements as you usually would. The only difference here is a technical one—the size of your brush and therefore the width of your strokes. Big, bold strokes can be effective in almost any kind of work.

Like so many other new approaches—including most of those covered in this book—a single trial won't get you very far. Try the big brush several times until you feel at home with it. The clumsiness will disappear. Then you will be able to decide if you have found a new direction you want to follow. Whether or not this is your conclusion, you will have investigated a new road to boldness.

Paint on Colored Paper

Painting bold and free is often a matter of breaking habits. New concepts evolve when the artist is confronted by new conditions. Here the idea is to replace the usual glistening white paper with tinted paper, some unusually textured paper not generally associated with watercolor, or a combination of such papers.

Colored paper was often used in the past. Turner used colored paper for many of his smaller sketches, making quick, loose statements, and some of Cézanne's watercolors were also done on colored paper, including several shown in *Cézanne: The Late Work*, published by the Museum of Modern Art, New York, 1977. Light tints were always chosen for the paper. Deeper colors would obviously impair the essential transparency of the medium. The technique is less common now. One reason is that contemporary watercolorists are accustomed to working wet, and tinted papers are seldom available in stock heavy enough for this technique.

When using colored paper you start, of course, with the one color given by the paper itself. All the other colors supplied by pigment should be related to that color and will be affected by it. Thus any blue painted on a light ochre sheet, for example, will tend toward a green. Areas left clear will show that ochre. White would have to be applied.

Here would be a chance to use Chinese white. This is a pigment often disdained by the artist seeking transparency in its purest sense, since Chinese white is opaque. Working on colored paper, however, adds a new dimension to the use of white. The white gives a lighter effect than the paper itself. Since the paper is a middle value, comparatively, you can go in two directions, lighter as well as darker. The white paint allows for those lights, and other colors provide the darks. Brilliant white accents can be most striking.

You will have to work dry for the most part. You may be able to dampen some small areas before putting on paint, but an all-wet sheet may not be feasible. Whatever looseness you achieve will come from bold brush handling, not wetness. Dry brushwork will be your chief tool. Softening edges with a damp brush will allow for some fluidity.

These considerations should be studied in advance. You will want to have a mental picture of your eventual finished work embodying your lights and darks, and allowing some of the paper to remain bare.

Begin with the color of the paper dominant. Decide how much of that dominance you want to remain and how much you want your own colors to take over. Naturally, the larger the proportion of space that you actually paint, the less dominant the paper's color will be. Theoretically you could cover *all* your paper, but then you would be losing most of the value of the tint. A happy balance between paint and paper offers the best results.

Try a number of different colored papers. Each one will add to your repertory of color combinations, since each will have a preliminary color that will alter the appearance of every color of paint applied to it. Each color of paper will have to be worked in an individual way.

A few words should also be said about rice papers. These are available in a staggering variety. The only way to discover what works best for you is to try as many of them as you can. It's an exciting pursuit. They come in all degrees of whiteness and in many textures. Since many of them are handmade, they can vary from sheet to sheet.

All of them are thin, and they are either not porous or very porous. That means that your paint will remain on the surface, until dry, or that it will sink in quickly, and that the paper will buckle. These very obstacles will produce accidental effects that may be to your liking. (Mopping up with tissue or a sponge will help you overcome most of those you don't like.)

Another quality of rice paper is an unevenness of texture caused by the fibers embedded in it, which vary in size and number, but their prevalence is characteristic of all such papers. These fibers pose further obstacles and opportunities. Your brush might catch on a protruding fiber and cause unpremeditated spatter. Or a fiber will form a wall against which a wash will collect, since fibers will not absorb pigment. They will stand out, bare, as slim accents. Your colors will enhance these filaments so that the texture they provide becomes more visible. Be ready to benefit from what rice paper offers. It is seldom predictable.

Variety of paper adds to the versatility of your medium. A few artists even stretch this versatility to its limits by working on several different kinds of paper in *one* painting, using one kind in one section and another in another, pasting and layering these papers according to their desire for differing textures.

Use Just One Brush

Still Life with Apricot Nectar, *by David Rohn, 11 × 15 in. (28 × 38 cm).*

"I use one brush—a number 12 Winsor & Newton round red sable (with hairs 1⅜"
long)—regardless of the size of the painting," says the artist, "and try to make the
separate applications clearly and distinctly their own puddles." He uses the word
"puddle" for what most others describe as a watercolor wash. "In my best work I
think I achieve a balanced tension between the integrity as a puddle and the obliga-
tion to describe." He adds that his tendency to limit his number of strokes may come
from his background in etching. He also worked for several years doing abstract
paintings in oil. The simplicity of Rohn's work reveals a deep knowledge of spatial
relationships. His shapes interact in a field of maximum clarity. Positive and nega-
tive shapes are equally important; nothing is hidden. The use of a single brush
doubtlessly aids the artist in working with his bold shapes. Like any tool, however,
it is expressive of no more than the artist intends. Rohn's intentions are concerned
with making strong statements with simple objects. He is a Vermont artist.

PARCEL OF CLIFFNESS, *by Alexander Nepote, 30 × 40 in. (76 × 102 cm).*

Paper doesn't play its usual passive role in the watercolors of this veteran artist. His contribution has been adding, subtracting, and working with layers of thin watercolor papers and other heavier rag papers used by printmakers. The paper is put on and removed, sanded, scratched, and stained as applied pigment in transparent watercolor is manipulated. "I don't fear losing the white paper," Nepote explains. "I just put more on. By adding paper I can regain 'light' lost by having stained the paper and afterwards can peel off some of the added paper for either regaining light or creating a texture. In this way one battles with the concept, and the accidental—so important in watercolor—takes on a new dimension. The content gets stronger and richer." He believes there is a reality of great expressive beauty—of truth—when cliffs disintegrate and break apart, when leaves turn red, fall, and decay, when waters cascade down ravines, and when vegetation as well as lichen and moss in damp areas creep into cracks. His paintings are not planned in advance, although he does work up a series of small sketches. Then "I meditate, reflect, dream, and get a general idea of what I want to express. I cannot predict the final result. I eagerly look forward to seeing what I'll get." The artist lives and works in California.

Experiment 61

Stain and Layer

Beguiling technical effects can be obtained through a process of laying down washes, pulling them up to leave only a stain, and then applying second or third washes in the same place and in the same way. For the sake of simplicity I'll call this staining and layering. No two artists are apt to produce even similar effects. Hence this experiment has its own particular allure.

Layering is actually a process long rooted in the history of watercolor. Classic painting in the eighteenth and nineteenth centuries was done in this manner, especially by English watercolorists. They would paint a thin film of underlying color (always on dry paper). When that layer dried, they would build up successive layers, each time waiting until the layer had dried, until they had formed their desired images.

Contemporary artists have reverted to this method with a difference. Their layers are applied more freely and suggestively. They seek more visual enjoyment from the qualities of the layers themselves, rather than using them as a means to form concrete images. Any image, while not accidental, is subservient to the total aesthetic impact. Creation of that impact is wholly experimental—it cannot be reduced to a set of rules. You must find your own route. A few suggestions can be made to give you a start.

Plan a composition in the usual way, using a large sheet of good, heavy paper. Choose a sheet with a fairly hard surface (whether rough or cold-pressed). A harder surface bruises less easily than a softer surface. It will withstand tougher treatment in pulling up pigment.

Apply your washes with a *strong* saturation of color. Then, while the paint is still wet, pull most of it up, leaving only a stain. This pulling up can be done with blotting paper, a sponge, a cloth, or a sheet of facial tissue. The sponge should have a flat surface. The cloth or tissue should be laid flat, not crumpled. Then rub gently with your fingers until most of the paint is absorbed. Pull your material up carefully. A stain will remain. Let it dry before applying a second stain, in another color, but using the same technique.

This is the point at which you will encounter the experimental aspect of the process. There is no telling in advance—until you have considerable experience—how much stain will remain. Some colors will sink in and stain more indelibly than others. Moreover, the same color produced by different manufacturers will behave differently. In general, you can trust the thalo

(phthalocyanine) colors to stain best. These are found in much of the spectrum: blue, green, yellow-green, red, crimson, and violet. Other colors will also stain well. Try your whole palette on scrap paper to see which work most successfully. Further subtleties, of course, can be obtained by mixing colors.

Most of your effects will be produced by causing one color to shine through the one on top. You will get varied results from combinations of transparencies, just as you would by placing several panes of colored glass on top of one another. Much depends on which is on the bottom and which is above it. Yellow painted on green will look different from green on yellow, for example.

Timing is also a matter of experience. You will learn how long to let a particular layer sink in before pulling it up with your sponge, cloth, or tissue. Because timing is such as important factor, you would be wise to work in your studio, where conditions are relatively stable, rather than outdoors in capricious sunlight.

While this layering method differs markedly from the usual method of mixing colors in one wash, you will still want some of the glow of your paper to shine through. Any opaqueness destroys the transparency that is one of the unique beauties of watercolor. Stop short of opaqueness.

With care, you may be able to rub off an unsatisfactory stain. Try scrubbing it away with a sponge or bristle brush. See if you can get it up without damaging the surface of your paper. Some papers are sturdy enough to withstand considerable prodding, and even light scraping with fine sandpaper when dry. When an area is dry, you can try applying another stain. There are risks in this procedure, but they may be well worth confronting. You may be surprised how much you can rework without losing freshness.

Once you are satisfied with the number and variety of your layers, you can go on to use lines and accents for finishing touches. Or you may find that your layers in themselves produce a completed painting. This is not an impulsive way of working, so take time to make your final decisions.

Essentially what you will have created is a building up of layers, each one making a contribution. Together they will evolve an interaction that no one layer could achieve on its own.

Paint with Clear Water

In this experiment you will be painting with clear water—no color at all, not even a tint, just the clean water from your faucet or container. You will be creating textural interest by the furrows and lines that the colorless water makes as it dissolves paint on already applied washes. This experiment continues to be experimental no matter how many times you practice it. You are always taking chances, always encountering surprises.

This technique belongs exclusively to watercolor. You cannot even approximate the effect in oil, acrylic, or casein, the most comparable media. Water alone, coursing through washes in lyrical rhythms, spreads across your paper, producing delicate and luminous channels that extend, like fibrous roots, into neighboring passages of color. When they flow where you want them to flow, that is! Otherwise, like water elsewhere, they will be seen as leaks or floods, causing disaster.

Essentially you are capitalizing on what, in other watercolor paintings, you would call accidents. Here you will be creating accidents on purpose. Having created them, you will be trying to manipulate them as a major design motif.

Start with your usual paper and paint. Sketch one of your favorite themes, wet your paper thoroughly, and put down large painted washes over all or nearly all of your space. Then be ready with medium-sized brushes—round or flat (single-stroke brushes)—to paint with clear water. Keep the water handy. You must apply your clean-water strokes at just the right moment.

When is that, you ask. I wish I could tell you. Like putting "just enough" sugar on your berries, this is a matter of learning by experience. The wash on which you are going to impose strokes of clear water must still be wet enough for the new water to burrow into the drying color. But the wash can't be so wet that the new water will just spread imperceptibly into it. The wash must therefore be half-wet and half-dry. There really is no way of describing that stage of dampness precisely. You will have to feel your way.

As if that weren't enough, you also have to contend with different characteristics of colors when they are in the process of dissolving. This has to do with their chemical composition. Different manufacturers make their pigments differently. Again you must experiment to see how a wash of one color reacts differently from another when you apply clear water.

One thing you can count on is that there is no turning back. Once a furrow is made with clean water, while it may spread a bit, it will remain visible. It cannot be removed. Obviously, then, you should calculate the risks before you take them. Suppose a rivulet doesn't flow exactly as you had hoped? There's nothing to be done about removing it, so live with it peacefully. Try to duplicate it by creating a similar rivulet elsewhere in your composition. Perhaps it will spark a whole new concept in design, with numbers of similar rivulets producing a pattern that transforms your watercolor.

This technique is so unpredictable that you can't allow yourself to feel you have failed if you can't adhere to a pre-set plan. Rather, you should think yourself successful when you are able to coax those capricious streams of water into paths that ultimately form a happy composition.

Diligent brush-handling will give you some measure of control. A single stroke is all that's required to make one rivulet. More strokes usually create a puddle. Think about performing that single stroke artfully. Give it the right twist and pressure to cause a sensitive result. Keep a bristle brush handy. This can be used to soften the bank of a rivulet that threatens to form a blotch that *looks* like an accident. Often the softening of one side of that blotch will make it look like an *intended* passage and not an accident.

Since painting in clear water must be done at just the moment when a wash is at the correct stage of dampness, you will have to work quickly. Once that critical stage is passed, you can slow down, assay your results, and apply your finishing lines and accents (with paint, not pure water). Only the technique itself need be executed speedily.

The single valid criterion of success is whether or not the total result is pleasing. There are no rights or wrongs, in such an adventuresome technique. Don't form your conclusions too hastily, though. This will be a time of tension, and it will take a while before you can see whether you or the water has won.

Stain and Layer

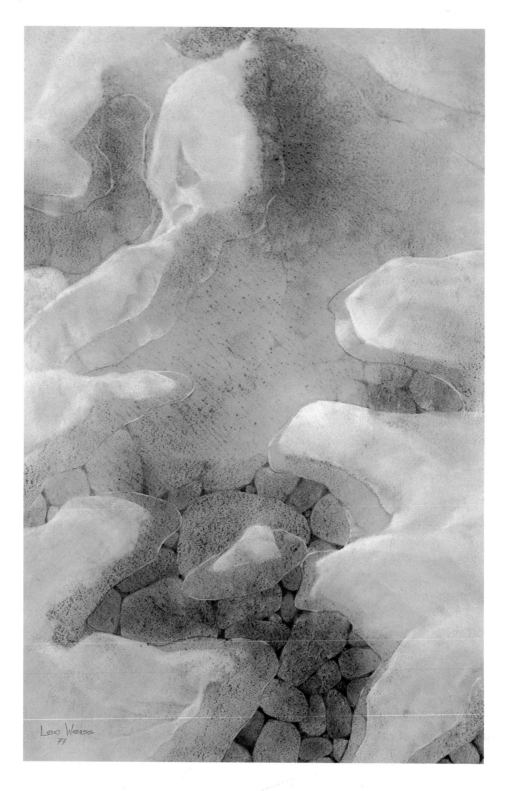

WHEN WINTER COMES, *by Lee Weiss, 40 × 26 in. (102 × 66 cm). Collection of Mr. and Mrs. L. Stephenson.*

By experimentation, artist Lee Weiss arrived at a technique similar to monoprint. She applies pigment to her surface and then flips the face of her paper onto a formica table. Where the pigment has been heavily applied and is still semi-wet, the contact with the slick tabletop and subsequent pulling away of the paper leaves a highly tactile surface. When the color is more thinly applied—and wetter—the texture is more delicate and directional. Sometimes going further, she lays different colors on the two sides of her paper and deposits them in turn on the tabletop by repeated flipping. In this way, color put down on one flip is picked up by the opposite side, superimposing one color upon another, allowing the pigments to mingle without becoming muddy, encouraging the pulling away of heavier pigments from lighter, and causing intricate edges and separations. "Many of my paintings appear somewhat monochromatic," she admits, but, in fact "they employ a multitude of colors."

FANTASY RIDGE, *by Lawrence C. Goldsmith, 18 × 24 in. (46 × 61 cm).*

The artist's use of clear water is responsible for the sense of fantasy in this painting. Clear water by itself, of course, is invisible. Its unique contribution is what it does to applications of paint already down. Painted into still-wet washes, it will form furrows in the paint in some places and dissolve paint in others. The clear water will also build walls of deeper color where it stops. All affect the central portion of this painting. The brush carrying the clear water was manipulated to guide the new shapes being created. They move upward on a slant toward the top of the ridge (where clear water was not used). There, more forceful passages of color were painted. The scheme was to let this stronger area of the painting contrast with and therefore highlight the delicacy of the lighter, clear-water shapes below it. To bring the eye back across the paper, a soft globule of blue was placed in the yellows of the sky. Thus, while clear water does generate much of the interest here, it was not relied on exclusively.

Experiment 63

Paint Around Forms

This is a technique that gives a new light to realism. Realism, after all, has more to do with how you see a subject than with the subject itself. A commonplace subject can be treated so poetically that the subject becomes incidental, dwarfed by the drama staged by the artist. One way to do this is to apply paint in wide strokes *around* your forms instead of relying mainly on brushwork within the forms. The surrounding belts of color take on a life of their own. They transform a motif that might otherwise be rendered conventionally into a bold, personal statement.

Begin by apportioning your paper so that generous space is left around your central objects. This is where you will apply your color enclosing them. Next, devise a color scheme for your objects and a *second* color scheme for the surrounding enclosures or bands. This second color scheme can be either closely related to the first one or dramatically opposite to it. Beware of too much diversity in color, however. Two color schemes that are related are likely to be safer—and more appropriate as well. Finally, plan a set of values for your forms and for those enclosing bands. There should be enough contrast so that the two are clearly defined.

By bands I don't mean uniform belts that are hard-edged inside and out. The inside edges can be hard, or hard in most places, but it is best to taper off the outside edges so that they appear to melt into the color (if any) used at the top, bottom, and sides of your sheet. It's as if paint slowly builds up until it reaches the outside of your forms and there it stops, with a hard edge.

Develop your early washes and preliminary definition. Foresee how areas will look when partially enclosed from the outside. Not that you can't go back to the interior forms later after you have put in the bands. You will be able to do so, but try to resolve the problems within the forms first. Then let those areas dry before working on the outside enclosures.

Being bold, the enclosing belts will require your largest flat brush. Even a two-inch brush isn't too wide if you are working on a half-sheet or larger. Load your brush with pigment that you have sampled on a piece of scrap paper. A melding of two colors that you pick up on a single brushstroke is entirely possible and sometimes most rewarding. Bear in mind the caution above about using too many colors, however.

Work swiftly but deftly. The side of your brush that forms the inside of the bands especially needs to be handled skillfully. Here will be the visible patterns along the hard edge that can add so much energy to your design. The other side of the brush will form the outside edges, which will taper off to melt into the background. Tapering is accomplished by approaching a wet edge from the nearby dry area of paper, with your brush containing clean water. Experience will tell you just how much water you need. Too dry a brush will create surface texture. Too wet may flood water into your wet paint and form rivulets. Your own technical efficiency will show its worth here.

Place those strong bands around some of your forms first. Then see if you want them around more of the forms, or even all of them. You probably also will want to vary color or value, or both, as you go along.

Essentially you are creating shapes from the outside. The character you gave your forms earlier came from the interior. That character becomes changed by those encircling wide strokes. Because these strokes taper off on the far side, their inner sides—which confine your forms—now dominate. At the point where the new strokes reach the forms, they establish outlines that define the forms in dramatic fashion.

This technique can also be used to rescue a watercolor that seems to be going sour. Not every watercolor, of course, proceeds step-by-step to its triumphant conclusion. Sometimes success is accomplished by performing drastic surgery at some midway point. Painting around forms might be the needed operation. Naturally, everyone would rather work along a direct path than have to pull a painting out of a detour. But remember this experiment when you get into a fix.

Like any other technique, this one works best when you plan on using it from the start. Well used, this system of painting around forms can enlarge and deepen the impression a painting gives. Imagine what your forms would have looked like had you not enclosed them. See if creating your shapes from the outside gives you ideas for other shapes, in other paintings, done in a similar way.

Let "Accidents" Take Over

Let accidents happen. They are not only inevitable, they can make contributions to a painting that would not occur to you. In many ways, they are more powerful than you are. The attempt in this final experiment is to try to harness that power, so that even when accidents dictate the direction a watercolor takes, you are still their master.

Dismiss from your thoughts the fiction that accidents don't happen to everyone. They do. Take a piercing look at the work of artists you admire the most. Turner? No accidents in Turner? Indeed there are. They are so subtly incorporated into his total effects that they are not quickly noticeable, but they *are* there. About the only exception to the generalization that accidents are universal is seen in the output of the artist who is so controlled that his work is lifeless. Where there's life, there's happenstance.

Occurrence of accidents, moreover, is one of the unique properties of watercolor. Beautiful things happen inexplicably, which is not true of oil or acrylic because they never flow with such rapidity. A burst of colored water—which we call an accident unless we planned it—takes it upon itself to build intricate hard edges, or thins itself out to paint a film with soft edges. These sudden changes may by themselves suggest a change in theme, or may be used to strengthen the original theme.

How can you go about making *deliberate* use of accidents?

The first requirement, of course, is to let them happen. Accidents have an uncanny way of happening when you don't want them to, not when you *do*. Probably the best way to invite them is to cultivate a receptive attitude.

Approach your paper with studied carelessness. A further incentive to accident would be to run unusual risks. Squeeze a wet brush with its hairs pointed downward so that a large drop falls on a damp wash. Or paint into a wash that is nearly but not entirely dry. You could even be so bold as to jog your own elbow when your fingers are holding a loaded brush. Something is bound to fall somewhere. These, of course, are induced accidents. You also have natural accidents to deal with if you are fortunate. Both kinds can be treated in the same way.

Basically, your aim should be to convert an accident from an unwelcome blotch into an effective element in your composition. Often this can be done by the simple expedient of softening one or more edges of the area with a damp brush, preferably a bristle brush. Doing this will unite the area to surrounding areas. Another device is to extend the accident with a couple of brushstrokes similar to those used elsewhere. This, again, will relate it to the rest of your painting.

To diminish attention paid to an accident, try a sharp accent near it. Use deep color and a sharp line. Or surround it with an interesting line, thus turning it into a purposeful shape.

One accident will appear less obtrusive if there is a similar accident, or series, to balance it. Producing an accident of the kind you want, where you want it, requires the utmost skill. See if you can duplicate the exciting shape of a raw oyster with those crinkly edges! When you succeed in doing this you will have renewed respect for the variety of texture that accidents can offer.

Once a watercolor shows a number of accidents—deliberate or truly accidental—they begin to take over the painting. Let them. You will get effects that can be obtained in no other way. However, you must take care so that these effects relate to one another. Try to avoid introducing other features that would conflict. Properly, the eye will skip from one accident to another, and the impression will be given that they *belong*.

Study your finished painting from the viewpoint of the accidents' influence. Do they contribute aesthetic pleasure? Do they help establish your theme? Do they bring excitement? Accidents need not be considered as mistakes. They can be valued as tools of the artist, proudly used. Glorious accidents!

Paint Around Forms

SEVEN FISH IN A HILO POND, *by Joseph Raffael, 28 × 43 in. (71 × 109 cm). Courtesy of the Nancy Hoffman Gallery, New York.*

Painting around forms is demonstrated skillfully here. The artist lets his paint flow up to the edges of his fish shapes, outlining them with exactitude. In many places, this outside color is then lightened, and even darkened, over the shape. This dovetailing unites the fish with the water. Mosaiclike patterns of light thus illuminate both. Further brilliance is given to the central portion of this watercolor by the contrasting rich darks at the top and the right side of the painting, dramatically set off by the spray of foliage, again outlined from the outside. Raffael's work gives a momentary sensation of ultra-realism, but a more careful study reveals a painterly, impressionistic handling of fluid washes, angular insertions of refracted light, and impulsive spots—all stemming from his background in abstraction. The artist describes his work in watercolor as "a kind of folk dance I do with the brush, the water and color, and the paper. We all meet in an intermingling of energies." He does his paintings wet, affording him an "experience of wonderment and surprise." Raffael was born in Brooklyn and now works in California.

SEED STALK, *by Lawrence C. Goldsmith, 18 × 24 in. (46 × 61 cm).*

The accidents that almost inevitably occur in a free watercolor play a role in this impression of autumnal withering. They were not sought, but neither were they resisted. In some instances they were seized upon as originators of images. More rarely, accidents were deliberately caused in order to complement other accidents that came about naturally. It may be difficult, therefore, for the viewer to distinguish between what was accidental and what was not. The more obvious accidents are the result of large drops of warm sepia falling in the "wrong" places and spreading. Rather than try to obliterate them, an attempt was made to make them look logical. Additional color was introduced. Then these accidents were consciously reproduced elsewhere as the composition seemed to dictate. Other accidents—this time puddles—near the base of the stalk were deepened and outlined. The painting process then continued under greater control. Although always taxing the resourcefulness of the watercolorist, accidents themselves lie beyond total control. Their personality happily survives.

Index

Italicized numbers indicate illustrations.